The Art of
Alexander and John Robert Cozens

By Andrew Wilton

Yale Center for British Art · New Haven, Connecticut · 1980

Cover Illustration:
John Robert Cozens, *On the Lake of Nemi* (cat. no. 96)

This catalogue was published on the occasion of an exhibition at
the Yale Center for British Art, New Haven, Connecticut,
September 17 through November 16, 1980.

Copyright © 1980 by Yale Center for British Art
Library of Congress Catalogue Card Number 80-51668
ISBN 0-930606-27-2

Design: Juan López-Bonilla
Typesetting: Ro-Mark Typographic Co., Inc.
Typeface: Baskerville
Printing: Rembrandt Press
Binding: Mueller Trade Bindery
At the direction of: Yale University Printing Service

Contents

Foreword

The *Art of Alexander and John Robert Cozens* belongs to a series of Center exhibitions devoted to particular aspects of the permanent collection. These displays have various purposes. Not only do they provide a means of making known the resources of the institution; they also serve as a vehicle for the raising of questions of interest to scholars and students. Former projects include the popular exhibition of Rowlandson drawings from the Paul Mellon Collection shown in 1978 and the comprehensive survey of portrait drawings and miniatures presented in 1979. Exhibits centered on the work of Paul Sandby, Samuel Palmer and John Frederick Lewis are under consideration for the future. The current project attempts to document the relationship between Alexander Cozens and his son John Robert, while providing a complete catalogue of the extensive holdings of the two artists in the Yale Center for British Art.

The conception and realization of the exhibition are owed to Andrew Wilton, whose catalogue contains complete, critical entries on the individual works and a valuable essay on the general subject. Our thanks go to him as well as to the various members of the Department of Prints and Drawings who assisted him in the undertaking; in particular, Angela Bailey, Dolores Gall and Elizabeth Woodworth for their help in preparing the catalogue and Ursula Dreibholz, Paula Jakubiak and Mark Walas for carrying out the numerous conservation tasks that were required. Patti Tohline, who typed the bulk of the manuscript, also deserves our thanks. Lawrence Kenney edited the text. Juan López-Bonilla, a graduate student in the School of Art, designed the catalogue; and its production was entrusted to the Yale University Printing Service. To all of the above we extend our very sincere gratitude.

Edmund P. Pillsbury
Director

Introduction

The purpose of this exhibition is to show all the works by or attributed to Alexander and John Robert Cozens in the Yale Center for British Art, and at the same time to present the output of these two artists as part of the continuous evolution of a certain type of landscape painting in eighteenth-century England. In particular, the exhibition seeks to explore the relationship of the two Cozenses, father and son, not only with their contemporaries but to each other. Their connection by blood has often been used as the basis for superficial conclusions as to the continuity represented by their work; but there is all too little evidence to lend these conclusions real weight. A tantalizing ambiguity hangs over the problem. The facts tend to show that John Robert learned remarkably little from his father. His achievement is in a very different field from that of Alexander; while the latter sought to eliminate the representation of specific scenes from his work in order to create a more universal language of landscape, John Robert almost never departed from the topographical use of actual places for his inspiration, attaining universality by his highly personal, rarefied interpretation of reality, and eschewing the imaginary and the ideal.

Yet it is hard to believe that Alexander did not exert a profound influence on his son. He was a teacher all his professional life, and one, evidently, with a considerable ability to charm and impress his pupils. In addition to enjoying a wide practice among the aristocratic amateurs of England and maintaining a post as drawing-master at Eton, possibly for as long as twenty years, he was an enthusiastic theorizer, a man whose temperamental bent was for explaining—a natural pedagogue. His explanations, it must be confessed, did not always make things simple. Sometimes his propensity to categorize, enumerate, and tabulate renders his subjects unnecessarily confusing; but it indicates a deep and imaginative concern with natural phenomena and the means by which an artist can set about representing them. Some of his schemes were of a general philosophical nature (see Whitley, 1928, pp. 320–21); but many were apparently evolved explicitly to aid his students, like the "blotting" system that he explains in his *New Method of assisting the Invention in Drawing Original Compositions of Landscape* (see nos. 26–68).

By that period, the last few years of his life, he was, as his patron and friend William Beckford said in 1781, "almost as full of Systems as the Universe." But it is clear that his habit of systematizing was developed very early on. The elaborate directions to himself that fill several pages of the Roman sketchbook (no. 2) are a demonstration of his love of inventories, lists, and comparative tables. An album in the British Museum (1888-1-16-8,9) contains some sketches for a "system" which may well have been embarked on shortly after he had returned to London, for it includes several classical landscape compositions of a type that he seems to have favored in the years following his Roman stay. The album is

labeled in an unknown hand: "Sundry Studies of / Landscape Composition / by Couzens the Elder / They appear to me to have been intended by him for the improvement of His Son at whose Sale I bought them." (This would have been the sale of 1794.) As Oppé points out (1952, p. 72), this hypothesis is probably "a complete misconception," though there is no reason why such sets of landscape schemes as the album contains should not have been shown to John Robert and even copied by him. The album includes two distinct series of drawings, one of which, as Oppé says, is a "system" of seven sheets, each having sixteen tiny landscape compositions, together with one sheet of only two designs. The first sheet is a series of roughly recognizable landscapes with trees, clouds, water, and so on; the second and third show a gradual simplification and "abstraction," and sheets five and six are so schematic as to be nothing more than sequences of brief scribbles vaguely indicative of a repoussoir and a distance. The seventh is slightly more concrete again. The eighth sheet with its two larger designs shows a pair of well-balanced classical scenes including figures.

These studies may have been connected with an *Essay on the Invention of Landscape Composition*, which Alexander published in 1759. No copy of this work has been recorded hitherto, though Oppé noted (1952, p. 23 and note) that one, bound up with the *New Method*, had been in Beckford's collection and was sold at Sotheby's on 10 July 1882 (2221). This copy is presumably that now in the Hermitage, Leningrad: it is in an album which includes some of the original drawings for *The Shape, Skeleton and Foliage of Thirty-two Species of Trees* (see no. 18). The title page of this album is inscribed in manuscript: *Delineations / of the / General Character, / Ramification and Foliage / of Forest Trees. 1786. Also / an Essay on the Invention of Landscape Composition. 1759. / And / A New Method of / Assisting the Invention / Composition of Landscape. 1785. / BY / ALEXANDER COZENS.* Another group of drawings in the Hermitage adds further testimony to Cozens's continuous interest in the codification of his art: it is labeled *Miscelaneous Thoughts on Landscape* and seems to be a draft connected with the *New Method*: there is a passage of manuscript which begins "The method Blotting was first suggested by Leonardo...," which is similar to Alexander's remarks on p. 5 of the *New Method*; and there follows a group of blots with drawings derived from them (Hermitage nos. 41594–41776). One blot is made on an envelope addressed to *Henry Stebbing Esqre / Chancery Lane*; the album bears the ex libris of *Henricus Stebbing Grayensis Anno 1769*. Related to the *New Method*, though perhaps undertaken considerably earlier, was *Various Species of Composition in Nature* (Oppé 1952, p. 45 note), a set of landscape compositions which were first drawn in outline and then etched (see no. 13), offering the student a guide to sixteen different landscape types. No text has survived for

these beyond the titles transcribed by Constable (one list is in the Lee of Fareham extra-illustrated copy of C. R. Leslie, *Memoirs of the Life of John Constable*, now in the Yale Center for British Art; see entry to no. 13); likewise the sets of *Trees* and *Skies* have no known letterpress and are usually to be encountered bound up with copies of the *New Method*. An unrecorded group of sky studies by Cozens forms another album preserved in the Hermitage; it is labeled *Studies of Skies by Alexander Cozens* and consists of twenty-five drawings in brown wash, numbered 1 to 25 in their top left corners (the numbers sometimes, as so often with Cozens, scratched out, perhaps during a revision of their order in some "system"). The sheets are Hermitage nos. 41565–41589; the album is apparently another from Beckford's collection, for there are a few loose sheets in it with drawings of figures, animals, and landscapes signed *J. Huber Fonthill 1785*. The sky studies are perhaps related to the published series (see nos. 42–61), but they are far more expressive than anything in that dourly methodical attempt to pigeonhole the nebulous: they include subtle effects of haze with the sun shining through it; mountain tops lost in mist; the sun edging dark clouds with an aureole of light.

Such poetic flights as these must surely have made their mark on the young John Robert; there is one study of a sunset by him which is strongly reminiscent of them (no. 111). But there is no evidence that Alexander's systems influenced his outlook at all. It is possible that the two men were temperamentally opposed to one another and never really worked together. The fondness that Beckford showed for Alexander all his life is contrasted with his rapid disenchantment with John Robert, who, he decided, was "an ungrateful scoundrel." Sir William Hamilton thought the son "indolent"; while Alexander, with his full teaching program and active mental life, can hardly have been that. Yet the dreamy mysticism that Beckford enjoyed in both father and son suggests an obvious link between them.

A still more evident connection is provided by the titles of the works that John Robert sent to the exhibitions of the Society of Artists while he was still in his teens. His first entry was "A drawing of a landscape," shown in 1767 when he was only fifteen, and he sent various "drawings" and "landscapes" from that year until 1771, when his submission was titled "A landscape; in chiro-oscuro." This is precisely the way in which Alexander titled his entries around 1770, and although it is by no means an unusual form of words for the time (though the spelling varies), the similarity suggests that John Robert's submissions were essays in the same vein as his father's. If so, there is a possibility that some of them have survived with mistaken attributions to Alexander which have prevented their being recognized as early works of John Robert. The British Museum album already referred to, with its label suggesting that it contains drawings "intended . . .

for the improvement of His Son," contains, in addition to the "system" just discussed, fifty-one drawings. These are mostly in brush and black ink, and vary greatly in handling from precision to extreme breadth or sketchiness. Two of them (on leaves numbered 5 and *34*) are of inferior quality and seem to be the work of a pupil. It is conceivable that the writer of the label was correct about this group at least, and that these items are imitations of Alexander's manner by John Robert. But it is just as likely that they are by some other pupil. The imitation of Alexander that is exhibited here with an ascription to an unidentified pupil (no. 155) is in the same category of doubtful works.

The range of the studies in the British Museum album raises the very considerable problem of the dating of Alexander's work. Many of the sheets are executed in the "blottesque" manner that is usually associated with his later years, when the *New Method* was published. Others are tighter, more carefully drawn; but there is no reason why both types of work should not have been produced at the same time. Some of the finished drawings based on highly schematic "blots" are of a delicacy and neatness that cannot be surpassed in Alexander's output. The question to be answered is whether he evolved his "blot" process relatively early in his career and only delayed publishing it until the end of his life or whether he arrived at it (accidentally, as he claims) only after a lifetime's experiment and a gradual shedding of formal restraints. This latter theory seems implausible. In the eighteenth century there was no presupposition that breadth of handling was in itself "progressive"; drawings (and paintings too) were handled broadly or otherwise as their function or context demanded. Few artists make this point so clearly as Alexander, who sought a conceptual breadth in all his work but tried to achieve it by various technical means, including the very literal method of smearing the paper with ink to activate the imagination by bold, general images without specific reference. But as the *New Method* makes clear, the end product was a more thoughtfully and precisely calculated work than a mere blot.

Nevertheless, there is a certain type of neat, detailed landscape that may be connected directly with Alexander's experience in Italy; a landscape of winding streams, shapely hills, and artfully disposed ruins or Italianate buildings, often drawn with fine strokes of a small brush. There is a decidedly "classical" flavor to these designs, and in this catalogue drawings of such subjects have been given early dates. Another element in Alexander's early work is the influence of the rococo: a sinuous rhythm of curves and loops which is rather French in inspiration and which can be traced even in one of John Robert's rare copies after his father, the *View in the Farnese Gardens* that he made for Beckford in 1783 (Bell and Girtin, no. 358, repr. pl. XXVI b). This is derived from one of Alexander's studies of 1746 (see Oppé 1952, p. 80), and in it the

strokes of the brush which normally in John Robert's work would build up mass and tone are here employed to create a restless linear movement in stark contrast to his more accustomed style. The origins of this rococo element in Alexander's work are to be found in the prints that he must have looked at and copied in his youth. That prints contributed largely to his visual education is evident from the technique of many of the Roman drawings as well as from their subject matter. Many of the subjects in the British Museum collection have the air of having been copied from prints rather than being drawn direct from nature; they often have fine pen outlines and hatching in imitation of engraving. The etchings of the Frenchman François Vivares (see no. 139) exemplify the type of image that Alexander imitated; they are simplified memories of the compositions of the Italian or Dutch painters who worked in Italy in the seventeenth century—Breenbergh, Poelenbergh, Berghem, Grimaldi—overlaid with a flavor of the French rococo.

Alexander was also absorbing the more fantastic landscape idioms of less Italianate artists—the exponents of the Flemish tradition from Patenir and Brueghel through Bril and Momper to Teniers. This strain too was to be found in prints both by the masters and by lesser practitioners (see no. 140), and it had its effect on Alexander's approach to landscape. The fantastic element in the art of the northern landscapists was something that Alexander could hardly fail to admire, and certain forms of it he readily adopted as his own, integrating them with the classical idioms he had picked up in Italy. The most persistent of these forms is the craggy, irregular rock, which he was to use repeatedly as a repoussoir in his designs and which he eventually married to the more elegant Italian mountain shapes to create the strange, otherworldly peaks that dominate his later landscapes (see no. 23). The outlines of these rocks are unpredictable, dreamlike patterns which lend his designs their own peculiar rhythms, so typical of Alexander that it is something of a surprise to find that they occur quite frequently in John Robert's work as well.

Only once, perhaps, did Alexander encounter in real life mountain peaks with the qualities of those imaginary ones he had seen in Flemish painting; that was on the island of Elba, where he made a few studies in 1746 (see no. 24). And apart from the view in the Farnese Gardens just mentioned, John Robert's only use of his father's sketches was for a *View In the Island of Elba* of about 1789 (Bell and Girtin, no. 433, repr. pl. XXXIII a). This is a subject which consists almost exclusively of rocky pinnacles of the kind that Alexander was fond of drawing and which he included as a "landscape type" in his *New Method* (see no. 27). There is, however, a group of drawings by John Robert which bear an exceptional and unparalleled resemblance to Alexander's style, and they are of subjects entirely composed of rock forms. They are imaginary

scenes in subterranean caverns; three are circular compositions with figures apparently by another hand—Oppé suggests Cipriani (1952, p. 126). In these mysterious drawings the abstract shapes made by weird rocks as they meet and divide to form chasms and chimneys filled by water or flames are of the type developed by Alexander in his rock studies. The subject matter seems to be connected with Milton's Satan (it oddly anticipates a study of a Satanic figure seated among rocks, probably executed by Thomas Girtin for the Sketching Society in the late 1790s; Yale Center for British Art, B1975.4.1216); the drawings may have been done for William Beckford, but there is no evidence for this. A further roundel which also uses a strange rocky form, this time as a repoussoir more directly in the tradition of Alexander's compositions, is more easy to identify. It is a scene of Hannibal with his army on a crag above the plains of Italy—the subject of an oil painting that John Robert showed at the Royal Academy in 1776 with the title *A landscape, with Hannibal in his March over the Alps, showing to his army the fertile plains of Italy*. Because of the identity of their subject-matter, the drawing and the painting have been supposed to belong to the same year, and the whole group of roundels has been allocated to this date. The painting of Hannibal is lost; it may be that the drawing is a record of the subject after it was finished rather than a preliminary study for it (repr. Joseph R. Goldyne, *J.M.W. Turner—Works on Paper from American Collections* [Berkeley 1975], p. 183). 1776 was the year in which John Robert departed on his first visit to Italy. If the drawing was made before he left England, it displays in remarkably complete form the style he is supposed to have evolved specifically in response to his experience of the Alps. The foreground fir trees and distant plain recur in very similar guise in later works such as the *Pays de Valais* (no. 135). The odd, angular rock forms that compose the repoussoir to the right, and which make up the compositions of the "Satan" roundels, reappear in the large watercolor of *Chiavenna* (no. 95); in all these works the fantastic imagination of Alexander seems to have operated as an influence on John Robert. It is possible that the circular designs were undertaken at the same time as Alexander's roundel of a *Landscape with a Woman seated by a dark pool* (no. 22); but nothing certain can be concluded from these observations, as it is difficult to relate the drawings to anything else in John Robert's output or to assign a precise date to them.

The most perplexing problem is posed by the earliest of John Robert's works to have survived: the set of Bath views which he etched in 1773 (nos. 75–82). This was two years after he had ceased to show "landscapes in chiaroscuro" at the Society of Artists; two years later he made the topographical views of Lundy Castle which Francis Grose had engraved for his *Antiquities of England and Wales* (see no. 85). Alexander himself undertook very little topographical work; some of his

Roman drawings are more or less records of particular places, but usually the facts of any view are subordinated to compositional needs. The view of Eton College of 1743 (no. 1), his earliest datable design, is a wholeheartedly topographical design, lacking almost all the pictorial sophistication he was later to acquire. The *South View of London* of 1763, which was perhaps never engraved as advertised, on the large scale of four feet by one, was presumably a more rigorously topographical exercise than, say, the *View of Capo de Bove, near Rome*, which appeared at the Society of Artists in 1762; the *View in North Wales, taken from Wynstay* shown at the Royal Academy in 1781 was probably a fairly accurate record of a particular spot. Alexander's teaching methods, his "systems," his whole approach to landscape, tended to encourage not only the avoidance of specific topographical matter, but the careful and self-conscious construction of abstract designs with their own purely pictorial harmony. The etchings of Bath that his son made in 1773 could hardly display a more different attitude to landscape. They are in some respects ambitious: the view of the city from the London Road with its sharply receding perspective and complicated distance of hills and buildings, or the view of the Crescent in which the spectator is placed well below the main subject, looking up at it across rolling meadows—these compositions attempt to convey a feeling of space which perhaps anticipates the preoccupations of the mature artist. The *South View of Bath*, in which the city is glimpsed as a cluster of buildings in a valley beyond a screen of trees and bushes, could almost be the model for some of the Abruzzi subjects of eight years later. But in technique there is no point of similarity. The thin etched outlines are uninteresting and often erratic. The monochrome washes that have been applied by hand to the set exhibited here are equally uncertain; though it might be argued that they contain the germ of the flecked, nervous brushstroke that is typical of John Robert's mature work. Only in the tranquil streaked washes of the skies is the spirit of Alexander even faintly perceptible; and here it may well be a chance similarity rather than a real influence that is involved. All in all, there is no reason to connect these, our first documents of John Robert's style, with his father in any way whatever. And the two views of Lundy, though they are known only from the engravings after them, are equally unlike him; they are certainly much less adventurous than the Bath subjects.

A more interesting hint of what may have been happening at this period is provided by the two pen drawings on tracing paper of scenes in the Avon Gorge at Hot Wells, outside Bristol (nos. 83, 84). There is scant evidence to associate these studies with Cozens, but they are traditionally ascribed to him, and the sensitive notes of natural effects that appear on them indicate that a perceptive mind is at work. The neatly laid-out lists of numbered points are reminiscent

of Alexander's procedure; they are perhaps the nearest we can come to a glimpse of the father in the son. The penwork has something of the same undisciplined roughness that we find in the etched outlines of the Bath set—a roughness that was to remain a characteristic of John Robert's drawing style until after the first Italian tour. Although they are drawn on very thin paper (the sheets were originally mounted on sugar paper, apparently from an album), these studies are probably not tracings but direct records from the motif; if they were traced, they would provide a precedent for the many tracings from subjects noted in sketchbooks that John Robert was to make later in his career, but they perhaps imply that some of the so-called tracings for which no original is known were actually drawn direct onto the tissue paper.

The "Beaumont Album" of tracings presents many problems; some of these are discussed in the catalogue (see pp. 43–44). What has not been noticed is that one of the three principal sets of drawings that it contains—those which John Robert has marked "K.K."—includes a number of subjects of a type more characteristic of Alexander than of his son. There are imaginary views of cities, classical landscape compositions, and so on, whch are close in spirit to the drawings of Alexander's Roman stay. What is more, some of the tracings of this group are actually executed in a linear style not dissimilar to Alexander's style of 1746. Occasionally (as in no. 109 here, for instance) there are hints of the continental rococo—of Watteau, for example, in the gentle use of pencil to suggest an idyllic outdoors. This, too, associates the group with the decidedly rococo manner of much of Alexander's early work. We know that John Robert found a lost album of his father's Italian drawings in Florence in 1776—an extraordinary stroke of luck for which there is documentary evidence in the collection of these drawings now in the British Museum (Binyon nos. 1–34)—and although none of the surviving subjects corresponds with any of the tracings, it is possible that he made use of his father's studies by tracing them; as we have noted, he did use one or two of the Roman subjects as the basis for watercolors. If this theory is correct, then John Robert can be shown to have taken an active interest in his father's work well after he had launched into his mature career. Is there any further evidence that he applied its lessons to his own art?

Perhaps the most obvious way in which the work of the two men is linked is in coloring. The formal preoccupations of Alexander led him to neglect color almost completely. Some of the Roman views are tinted with clean, clear watercolor—green, pink, or ochre; but there are very few surviving finished drawings in which color plays an important part. With the oil paintings it is of course another matter, and in such works as the sky studies that he made in oil on paper (see no. 19) he reveals an exceptionally sensitive understanding of color, though it is always muted by twilight or

stormy dusk. The view of Greenwich in watercolor that he dated 1766 is the only mature work in this medium (repr. Hawcroft, *Burlington Magazine* [November 1960], p. 488). The semi-topographical drawing of *Weymouth Bay* in the Whitworth Art Gallery, Manchester, has been thought to incorporate a wash of green color (see Oppé 1952, p. 84), but this is not perceptible today, and it seems likely that the effect is illusory: the drawing is apparently executed entirely in gray and yellowish-brown wash over pencil.

It was inevitable that Alexander should gravitate toward monochrome: his concern with the theory of pictorial composition allies him with other theorists of the period—notably William Gilpin and Gainsborough—whose formulations of ideal landscape are nearly always without color—Gilpin's in gray or brown washes with a pen outline, Gainsborough's in black and white chalks on blue or gray paper (see nos. 152–154). Cozens's adoption of prepared grounds which have a yellow, buff, or tan color is in keeping with this general practice; they give his work a warmth which it would otherwise lack and lend a very distinctive mood to his typical landscapes, a mood easily borrowed by his pupils (see nos. 155, 156). However his son's art may have differed from his, to begin with, a concentration on monochrome drawing is almost certain to have characterized it. The Bath views with their gray washes, the roundel of Hannibal (which is perhaps from the mid-1770s), and the Payne Knight drawings of 1776 (see nos. 86–90), all indicate a habitual use of monochrome. When John Robert eventually began to use color, in the finished drawings that he made toward the end of his first stay in Italy, he almost at once settled into a very restricted palette of soft blue, green, and gray which, with modifications, he was to retain for the rest of his life. One drawing, the *Tivoli* of 1778 (no. 91) makes use of a rather startling green, but other works of the same year have already established a more sober scheme which avoids sharp contrasts or vivid effects of color for their own sake. Indeed, it is clear that color always played a secondary role for him; the most important element in the drawing is the tonal contrast that makes possible the evocation of space and atmosphere. Blue only augments the spaciousness of the sky, green merely increases the verisimilitude of trees and fields; the essential distinctions are achieved by tone, just as they are in the work of Alexander. What is of crucial importance, nevertheless, is that these tonal contrasts are built up by means of touches which are inherently colored. Sometimes the color is pure black or a deep blackish green or blue; but color is present as an inherent ingredient in the construction of form; hence the completeness and conviction of John Robert's pictorial structures. In this, the restrained coloring that he uses is very far removed indeed from the total monochrome of his father to which it seems at first to bear so close a resemblance. Other artists of his generation, notably Edward Dayes and Thomas Hearne (see no. 163),

likewise used a restricted palette of pale greens and blues; but they never absorbed color into form in the same way and hence their work is not of such intense and revolutionary significance.

An important consequence of this technical advance was the relegation of outline to a subordinate role. Since form was built up fragment by fragment, as it were, in the actual painting of objects, there was no need to define it in a linear fashion. Nevertheless the compulsion to seek defined outlines reveals itself in John Robert's developing style, and it surely expresses a need that we should expect to find in the son of an artist whose concern was so consistently with abstract pictorial problems. The theory of pictorial composition could hardly be discussed without outline; it was one of Alexander's profoundest contributions that he tried to divert the discussion into a tonal idiom—that of his "blots." The absence of linear prejudice in these blots is remarkable. They are composed of tone and mass alone; in seeking to escape the specific detail that natural prejudice demands in landscape, they deliberately abandon the means of creating detail—line.

But it does not seem likely that the "blot" system greatly affected John Robert's art. What did, however, was his father's equally insistent and methodical use of outline in other contexts. Once the initial blot had been made, the general form of the composition alighted on, then it was outline which could give it concreteness and reality. Alexander's outlines are extraordinary. They occur where we should least expect them: no parts of his drawings are more elaborately delineated than his skies. Clouds are shaped and disposed across his pellucid heavens with the most scrupulous care, each softly but firmly established as a form in its own right by a fine pencil line. There exists (in the Metropolitan Museum of Art, New York) a set of etched landscapes by William Austin after Locatelli in which the skies have been added in pencil with fine brushwork by Alexander Cozens. These carefully designed skies add a new dimension to the compositions that they decorate. Other methodical sky drawings have already been discussed. In all these exercises outline plays an important part, discreet yet decisive in balancing the airy atmospheric effects of cloud or sunset against the orderly distribution of two-dimensional forms in the picture space. John Robert's skies also partake of this ambiguity, though they are far more emphatically concerned with space and light. In them, too, we find wisps of cloud deliberately shaped and poised in delicate relation one with another, so that they create gentle abstract counterpoints of their own. These are confirmed by means of soft pencil outline, tentative in the earlier drawings, but becoming more and more precise in the 1780s.

Similarly, the forms of foliage in John Robert's work of the second Italian tour and later tend to be expressed more regularly and easily, with a fluid but even pattern of scallops and jags in fan shapes. The increased precision of his drawing

style between about 1779 and 1782 is perhaps attributable to the contact he had in Italy with the German Hackert (see no. 147), whose clear-cut outlines and rhythmic formulas, typical of the continental draftsmanship of the time, must have constituted a revelation to the young Englishman. The fluency and firmness of his drawing by the end of the second tour is apparent in the tracings, where pencil outlines are used unaided by wash. The style is already evident in the early sketchbooks in use on the tour, but is certainly not fully developed in watercolors dated to the years preceding it. Outlines of both clouds and foliage are more tentative and irregular in works such as the *Tivoli* of 1778 (no. 91), or the more typical *Lake Garda from Peschiera* of the same year, now in the Stanford Museum (78.161). A comparison of the two stages of his progress can be made in the versions of *The Lake of Albano and Castel Gandolfo* in this exhibition (nos. 93 and 134).

Coloring is more difficult to chart progressively. The startling color of the *Tivoli* already referred to is unlike the softer greens and blues of the Stanford *Lake Garda* drawing, where, however, an unexpected orange-tan is used in the foliage along with a more typical green. The sheet is somewhat faded, which makes a just assessment of its palette almost impossible. It seems to be the case that many of John Robert's richest works, those employing dark greens and much black, belong to the first tour and to those drawings completed as an immediate result of it. On the other hand, there is a wide range of type even within this limited period: the *Lake and Town of Nemi* (no. 94) is as weighty and sombre as any of his subjects, but the *Pays de Valais* is based on an altogether lighter, softer tonal system, characterized by the grays and gray-greens which were to become the standard palette of the final years around 1790. The series of drawings that he made for Beckford about 1783 includes some of the most colorful of his works, often with a deep rich blue in the skies that is not paralleled at any other time. The oddest feature of this set is that many of them are executed on a coarse-textured paper quite different from his usual support, which is a fine white laid or wove (he seems to have been indifferent as to which he used, though the later drawings are usually on the newer wove paper). Since many of the watercolors are repetitions of earlier subjects and obviously retain the palette of the original, it is not possible to offer a precise analysis of John Robert's development as a colorist. But the general observation may be made that on the whole his color is rather rich in the late 1770s, applied with a varied touch which reflects the mood of the work and the rhythms of its design, and that this richness and variety are still to be found in the Beckford drawings of 1783 or thereabouts. The later work displays much greater uniformity of coloring, within the convention of soft greens, blues, and grays, and makes use of a more mechanical pencil outline.

Altogether, the dating of drawings by both Alexander and John Robert Cozens is a hazardous task, mainly because each artist seems to have sustained a basic method of working throughout his life, and neither supplied dates regularly. Alexander's work is hardly ever dated, except for some drawings made between 1763 and 1768. This catalogue attempts to assign every work to a definite year or period, not so much in the belief that these dates are correct as in the hope that they will stimulate more constructive discussion of a thorny problem. It will be seen from the summary made above that the work of John Robert resists any straightforward stylistic description; as far as Alexander is concerned, the mass of studies, often very slight, that exist with attributions to him offers an enormous and apparently intractable field for investigation. So far, no one has suggested that a great many of these studies may in fact be by hands other than Alexander's. This is very likely, given his extensive practice as a teacher. One group of drawings in particular has caused students difficulty in the past: the so-called Rhone group, which seemed to indicate a continental journey by Cozens for which there is no other evidence. What was more perplexing about these drawings was their marked lack of most of the qualities that give distinction to Alexander's best work. Their reattribution here to one of his most assiduous pupils, Mary Harcourt (see nos. 156–159), clears up a stylistic problem as well as a biographical one. Many more drawings can probably be reattributed in this way; it would perhaps be profitable to begin with the assumption that Alexander's reputation was not earned for nothing; his finest work is of a quality which is hardly compatible with the dull scribbling that constitutes many of the drawings given to him, and there seems every reason for redefining the boundaries of his *oeuvre*. Even a drawing such as the *Valley* (no. 21), the attribution of which to Alexander is retained here, ought possibly to be reconsidered in the light of this suggestion.

The collection of work by Alexander and John Robert Cozens which is catalogued here was assembled by Paul Mellon over a period of about fifteen years and covers many of the most important aspects of their output. Since the opening of the Yale Center for British Art, certain additional items have been acquired by Mr. Mellon with the purpose of rendering it more comprehensive as a representation of the combined achievement of the two artists. In particular, the Roman sketchbook of Alexander (no. 2) and the Bath etchings of John Robert (nos. 75–82) help to broaden the view of their stylistic development, providing an opportunity to survey the progress of their art more continuously and completely than has been possible before. The most substantial contribution to the Center's holdings is that from the collection of Thomas Girtin, acquired by Mr. Mellon in 1970, which includes many works that have taken their place in the canon of the most celebrated of English drawings. The Center

is also grateful to the curator of the Davison Art Center, Middletown, and to the librarian of the Beinecke Library at Yale for the loan of two important examples of Alexander's work as a theorist, the *Thirty-two Species of Trees* and the *New Method*.

It is to Thomas Girtin and his collaborators, C. F. Bell and A. P. Oppé, that the modern student of the Cozenses owes the greatest debt: the Burlington Fine Arts Club exhibition of John Robert Cozens held in 1922–23 was organized by these three men with H. Clifford Smith and offered the first serious study of his work. This was followed in the 1934–35 issue of the *Walpole Society* by the catalogue of John Robert's drawings compiled by Bell and Girtin. This, with its supplement (*Walpole Society* 27), remains the standard reference work. Alexander Cozens has been less well studied, perhaps because he poses greater problems. It was the exhibition of Herbert Horne's collection by the Burlington Fine Arts Club in 1916 which first drew the attention of a modern audience to his genius. The exhibition of drawings and paintings by him arranged by A. P. Oppé and shown at the Graves Art Gallery, Sheffield, and the Tate Gallery, London, in 1946–47 marked

an important step forward in the appreciation of his art, and Oppé followed this up with his book, *Alexander and John Robert Cozens* (1952), which contains the most complete account of the life and work of both artists that has been attempted. The thoroughness of Oppé's investigations and the justice of his conclusions make his book a source on which the student relies for all essential knowledge. The scope of this catalogue has precluded the possibility of covering every phase of the lives and careers of its two subjects, and the reader is referred to Oppé's work both for indispensable background information and for much important detail. Two further publications can be added to this brief list: the large exhibition entitled *Watercolours by John Robert Cozens* organized by Francis Hawcroft and mounted at the Whitworth Art Gallery, Manchester, and the Victoria and Albert Museum, London, in 1971; and the catalogue of the Hamilton Palace sketchbooks issued by Messrs. Sotheby for the sale of 29 November 1973, which reproduces every page from the seven books and contains an introduction by Anthony Blunt. To all these works, and to the others listed in the Bibliography, this catalogue is greatly indebted.

Chronologies

Alexander Cozens

1717 Probable year of birth, in Russia; son of Richard Cozens of Hampshire, England, shipbuilder for Czar Peter the Great from about 1699, and of Mary, daughter of Robert Davenport, also in the employ of Peter the Great. Alexander was one of three sons; his two sisters married Englishmen in St. Petersburg.

1742 By this date Alexander had traveled to England; his view of Eton College engraved by John Pine in this year.

1743 A drawing by Cozens dated to this year is in the British Museum (1923-10-16-2).

1746 To Rome, where he studied drawing, painting, and etching, and worked for a short period as a pupil of Claude-Joseph Vernet (1714–89). Later in the year or soon afterward he returned to London.

1749 Drawing-master at Christ's Hospital at a salary of £50 per annum.

1750 At about this time Alexander married the daughter of the engraver John Pine.

1752 John Robert Cozens born. An etching by Alexander dated to this year is in the British Museum (1937-2-15-3).

1753-4 Executed a drawing in black ink and wash (Hunterian Collection, Glasgow University) for William Hunter's *The Anatomy of the Human Gravid Uterus*, 1774, pl.xxi.

1754 Resigned post at Christ's Hospital.

1759 *An Essay on the Invention of Landscape Composition* printed.

1760 Exhibited at the Society of Artists *A small Landskip* (16) and *A View on the Tiber* (17), both apparently oil paintings.

1761 Won a premium of the Royal Society of Arts. Exhibited at the Free Society of Artists *An historical landscape, representing the retirement of Timoleon* (11), probably an oil painting; "Twelve drawings of landscapes; in one frame" (116); "Four drawings of landscapes; in indian ink" (118); "Two drawings of landscapes, in one frame" (128); and another similarly described (130).

1762 Exhibited at the Free Society of Artists *A view of Capo de Bove, near Rome* (16), and *A landscape* (64), both probably oil paintings.

1763 Exhibited at the Society of Artists *A south view of London* (28), probably an oil painting, and the basis for an engraved "South View of the City of London extending from Chelsea to Limehouse taken from Dulwich Hill", advertised as by W. Austin and P. C. Canot and measuring 2 ft. 1 in. by 4 ft.; no impression of the plate is known. Also exhibited "Nine drawings, shaded in brown" (162). A number of surviving drawings are dated 1763, in which year he may have taken up his appointment as drawing-master at Eton. His address was given as the Golden Lion, Tottenham Court Road.

1764 A drawing in the Victoria and Albert Museum (E 4275-1920) inscribed *View in the Tirol done from Nature, 1764* indicates that Cozens toured Europe this year; though the inscription possibly refers to the fact that the drawing derived from a study done on the spot in 1746. No work sent to the exhibitions.

1765 A signatory of the instrument of Incorporation of the Society of Artists. Exhibited at the society "Three drawings of a landscape in brown, two in black" (206); his address given in the catalogue as 4 Leicester Street, Leicester Fields, where he was to remain for the rest of his life. *A Treatise on Perspective and Rules for Shading by Invention* said to have been published this year, though no copy is known.

1766 On the teaching staff of Eton College as an extra master for drawing. Exhibited at the Society of Artists "Two large landscapes; in brown" (237) and "Two small landscapes; in brown" (238).

1767 Exhibited at the Society of Artists "Two drawings of landscape" (229)

1768 Exhibited at the Society of Artists *A landskip* and *Its companion* (36, 37), perhaps works referred to in correspondence with William Hoare of Bath; also showed "Two drawings of landskips; in brown" (229), "Six small landscapes" (26), and "Two drawings" (173).

1769 Exhibited at the Society of Artists "Two drawings of landscapes" (361).

1770 Exhibited at the Society of Artists *A landschape before a storm; in chiaro-oscuro* (28) and *A landscape after a storm* (29), and two items entitled *A landscape; in chiaroscuro* (30, 31); all four works were probably paintings.

1771 Exhibited at the Society of Artists two further works entitled *A landscape; in chiaroscuro* (233, 234); these were most likely drawings. *The Shape, Skeleton and Foliage of Thirty-two Species of Trees* first issued.

1772 Exhibited for the first time at the Royal Academy, sending *A piece of ground with a figure in chiaro oscuro* (58), probably an oil painting. Planned a "Great Work, MORALITY, Illustrated by representations of Human Nature in Poetry and Painting. In Two Parts"—the sequence to illustrate the Virtues and Vices, each to be dealt with in a poem as long as the *Iliad.*

1773 Exhibited at the Royal Academy two works entitled *Landscape in chiaro obscuro* (58, 59), presumably oil paintings. Possibly spent some time in or near Bath; this year John Robert Cozens's etched views of the city were produced. Alexander communicated recipes for varnish to Ozias Humphry, portrait draftsman and painter (1742–1810).

1775 Exhibited at the Royal Academy *A setting sun* (74), probably an oil study.

1777 Exhibited *A Landscape* at the Royal Academy (69).

1778 Exhibited at the Royal Academy *A drawing of a head in red chalk* (69), perhaps an illustration to the *Principles of Beauty, relative to the Human Head*, which was published this year. Cozens proposed as candidate for Associateship of the Academy but failed to be elected. Appointed drawing-master to T. R. H. Prince William and Prince Edward; continued in this position until about 1784.

1779 Exhibited at the Royal Academy *A landscape in chiaro-obscuro* (60); Cozens again failed to gain election as Associate of the Academy.

1781 Exhibited at the Royal Academy a *View in North Wales, taken from Wynstay, the seat of Sir Watkin Williams Wynn, Bart* (256). Cozens is known to have stayed with William Beckford this year "very happy, very solitary, and almost as full of Systems as the Universe." Beckford (1759–1844) had probably taken Cozens as tutor some time before; the two men became close companions. By this date Cozens had built up an extensive and fashionable clientele as a drawing-master, while retaining his post at Eton.

1784 *A New Method of Assisting the Invention in Drawing Original Compositions of Landscape* advertised. Beckford's association with Cozens ends.

1785 The *New Method* published.

1786 Death of Alexander Cozens on 23 April, probably at his home in Leicester Street. Buried in St. James's Church, Piccadilly, 30 April.

1787 31 March: Cozens's unsold paintings and drawings auctioned by Christie's.

John Robert Cozens

1752 Born in London, the son of Alexander Cozens; he had one sister, Juliet Ann.

1761 Date of a lost drawing of three figures, in pen, recorded by C. R. Leslie, *Handbook for Young Painters* (1855), p. 263.

1767 *A drawing of a landscape* exhibited at the Society of Artists (230).

1768 "Two drawings of landskips" exhibited at the Society of Artists (230); two further untitled drawings were also shown in the "special" category (174).

1769 "A drawing" exhibited at the Society of Artists (255).

1770 A drawing of "a landschape" exhibited at the Society of Artists (185).

1771 *A landscape; in chiro-oscuro* exhibited at the Society of Artists (234). Living with his father at 4 Leicester Street, Leicester Fields.

1773 The eight etchings of Bath views produced.

1775 Two views of Lundy Castle drawn for Francis Grose's *Antiquities of England and Wales*.

1776 Exhibited an oil painting at the Royal Academy, *A landscape, with Hannibal in his March over the Alps, showing to his army the fertile plains of Italy* (69). In August, set out for Italy with Richard Payne Knight (1750–1824), traveling via Geneva, Interlaken, Lucerne, Splügen, and Como. It has been suggested that they reached Rome by taking a ship from Genoa to Leghorn, then by land via Pisa, Florence, Perugia, Terni, and Narni. 27 November: among several artists listed by Thomas Jones in his "Memoirs" as "Old London Acquaintance" whom he met at the English Coffee House. Also there were Pars, Humphry, More, Tresham, Fuseli, and others.

1777 April: sketching in the Campagna. In the summer, recuperating from an illness at the Villa of Signor Martinelli outside Rome, and "when the Weather was favourable, riding about on a jackass which he had purchased for that purpose."

1779 8 April: left Rome to return to England.

1780 Working on drawings derived from studies made in Italy for various patrons, notably Beckford.

1782 Formed part of Beckford's suite on a tour to Italy, leaving England probably in May. The party included Beckford's tutor, Dr. John Lettice, a physician, Dr. Ehrhart, and a musician, John Burton. They traveled via Innsbruck and the Tyrol, where Cozens began to use the sketchbooks that record much of this journey. They visited Venice, Verona, and Padua, and arrived in Naples on 10 July. Cozens was sick with a fever on the 14th but had recovered by 3 August. Beckford was also sick, and apparently the musician Burton caught the same disease, for he died in a delirium on 3 September. 10 September: Beckford left Naples, Cozens remaining there, "a free Agent and loosed from the Shackles of fantastic folly and Caprice" (Thomas Jones, "Memoirs"). Visited Sir William Hamilton, British envoy in Naples, who found him "a good stick upon the violoncello." December: traveled from Naples to Rome, arriving there about the 11th.

1783 15 September: left Rome for England, traveling via Terni, Florence, Lake Maggiore, the Mont Cenis, and Grande Chartreuse to Geneva, where he may have met Beckford and received commissions based on drawings in his sketchbooks. Worked on these and other commissioned drawings after his return to London, but Beckford broke off relations with him this year or shortly afterward, calling him "an ungrateful scoundrel" (Farington, *Diary*, 17 June 1797).

1789 Fourteen soft-ground etchings of trees published. "About thirty capital views in Italy and Switzerland, taken on the spot by Mr. Cozens" sold at auction by Greenwood.

1790 Several drawings, repetitions of continental subjects and new English scenes, dated this year. May have stayed with Sir George Beaumont in Essex and with Thomas Sunderland in the Lake District. A small group of large watercolors of views in Greece after sketches by James "Athenian" Stuart (1713–88) executed; two of these later engraved for the *Antiquities of Athens*. By this date Cozens was living with a woman who bore him a daughter, Sophia, about this year.

1792 A drawing of *Beech Trees* in the Victoria and Albert Museum is signed by Cozens and dated this year, which was probably the last of his active career.

1794 January: Cozens seriously incapacitated by mental illness. 23 February: Farington reported that Cozens was in the care of Dr. Monro; financial support for Cozens and his family granted by the Royal Academy. The contents of his studio sold at auction by Greenwood.

1795 Sir George Beaumont and others organized a fund for the assistance of Cozens's family, to which Payne Knight and Mary Harcourt contributed. Beckford did not do so.

1797 Cozens's aunt, Miss Pine, bequeathed to him a house in Twickenham. December: died in Monro's care at Northampton House, John Street, Smithfield. Buried 1 January 1798 at St. James's Church, Clerkenwell.

1805 10 April: Beckford's collection of Cozens drawings sold at Christie's as "a capital and truly valuable collection of original Highly Finished Drawings, the whole executed by that eminent Artist the younger Cozens, during a Tour through the Tyrol and Italy, in company with an amateur of distinguished taste."

Catalogue

Note to the Catalogue

The catalogue lists the works of Alexander and John Robert Cozens separately, adhering as nearly as possible to the chronology of each. Comparative material, illustrating the work of their contemporaries, pupils, and followers, is placed as a third section of the catalogue, roughly chronologically. Measurements are given in inches and millimeters, height before width. The most frequently cited works are abbreviated as follows:

Bell and Girtin	Bell, C. F. and Girtin, Thomas. "The Drawings and Sketches of John Robert Cozens," *Walpole Society* 23, 1934–35.
B.F.A.C. 1916	Burlington Fine Arts Club, London. *Exhibition of the Herbert Horne Collection of Drawings with special reference to the works of Alexander Cozens*, 1916.
B.F.A.C. 1923	Burlington Fine Arts Club, London. *Drawings by John Robert Cozens*, 1922–23. Bell, C. F.; Smith, H. Clifford; Girtin, Thomas; Oppé, A. P. (organizing committee).
Farington *Diary*	Farington, Joseph. *Diary*, ed. Kenneth Garlick and Angus Macintyre. London and New Haven, 1978–.
Hawcroft 1971	Hawcroft, Francis. *Watercolours by John Robert Cozens*. Exhibition catalogue, Whitworth Art Gallery, Manchester, and Victoria and Albert Museum, London, 1971.
Martin Hardie 1966	Hardie, Martin. *Watercolour Painting in Britain*, vol. 1. London, 1966.
Oppé 1946	Oppé, A. P. *Drawings and Paintings by Alexander Cozens*. Exhibition catalogue, Graves Art Gallery, Sheffield, and Tate Gallery, London, 1946–47.
Oppé 1952	Oppé, A. P. *Alexander and John Robert Cozens*. 1952.
Williams 1952	Williams, Iolo A. *Early English Watercolours and some cognate drawings by artists born not later than 1785*. London, 1952.

Supplementary Bibliography

Alexander, Boyd. *England's Wealthiest Son; a Study of William Beckford*. London, 1962.

Angelo, Henry. *The Reminiscences of Henry Angelo*, 2 vols. London, 1904.

Ashby, Thomas, "Topographical Notes on Cozens," *Burlington Magazine* (1924): 193–94.

Blunt, Anthony. "John Robert Cozens in Italy," *Country Life* (30 August 1973): 568–70.

Davies, Randall. "Thomas Sunderland 1744–1823, Some Family Notes." *The Old Water-Colour Society's Club Annual* 20 (1942): 31–39.

Gemmett, Robert J., ed. *Dreams, Waking Thoughts and Incidents by William Beckford of Fonthill*. Rutherford, N.J., 1972.

Gibson, F. "Alexander and J. R. Cozens." *The Studio* (1917).

Girtin, Thomas, and Loshak, David. *The Art of Thomas Girtin*. London, 1954.

Hardie, Martin. "Early English Artists of the British Water-Colour School: Alexander Cozens." *The Collector* 11 (December 1930): 133–39; 181–87.

Hawcroft, Francis. "A Watercolour Drawing by Alexander Cozens." *Burlington Magazine* 102 (1960): 486–89.

Jones, Thomas. "Memoirs." *Walpole Society* 32, 1946–48.

Lebensztejn, Jean-Claude. "En blanc et noir." *Macula* I(1967): 4–13.

Leslie, C. R. *A Hand-book for Young Painters*. London, 1855.

Marks, Arthur S. "An Anatomical Drawing by Alexander Cozens." *Journal of the Warburg and Courtauld Institutes* 30 (1967): 434–38.

Marqusee, Michael, ed., *Alexander Cozens A New Method of Landscape*, 1977.

Mayer, A. Hyatt. "A Modern Artist of the Eighteenth Century." *Metropolitan Museum Bulletin* 12 (December 1953): 100–104.

Monkhouse, Cosmo. *The Earlier English Water-Colour Painters*, 2d ed., London, 1897.

Oppé, A. P. "The Parentage of Alexander Cozens." *Burlington Magazine* 35 (1919): 40.

Oppé, A. P. "New Light on Alexander Cozens." *Print Collectors Quarterly* 8 (April 1921): 62.

Oppé, A. P. "A Roman Sketch-book by Alexander Cozens." *Walpole Society* 16, 1921–28.

Oppé, A. P. "A Roman Sketch-book by Alexander Cozens." *Walpole Society* 16, 1927–28.

Parris, Leslie. *Landscape in Britain, c. 1750–1850*. Exhibition catalogue, Tate Gallery. London, 1973.

Posnett, D. W. "John Robert Cozens in Rome in 1783." Letter to the Editor, *Apollo* (February 1975): 155.

Roche, Sophie v. la. *Sophie in London 1786*. Translated from the German with an Introductory Essay by Clare Williams. London, 1933.

Roget, J. L. *History of the Old Water-Colour Society*, 2 vols. 1890.

Russell, A. G. B. "Alexander Cozens at the Burlington Fine Arts Club." *Burlington Magazine* 24 (1917): 66.

Shestack, A., "Lift Ground Prints by Alexander Cozens." *Artists Proof* 8 (1968): 82–86.

Sotheby & Co. *Catalogue of Seven Sketch-books by John Robert Cozens*, Introduction by Anthony Blunt. London, 1973.

Victoria and Albert Museum. *Dr. Thomas Monro and the Monro Academy*. Exhibition catalogue. London, 1976.

Whitley, W. T. *Artists and their Friends in England, 1700–1799*, 2 vols. London, 1928. Pp. 316–26.

Wiel, A. "An Oil Painting by J. R. Cozens." *Burlington Magazine* 14 (1924): 304.

Wilton, Andrew. *British Watercolours 1750–1850*. Oxford, 1977.

Zerner, Henri. "Alexander Cozens et sa methode pour l'invention des Paysages." *L'Oeil* 137 (1966): 28–33.

Alexander Cozens

John Pine (1690–1756) after Alexander Cozens

1. East View of Eton College. 1742 Plate 1

Engraving with watercolor on laid paper 11¹³/₁₆ x 18¼ (300 x 460)

Inscr. at lower edge of plate: *A.Cozens delin.* and *J.Pine sculp.* and *To the Reverend yᵉ Provost & Fellows of the ROYAL COLLEGE OF ETON, This East View of the said College, is most Humbly Inscrib'd by Their Dutiful and most Obedient Humble Servant W.Collier.* and *Published according to Act of Parliament by W. Collier at Eton, 1742. By whom Lands are Survey'd & Maps drawn of yᵉ same in yᵉ best & cheapest Manner. Sold by J.Pine Engraver in Old Bond Street, & T.Bakewell, Printseller in Fleet Street.*

Lit: Oppé 1946, p. 6; Oppé 1952, pp. 12, 77

Coll: London, Parker Gallery, from whom bt. by Paul Mellon, 1968

B1978.43.211

The coloring of this plate is probably modern. As Oppé notes, the engraver, John Pine, was later to become Cozens's father-in-law (the artist married his daughter about 1750). This type of topography is rare in Cozens's work, though the painting of London engraved in 1763 and the watercolor of Greenwich dated 1766 (see Francis Hawcroft, "A Watercolour Drawing by Alexander Cozens," *Burlington Magazine* 102 (1960):486–89, and repr.) are important exceptions.

2. The Roman Sketchbook 1746 Plate 1

Originally consisted of 87 numbered pages of laid paper, bound in vellum 7¼ x 5 (185 x 127), of which 27 have been extracted, together with other, unnumbered leaves

Lit: A. P. Oppé, *A Roman Sketch-book by Alexander Cozens,* Walpole Society, 1927–28, vol. 16, pp. 81–93; Oppé 1952, pp. 13 ff.

Coll: By descent in the artist's family to Ralph George Norwood Young; his sale, Sotheby 16 March 1978(46); bt. by Yale Center for British Art

B1978.43.166 (a–hhh)

This sketchbook and the fifty-seven drawings acquired from Cozens's granddaughter, Mrs. Thomas Smith, by the British Museum in 1867 are almost the only surviving works of Cozens's stay in Italy in 1746 (a drawing in the Victoria and Albert Museum, E 2784-1930, is dated to the same year). Although it contains only one colored drawing (f 86 verso) and a small number of studies in pen and black ink, the book includes examples of almost all the types of drawing in which Cozens engaged during his stay. These include a large number of compositional studies in pencil, often squared for enlargement, with pinhole register marks at the corners of each design. Several pages at the beginning of the book list procedures for drawing and coloring landscapes both "at home" and "from Life" in watercolor and in oil. These notes are transcribed by Oppé but are included here for completeness' sake. All drawings and inscriptions are in pencil unless otherwise indicated.

p. 1:
[missing]

p. 2 *recto:*
[female heads, one wearing a crown]

p. 2 *verso:*
[list of *Peshe; Pane; Vino; Brocholi; Ove,* with prices]

p. 3 *recto:*
[seated woman playing a viol da gamba]

p. 3 *verso:*
[slight sketch of a street(?)]

p. 4 *recto:*
1 yᵉ whole from Life with led pencil & brush by masses of tints: cording to each degree &c.
2 yᵉ particulars large & correct from Life
3 at home draw yᵉ outline of yᵉ whole from yᵉ parts
4 yᵉ lights with watercol: from Life
5 yᵉ Colouring with dust collours with stumps [of Lether *erased*] on yᵉ whole

1 yᵉ sketch of yᵉ whole
2 correct it
3 at home coppy each forth part on same size of yᵉ who[le]
4 each forth correctly outline from Life
5 pick out any of yᵉ sketches most fit to shade & coll: em accordg to yᵉ method from Life

1 sketch yᵉ whole
2 correct it
3 at home gradation of yᵉ tints &c
4 at home coppy each fourth part in large
5 then (if mind to pick any of yᵉ compositions to finish from Life fit to paint after) take yᵉ whole whose gradations are done at home. & light up yᵉ lights with pencil & one warm light collour pretty liquid & go over it 3 times &c
6 take each part in yᵉ large & finish correctly yᵉ outline

p. 4 *verso:*
[blank]

p. 5 *recto:*
1 sk: yᵉ whole
2 coppy each fourth part in large at home fro yᵉ whole
3 from Life finish each part correct
4 at home outline yᵉ little whole with pen from yᵉ parts in large & pencil yᵉ gradations
5 then (if mind to pick any of yᵉ compositions to finish from yᵉ Life) &c.
6 colour yᵉ whole with dust col: & stumps of leather

another way viz for a view in a fixt light & shad: as in a summer's day
1 yᵉ whole on coloured paper
2 coppy each part as above
3 from Life fin: ea: part
4 outline yᵉ whole with pen from yᵉ foresayd parts
5 pencil yᵉ shades only from life
6 pencil yᵉ lights &c
7 colour yᵉ whole with dust coll. &c

1 yᵉ whole on white paper
2 ditto
3 yᵉ whole fro yᵉ parts with lavis [Oppé reads *pains(?)*] correct & pretty hard
4 from Life all but yᵉ skye with one tint faint
5 light [*deleted*] & shadows of yᵉ whole with brush fro life
6 yᵉ lights &c

p. 5 *verso:*
[blank]

p. 6 *recto:*
1 sketch yᵉ whole on staind paper
2 with brush with one tint those objects next yᵉ skye

3 yᵉ parts frõ life in large [*all erased*]
4 correct yᵉ whole from them with bl: led [*all erased*]
3 coppy yᵉ yᵉ [*sic*] parts in large from yᵉ whole on white paper
4 yᵉ parts frõ life in large
5 at home with brush do all yᵉ rest of yᵉ whole with same tint of yᵉ
out side objects.
6 correct yᵉ whole frõ yᵉ parts in large
7 from life shade yᵉ whole [on white paper *erased*]
8 with 3 degrees or times lights yᵉ whole from life in time of fine light
& shad

———————

1 yᵉ whole on staind paper
2 with brush with one tint those objects next yᵉ skye
3 at home or if convenient abroad with brush do all yᵉ rest of yᵉ whole
with same tint of yᵉ outside objects
4 from life shade yᵉ whole in common & naturall circum:stance [*all
erased*]
4 coppy yᵉ parts in large from yᵉ whole sketch on white paper
5 yᵉ parts from life in large
6 correct yᵉ whole from yᵉ parts in large
7 from life shade yᵉ whole in common & naturall circumstance
p. 6 *verso:*
[blank]
p. 7 *recto:*
8 last of all when find fine light & shadow in 3 degrees or times light
yᵉ whole &c

———————

1 yᵉ sketch of whole on colourd paper pretty dark
2 coppy yᵉ parts in large frõ (?) of yᵉ whole
3 yᵉ parts from life
4 at home correct yᵉ whole from yᵉ parts [& *deleted*]
5 yᵉ naturall shades of objects &c at home
6 yᵉ lights from life

———————

1 yᵉ whole on white paper
2 coppy yᵉ parts in large frõ yᵉ whole
3 D° from life yᵉ outline correct
4 correct yᵉ whole from yᵉ parts. with pen
5 each object one tint accordg to ther gradations
6 lights from life

———————

whilst in Italy
1 yᵉ whole sketch from life
2 coppy ye parts in large frõ yᵉ whole
3 yᵉ parts from life
4 at home corr: yᵉ whole from yᵉ parts in ink
5 shade yᵉ whole with led pen: from life
6 finish it in indian ink at home
7 with dry coll: & stumps. collour it from life
8 etch much
9 [a line of shorthand]
p. 7 *verso:*
[blank]
p. 8 *recto:*
[sketch of a drawing board with *a bag* beneath the paper, and *past-
board* flap with *leather* cover and straps]
p. 8 *verso:*
[blank]
p. 9 *recto:*
I will studdy beauty of Form & injoy elegant Ideas set yᵉ Image of a
charming face fore my mind feed on its lovely Innocence & by it flatter
my longing Soul with Visions of happyness tho' but in Picture for I
will immure myself in solitude & paint yᵉ Graces act [?] Truth and

contemplate Virtue.
[sketch of two female heads]

———————

3 days in drawing from Life
1ˢᵗ: sketch as many Compositions as time will permit
2ᵈ yᵉ outline of one of them or more
3ᵈ: yᵉ light & sh: & coll: with dry coll:

but must have 2 iron rings open in one part to put on yᵉ leaves of yᵉ
book that they may be fixt. &c
tis a small [*all deleted*]

———————

1 yᵉ sketch from life
2 ouline [*sic*] in ink from life
3 common light & shade with led p: frõ life
4 finish do with brush at home.
p. 9 *verso:*
[blank]
[a page torn out here]
p. 10 *recto:*
5 yᵉ shineing lights with col: & brush frõ life
6 in yᵉ same circumstance coll: it frõ life with dry Collours

———————

1 Sketch
2 outline with led: very cor: frõ life
3 outline with fine pen Home
4 shades with brush contrary to yᵉ shineing lights at home beginning
bout yᵉ middle of yᵉ Objects leave room for shineing lights
5 shineing lights with brush &c abroad
6 collour at same time of yᵉ Day when did yᵉ lights

———————

or this
1 D°
2 outl: with led
3 outl: with fine pen
4 shineing lights with white chalk
5 shades with led frõ life
6 D° with brush at home
7 shineing lights from life
8 collouring from life

———————

on white paper this on ordinary occasions [*sic*]
1 Sketch
2 outline with led
3 D° with pen at home
4 shade with led beginning with a mezzotint next yᵉ shing [*sic*] light
for wh: leave yᵉ paper
5 D° with brush at home
6 Collourg from life

———————

or this
1 D°
2 D°
3 D° with pen at home
4 D°
5 D°
p. 10 *verso:*
[landscape sketch: the tomb of Caius Cestus?]
p. 11:[has been cut out]
p. 12 *recto:*
4 for travelling
1 sketch
2 outl: with pen from life
3 collour with dry collours at once beginning with yᵉ lights

a machine for drawing book of dry Coll for travelling
[sketch of color holder and frame]

to make ink on sudden occation [*sic*] to draw with
[?1] take a quart[er?] of yᵉ whole [?] vial of water & fill it up with lamp black to quarter or less of gum arab: fine pow^derd & shake em together good while

5 for travelling
1 Sk:
2 outline with pen frō life
3 shades with different degˢ: of in: ink frō life:
4 with dry coll: from life:
Carry[?] lamp bl: in dry balls powderd Gum: & tin vessel of Water
p. 12 *verso:*
[faint sketch of foliage (?)]
p. 13 *recto:*
to paint at home
1 have bladders of yᵉ originall collours
2 as I want them mix any with turpent: oil & drying & put em into glasses for out doors as well as home.

for Painting in oil
1 beginning with distant with tint[?] light & shadow of yᵉ whole object &c
2 particular shades in their diff: tints
3 partic: lights in their diff: tints
4 then yᵉ next degree &c

to spend this Summer
1 every Morng[?] with Sigʳ Georgio to sketch & outl: Land from life
2 then come home & studdy etching
3 then 1[?]out for an hour landskapes[?] of Mʳ Verney
4 then with Sigʳ Georg: dine[?] at yᵉ Capitoll
5 then for rest of yᵉ afternoon [?] finish [with him *deleted*] some landsk[?]
6 then sup.—
7 then in evening Itall

thus at present before yᵉ summer commences
1 soon in Morn: outline Views
2 to Miss Bruce
3 dine & studdy with yᵉ Glass &c at Capitoll
4 to Verney
5 finish light &c of some outline
6 Itall
p. 13 *verso:*
[view of buildings behind wall, with trees and hills beyond. Inscr. above *viz* and with a shorthand note]
p. 14 *recto:*
[two sketches of a support for drawing paper (?) and a bracket and screw]
Method 6
1 with watercollours 30 in all in bottles in frame &c without drawing begin at once yᵉ distance only yᵉ generall [*sic*] Masses then yᵉ particulars
2 yᵉ second degree D°
3 3ᵈ degree D°

Views wh: I see in travelling or by yᵉ way shou'd take em for their outlines & Composition because that kind of variety is seen most in travelling.
so method yᵉ 5ᵗʰ is best for quickness

but Views wh: I wou'd take quik in a settled Place shou'd be for light shadow or Collouring. because thats as variable in one Spot as in 5 or 10 for this take Method. 6.ᵗʰ

try this for travelling
1 sketch with led on staind Paper
3 shade correctly with pencil & in ink. beging: distance
4 lights with pencil & gumd white
5 dry Collours
p. 14 *recto:*
[blank]
p. 14 *verso:*
[landscape composition, squared]
pp. 15, 16:
[cut out]
p. 17 *recto:*
[blank]
p. 17 *verso:*
[divided in half; in the left half a sketch of a building in a high wall]
p. 18 *recto:*
[blank]
p. 18 *verso:*
[head of a female (upside down)]
p. 19 *recto:*
[a tower in a landscape]
p. 19 *verso:*
[a piece of sculpture: a nude youth (?) (upside down)]
p. 20 *recto:*
[blank]
p. 20 *verso:*
[studies of a tree, a hand, and a nose (upside down)]
p. 21:
[cut out]
p. 22 *recto:*
[blank]
p. 22 *verso:*
[study of rocks and a waterfall (?)]
p. 23:
[cut out]
p. 24 *recto:*
[blank]
p. 24 *verso:*
[study of foliage in pen and black ink]
p. 25 *recto:*
[blank]
p. 25 *verso:*
[view along a road: trees, walls, and a house]
[sheet torn out]
p. 26 *recto:*
[blank]
p. 26 *verso:*
[blank, except for a few pencil strokes]
pp. 27–30:
[cut out]
p. 31 *recto:*
[blank]
p. 31 *verso:*
[a road with building: slight sketch]
p. 32:
[cut out]

p. 33 *recto:*
[blank]
p. 33 *verso:*
[two men sketching beside a column in the Piazza of St. Peter's (?)]
p. 34 *recto:*
[slight sketch of St. Peter's Piazza (?)]
p. 34 *verso:*
[inside a pencil "frame": composition of a colonnaded piazza, obelisk, and fountain (cf. drawing on p. 34 *recto*)]
pp. 35–40:
[cut out]
p. 41 *recto:*
[blank]
p. 41 *verso:*
[sketch of buildings on a cliff (?)]
p. 42:
[torn out]
p. 43 *recto:*
[blank]
p. 43 *verso:*
[divided in two: above, an old man (head and shoulders in profile); below, a classical altar in a ruin (in the Colosseum ?) (upside down)]
p. 44 *recto:*
[blank]
p. 44 *verso:*
[St Peter's from the Villa Barberini]
p. 45 *recto:*
[blank, except for a few pencil lines]
p. 45 *verso:*
[a dome among trees (inside a pencil "frame")]
p. 46 *recto:*
[blank]
p. 46 *verso:*
[St Peter's seen from the Loggia of Constantine (inside a pencil "frame")]
p. 47 *recto:*
[blank]
p. 47 *verso:*
[female head (upside down)]
p. 48:
[torn out]
p. 49 *recto:*
[blank]
p. 49 *verso:*
[composition: a landscape with the bank of a river or canal (inside a pencil "frame")]
p. 50 *recto:*
[blank]
p. 50 *verso:*
[slight sketch of trees and buildings]
p. 51 *recto:*
[blank]
p. 51 *verso:*
[sky study, with trees and buildings along lower edge (binding) of sheet]
p. 52 *recto:*
[blank]
p. 52 *verso:*
[a building in a landscape]

p. 53 *recto:*
[blank]
p. 53 *verso:*
[a church and a fountain in a composition (inside a pencil "frame")]
p. 54 *recto:*
[blank]
p. 54 *verso:*
[composition: buildings (inside a pencil "frame")]
p. 55 *recto:*
[inscr: *Bartolomeo un Scultore/ at y^e Temple of Diana* (upside down)]
p. 55 *verso:*
[composition: a road with a wall and trees (inside a pencil "frame")]
p. 56 *recto:*
[blank]
p. 56 *verso:*
[composition: trees and buildings]
p. 57:
[cut out]
p. 58 *recto:*
[blank]
p. 58 *verso:*
[composition: buildings seen through a square archway (inside a pencil "frame")]
p. 59 *recto:*
[blank]
p. 59 *verso:*
[divided into quarters: three of them have landscape compositions]
p. 60 *recto:*
[blank]
p. 60 *verso:*
[slight study of a standing figure (upside down)]
p. 61 *recto:*
[landscape composition (fills the page)]
p. 61 *verso:*
[three studies of praying figures and two heads (upside down)]
p. 62 *recto:*
[blank]
p. 62 *verso:*
[composition: view of a church (inside a pencil "frame")]
p. 63 *recto:*
[blank]
p. 63 *verso:*
[composition: looking past a gateway into a valley with buildings (inside a pencil "frame")]
p. 64 *recto:*
[blank]
p. 64 *verso:*
[view of the Roman Forum (fills the page)]
p. 65 *recto:*
[blank]
p. 65 *verso:*
[composition: looking down a road toward a gateway; pen and black ink and pencil (inside a pencil "frame"; foliage studies and pen trials in the margin)]
p. 66 *recto:*
[blank]
p. 66 *verso:*
[landscape with villa and mountain (fills the page)]
p. 67 *recto:*
[blank]

p. 67 *verso:*
[composition: a house among trees (inside a pencil "frame")]
p. 68:
[cut out]
p. 69 *recto:*
[blank]
p. 69 *verso:*
[composition: buildings in a landscape (inside a pencil "frame")]
p. 70 *recto:*
[blank]
p. 70 *verso:*
[expansive landscape (inside a pencil "frame")]
p. 71 *recto:*
there are two sort of light & shad: in Nature
1 yᵉ naturall i.e.: with yᵉ sun shing [*sic*] without cloud
2 yᵉ accidentall: i.e. occationd by clouds &c
for wh: must have two different ways of coll: or washing from Life
p. 71 *verso:*
[composition: buildings in a landscape (inside a pencil "frame")]
p. 72 *recto.*
[blank]
p. 72 *verso:*
[a house in a landscape (inside a pencil "frame"), squared; pen doodle in margin]
p. 73 *recto:*
[blank]
p. 73 *verso:*
[trees and buildings (inside a pencil "frame")]
p. 74 *recto:*
[blank]
p. 74 *verso:*
[buildings in a landscape (inside a pencil "frame"), squared]
p. 75 *recto:*
[blank]
p. 75 *verso:*
[view of buildings in a landscape (fills the page)]
p. 76 *recto:*
[blank]
p. 76 *verso:*
[buildings and ruins (fills the page)]
p. 77 *recto:*
[blank]
p. 77 *verso:*
[buildings with distant hills (fills the page)]
pp. 78–83:
[cut out]
p. 84 *recto:*
[blank]
p. 84 *verso:*
[in the Forum: the Arch of Constantine(?); pencil, pen and brown ink, and gray wash]
p. 85 *recto:*
[blank]
p. 85 *verso:*
[trees in a hilly landscape; pencil, pen and black ink]
p. 86 *recto:*
[blank, except for slight pencil tracing from other side of sheet]

p. 86 *verso:*
[landscape study; pen and black and brown ink, watercolor, and pencil (?)]
[page torn out]
p. 87 *recto:*
ow. Mʳ Ashby ow Mʳ Hawell[?]
Pallūs Paul./1 Biocks.
for Opra. 18 9
and *Torre di Specchio Sigʳ Antonio Betti*
sketch of wooden joinery(?)
p. 87 *verso:*
[slight sketches]
inside back cover:
[*Peggy Quere* and 2]

3. Castel Sant' Angelo. 1746(?) Plate 3

Etching on laid paper 10⅝ x 14¾ (270 x 374)

Inscr. below: *Cousens* and *London Published April 18 1801 by John P. Thompson Gᵗ Newport Street and N° 51 Dean Street Soho.*

Lit: Oppé 1952, p. 115; Richard T. Godfrey, *Printmaking in Britain* (Oxford, 1978), p. 62.

Coll: Private collection

This is one of two etchings by the Cozenses issued posthumously and bearing the ascription and publication line given above. An earlier state, of which an impression is in the British Museum (Godfrey, pl. 63), is without the publication line. Oppé considered that both were by John Robert but expressed the reservation that they might be the work of an imitator. There seems little reason to doubt that the other plate, of Lake Nemi, is by John Robert (see no. 94); this one, however, is not in his style and is more probably the work of his father. Godfrey conjectures that it was one of the plates on which Alexander experimented while he was in Rome in 1746, according to notes in his sketchbook (no. 2, p. 13). The free use of bold hatching in decorative parallels that is a feature of this plate is to be found in the finished pen drawings of that year. A watercolor by John Robert Cozens of the Castel Sant' Angelo is in the Courtauld Institute (Spooner Collection). It is an almost identical view but reversed, which is in fact the correct sense: the etching shows the subject in mirror image, which prompts the suggestion that Alexander etched his plate on the spot out-of-doors—an unusual proceeding for the period, though perhaps not impossible for an eccentric artist such as he was. It would consort with the rule that he laid down for himself in his sketchbook (p. 7): "whilst in Italy . . . etch much."

4. In Hyde Park. *c.*1746–50(?) Plate 3

Black chalk with some white bodycolor on laid paper prepared with a buff-gray ground 6⁹⁄₁₆ x 7¾ (167 x 197)

Inscr. on the artist's mount, lower left: *Alexʳ Cozens.* and, in another hand(?): *In Hyde Park—The Serpentine—*

Coll: John Manning, 1961; Colnaghi, from whom bt. by Paul Mellon, 1961

B1975.4.1102

The tight drawing and literal rendering of tree forms in this study argue an early date, but the rhythmic fluency and poise of the design indicate that it was executed after the Italian visit of 1746; the gazebo in the park is used rather as a classical ruin in an imaginary landscape. There is considerably greater pictorial sophistication here than in the drawings from the Roman group (in the British Museum, Binyon, nos. 1–34), which show the influence of such printmakers as François Vivares (see no. 139), and this slight study gives some measure of the extent to which Cozens had learnt from his intensive self-training abroad. The signature on the mount is typical of his signatures in the 1760s, which he may have used earlier; but it could have been added when the drawing was mounted, perhaps several years after it was made. Compare Cozens's usual "Roman" signature on nos. 5 and 6.

5. Buildings by a river with hills in the background. *c.*1746–50 Plate 3

Black chalk on laid paper prepared with a pale brown ground 4 x 6³/₁₆ (102 x 157)

Inscr. upper right: *C*

Coll: Colnaghi: Iolo A. Williams; Colnaghi, from whom bt. by Paul Mellon, 1964

B1977.14.5509

Williams catalogued this drawing (no. 248) as "Landscape" and noted that the verso was inscribed *30*. This numeral is now invisible as the sheet has been backed, but the number 30 occurs again on a small square of paper attached to the existing mount, which was apparently once part of the original mount. It is not certain, however, whether this inscription is in Cozens's hand.

Although the medium—black chalk—is not that of the Roman sketchbook, the composition of this subject is similar to some drawings in pencil which occur in the book. It may have been executed in Rome but perhaps belongs to the years immediately after Cozens's return to England.

6. Landscape with a ruined temple. *c.*1746–50 Plate 4

Pencil and brown wash on laid paper prepared with a brown ground 12⅝ x 16 (321 x 407)

Inscr. top left, in pencil: *C*

Exh: Colnaghi, *English Drawings and Watercolours* 1965(14, repr.); New York, Wildenstein, *Romance and Reality* 1978(21)

Coll: Colnaghi, from whom bt. by Paul Mellon, 1965

B1975.4.1802

While it is executed with a brush only, this drawing preserves many of the technical devices which Cozens had taken from the engravers, translating them into the characteristic penwork of his Roman drawings (see no. 2). The scalloped formulas used for foliage and the hatched lines which build form and tone acquire a new softness when the brush replaces the pen; the resulting atmospheric depth is enhanced by the contrasting shades of light and dark ink. In arriving at the design of this composition Cozens seems to have been influenced by the landscapes of early Dutch artists working in Italy

such as Bartolomaeus Breenbergh (1599–1659), whose approach to classical landscape was decidedly more "picturesque" than that of Claude. The initial *C* with which Cozens signs the sheet is his usual signature on the Roman drawings and may have been used for a few years after his return to England.

7. Landscape with a lake and distant mountain. *c.*1750(?) Plate 4

Brush and black ink with some pencil on laid paper prepared with a pale buff ground 6¼ x 7⅞ (160 x 200)

Inscr. lower left: *86* (deleted) *660* and bottom center: *Cozens*; verso: *86*

Exh: Colnaghi 1966(18)

Coll: Randall Davies; Colnaghi, from whom bt. by Paul Mellon, 1966

B1975.4.198

The repeated number on the back of the sheet is perhaps analogous to that now hidden on the verso of no. 5. The greater breadth and generalization of this drawing, together with the signature, suggest that it dates from a little later than the period of Cozens's stay in Rome, though its delicacy of execution is still that of the early post-Roman years. Compare the drawing of the mountain in no. 8 and in the view known as *The Lake of Nemi* in the Oppé collection (Sheffield, no. 91, repr. pl.16).

This subject has been called "Romantic landscape with lake" but this is a misnomer since it very definitely belongs with the classically inspired compositions of the first part of Cozens's career.

8. The Glade. *c.*1750(?) Plate 4

Brush and black ink on laid paper prepared with an orange-brown ground 5⅝ x 7⅞ (143 x 201) (the upper right corner torn away and inked in by the artist on the mount)

Inscr. in center of sheet: *10/8*(?); on the artist's mount, lower left: *Alexr. Cozens.*

Exh: Sheffield 1946 (23); London, Tate Gallery 1946–47(23); Richmond, Virginia, Museum of Fine Arts, *Painting in England, 1700–1850* 1963(55)

Coll: Martin Hardie, 1932; acquired from his collection by Paul Mellon, 1963

B1977.14.5796

The mountain that features in this study seems to have roughly the same configuration as that in no. 7. Cozens's brushwork is here more rapid and allows for less detail, and there is no indication that the two sheets were executed at the same time.

9. Tree and distant Hills. 1750–55(?) Plate 5

Brush and black ink on laid paper prepared with a brown wash 6⅜ x 8 (161 x 200)

Inscr. on artist's mount, lower left: *Alexr. Cozens.* and on back of mount (in different hand?): *45*

Exh: B.F.A.C. 1916(21); Sheffield 1946(3); London, Tate Gallery 1946–47(37); South London Art Gallery, *English Landscape Festival Exhibition* 1951(43); Washington, National Gallery of Art, *Drawings and Watercolors from the Collection of Mr. and Mrs. Paul Mellon* 1962(19)

Coll: William Ward of Richmond; Herbert Horne; Sir Edward Marsh, K.C.V.O.; Spink, 1948; L. G. Duke; Colnaghi, from whom bt. by Paul Mellon, 1961

B1977.14.4990

Herbert Horne's manuscript notes on this drawing indicate that it was one of a portfolio of Cozens drawings owned by Ward; Horne's exhibition of his specimens at the Burlington Fine Arts Club in 1916 marked the beginning of a revival of interest in Cozens. This sheet was one of those shown there. A related study is in the British Museum Album, 1888-1-16-9(9). This shows an almost identical tree on the left, the trunk articulated with some fine brushwork; the landscape to the right is however quite different from that in the Yale drawing, having a low line of mountains with an expanse of sky above them.

10. Landscape with Mountain and Lake. 1750s(?) Plate 5

Pen and brown ink, brush and black ink on laid paper; the sheet has been folded vertically just to the right of the center 3¾ x 7¾ (95 x 196)

Inscr. top left: *S*(?)

Lit: Martin Hardie, "Early English Artists of the British Water-Colour School: Alexander Cozens," *The Collector* 11 (December 1930):187 (repr. p. 138)

Exh: Sheffield 1946(22); Richmond, Virginia, Museum of Fine Arts, *Painting in England, 1700–1850* 1963(54)

Coll: Walker's Gallery, 1920, from whom bt. by Martin Hardie; Colnaghi, from whom bt. by Paul Mellon, 1961

B1977.14.5795

The letter S (or number 5) inscribed in the top left-hand corner of this sheet may relate the drawing to no. 11, which seems to be inscribed similarly. In fact, the two drawings, despite superficial resemblances, are rather dissimilar. This sheet is also freer and more generalized than no. 7, which retains much of the nervous outline and careful detail, including the ruined building, of drawings made during Cozens's Roman stay. Compare the drawing illustrated by Williams 1952, pl. 61, which is inscribed *23*.

11. River and Mountains, with Ruins. 1750s(?) Plate 5

Pen and brown and black ink, brush and black ink on laid paper 3½ x 6¾ (88 x 171)

Inscr. top right: *S*(?)

Exh: Sheffield 1946(19); Sheffield, Graves Art Gallery *Early Watercolours from the Collection of Thomas Girtin Jnr.* 1953(17); London, Royal Academy, *The Girtin Collection* 1962(11)

Coll: A. P. Oppé, by whom given to S. Girtin, 1920: by descent to Thomas Girtin; John Baskett, from whom bt. by Paul Mellon, 1970

B1975.3.813

The inscribed figure or letter in the top right corner of this sheet may connect it with no. 10 above. Compare *A Wide Valley* in the Oppé collection (repr. Oppé 1952, pl. 5) and the drawing repr. Williams 1952, pl. 61.

12. Study of two Willows.. *c.*1760(?) Plate 6

Brush with black and brown ink on laid paper prepared with a yellowish-brown varnished ground 3¹⁵⁄₁₆ x 6⅜ (100 x 162)

Exh: Richmond, Virginia, Museum of Fine Arts, *Painting in England, 1700–1850* 1963(52); Yale, *English Landscape 1630–1850*, 1977(20)

Coll: Agnew, from whom bt. by Paul Mellon, 1962

B1975.4.196

White associates this study with Cozens's book *The Shape, Skeleton and Foliage of Thirty-two Species of Trees*, which appeared in 1771, and he accordingly dates the sheet to about 1770. There is in fact no direct connection, however, and the delicacy and crispness of the drawing suggest that it might date from somewhat earlier. The way the elegant silhouettes of the trees, especially the feathery forms of that on the right, are placed against a blank sky recalls Cozens's use of the traditional compositions of Italian engravings while he was in Rome. Compare the study of a Silver Birch, on exactly similar scale, which Oppé reproduces (1952, p. 116[a]) and specifically contrasts with the "diagrammatic" manner of the etchings in the book; these reflect the style of the drawings from which they are taken (see no. 18). Compare also the drawing of *A View in a Wood*, dated 1764, now in the Huntington Art Gallery, San Marino, repr. Robert R. Wark, *Early British Drawings in the Huntington Collection 1600–1750*, San Marino, 1969.

13. Hilly Coast-line. *c.*1760–70(?) Plate 6

Etching on laid paper, approx. 4⅜ x 6¼ (110 x 160)

Inscr. top left: 5

Lit: Oppé 1946, p. 54, no. 102; Oppé 1952, pp. 70, 88

Coll: By descent in the artist's family to Ralph George Norwood Young; his sale, Sotheby 16 March 1978(46); bt. by Yale Center for British Art

B1978.43.166(ooo)

A single print from the series of *Various Species of Composition in Nature*, sixteen subjects in four plates, with *Observations and Instructions*, of which a complete set is in the British Museum (1928-2-14-41 to 48). The artist's pen outline drawing for the subject is in the Oppé collection (repr. Sheffield and Tate 1946–47 catalogue, pl. 20 and Oppé 1952, pl. 4b). A set of pen and wash copies of Cozens's plates with their original captions was made by John Constable in the 1820s. These are all in the Oppé collection except one (no. 16) which is in the Fogg Art Museum. The type of composition illustrated is "Flat ground or water bounded by a narrow range of forms

or objects parallel to the base of the landscape." The impression was preserved loose among other papers in the box containing Cozens's Roman sketchbook (no. 2). Oppé (p. 45 and note) points out the similarity of Cozens's aims in the *Various Species* and the *Essay to Facilitate the Invention of Landskips*, as well as in the much later *New Method*. He admits the possibility that the *Various Species* etchings belong to the period of the earlier work; but seems to prefer a later date for them. Their tightness and delicacy consort better with Cozens's earlier style, and it seems most likely that they do belong to the decade in which he produced his most concentrated outpouring of landscape "systems." On the other hand it should be noted that a very similar landscape type occurs as no. 5 in the *New Method* (pl. no. 15). An extra-illustrated copy of C.R. Leslie's *Memoirs of the Life of John Constable, Esq. R.A.*, from the collection of Lord Lee of Fareham and now in the Yale Center for British Art, contains some sheets of notes by Constable which seem to have been taken from the copy of *Various Species* which provided him with the models for the drawings mentioned above. One sheet (numbered 2) contains the following list:

No of Species.
1. Edge of a hill or Mountain near the Eye
2. Tops of hills or Mountains
3. A varied Landscape on one side—and a flat country or water on the other
4. Gulph or Bay
5. Flat Ground or Water—bounded by a narrow range or forms of object [*sc.* of forms or objects?] parallel to the base of the Landscape
6. A single object or Cluster of objects at a distance
7. a large object or Cluster of Large Objects or more than one object near the Eye.
8. a Water-fall
9. Two Hills mountains or rocks opposed to each other
10. A Road or Track—or River proceeding from the Eye
11. Objects or Clusters of Objects placed on Each side
12. flat Ground or pieces of Water surrounded by objects
13. a Hollow or chasm
14. a Recess near the Eye where little or no part of the sky is seen
15. a Landscape of a Moderate extent to the right & left in which no object or cluster of objects is predominant
16. a spacious or extensive Landscape

Other sheets have notes which are less easily ascribable directly to Cozens, but as they seem to be derived from his ideas and are couched in his language it is perhaps worth recording their contents here as clues to lost publications. Constable may have taken them all from the same work—the *Various Species*; though the wide-ranging philosophical connotations of the list on sheet 6 suggest a different subject.

Sheet 1:
Objects
1 — Water
2 — Ground or Land
3 — Woodland or shrubby
4 — Wild
5 — Barren
6 — Rustic
7 — Pastoral
8 — Cultivated — arable
9 — Garden
10 — buildings
11 — European
12 — Asiatic
13 — African
14 — American
Trees shrubs — buildings
Sheep [skies?] figures ——

Sheet 2: [transcribed above]
Sheet 4: [a metrical version of the Species on sheet 2, by Charles Davy]
Sheet 5 *verso:*
Cousins often did his foregrounds first he said it is often neglected. he said a high horizon is grand—and likewise a low [low?] one—it is the Medium [*sc.* horizon] that is beautiful—
Cousins said the figures in Landscape should so far from Intruding—that they should hardly be seen—to be "as if rising out of the ground"—and passing by—he said "tis a misfortune that many Landscape painters could nt draw[?] so well"—as they ruined their pictures by this [these remarks may have been recalled from reminiscences of Sir George Beaumont or some other pupil of Cozens]
Sheet 6:
The Spectator is supposed to be in a tranquil state of mind
Attention—Caution—Awe—expectation of an extensive country.[A?]dmiration from contemplating a great expanse of sky—fear terror.
Surprize Terror—Superstition[?]. Silence. Melancholy power. strength.
Chearfullness—riches commerce liberty.
Safety—Shelter from storms.
Delight.
Unity of Idea. Influence around us. power protection
Power combined.
Coolness—warmth[?]. Rage. force not to be resisted. Rage. Hurry
Greatness—simplicity. sequestered life. serenity innocence of memories[?]. repose frendship.
Progression of Liberty
Delight
Delight shelter coolness quiet.
Greatness. awe. surprize. Danger banditter[?] superstitious fear.
Study. coolness. repose melancholy. religious fear—concealment[?] peace security danger tranquility solitude stilness.
Chearfulness—amusement. equality of fortune frindship.
Publick happyness. liberty curiosity grande[u?]r admiration

Sheet 7:
Circumstances
1 — Dawn
2 — before sun rising
3 — sun rising
4 — foornoon
5 — noon
6 — afternoon
7 — setting sun
8 — after sunset
9 — close of day
10 — Night
11 — Spring
12 — summer
13 — Autumn
14 — Winter
15 — fog or mist
16 — Wind
17 — Rain
18 — after Rain
19 — flood
20 — before Storm
21 — a Storm — Thunder lightning
22 — after a storm — Hail &c. &c.
23 — fine a Volcano fine a Sea
24 — mixture of the sky or clouds with the Landscape
25 — principal light in the sky
26 — principal light in the Landscape

14. Coast with wooded Cliff.

c.1770(?) Plate 6

Pencil, black and gray washes on laid paper prepared with a brown ground 4¹⁵/₁₆ x 7⅛ (125 x 181) (varnished tissue; a hole lower left has been filled with color by the artist)

Inscr. top left: *2*, and on artist's mount, lower left: *Alexr. Cozens*

Exh: Sheffield and London 1946–47(24)

Coll: Martin Hardie, 1932; Colnaghi, from whom bt. by Paul Mellon, 1961

B1977.14.5797

Comparable in treatment to the two Oppé collection drawings repr. Oppé 1952, pl. 26 (a) and (b): *Rocky Coast-line with building and ship* and *Sea Coast with wild Trees.* Like nos. 15 and 16, this sheet seems to belong to a group of very loosely executed wash drawings, sometimes reinforced with firmer brush outlines, which are perhaps transitional in Cozens's development. They display neither the classical disciplines of the early work nor the characteristic pattern-making of the fully "systematized" Cozens, yet show a noticeably experimental approach to composition and the random effects of broad handling.

15. River and Boat. *c*.1770(?) Plate 6

Pen and brush with black ink over pencil on laid paper prepared with a light brown varnished ground (the sheet creased vertically just to the right of center) 5 x 6½ (127 x 165)

Inscr. in artist's mount, lower left: *Alexr. Cozens*

Exh: B.F.A.C. 1916(18); Sheffield and London 1946–47(18 repr.); Sheffield, Graves Art Gallery, *Early Water-colours from the Collection of Thomas Girtin Jnr.* 1953(16); London, Royal Academy, *The Girtin Collection* 1962(10)

Lit: Illustrated London News, 28 December 1946 (repr.)

Coll: Dr. T. C. Girtin; by descent to Tom Girtin; John Baskett, from whom bt. by Paul Mellon, 1970

B1975.3.812

A similar use of pen to draw the outlines and rigging of boats occurs in other subjects; two in the Oppé collection are referred to by Williams 1952, p. 37: Cozens "uses a very unexpectedly effective trick of drawing the rigging, masts, etc., firmly and precisely with the pen though the rest of the composition is entirely, or almost, without pen. . . ."

16. Mountainous Landscape. 1770s(?) Plate 7

Pencil, brush and black and white bodycolor on laid buff-gray paper 4¾ x 6¾ (122 x 171)

Coll: J. S. Maas, from whom bt. by Paul Mellon, 1963

B1975.4.197

In this study Cozens uses loose washes to create an unusual sense of atmosphere, even suggesting a broad, misty shadow that fills the mountain valley. Although the subject is probably imaginary, it may be based on the topography of the Valley of Chamonix (compare for instance John Robert Cozens's view of the Aiguille Verte, no. 87).

17. Castle in a Landscape. 1770s(?) Plate 7

Brush and black ink on laid paper 9¾ x 13⅛ (245 x 333)

Exh: London, Royal Academy, *British Art* 1934(572); Bucharest, *British Graphic Art* 1935–36(78); Sheffield and London 1946–47 (21 repr.); Washington, National Gallery of Art, *Drawings and Watercolors from the Collection of Mr. and Mrs. Paul Mellon* 1962(20, repr.); Richmond, Virginia, Museum of Fine Arts, *Painting in England 1700–1850* 1963(53, repr.); Aldeburgh, Legion Hall, *English Drawings, 1700–1850* 1964(10); Colnaghi, London, and Yale University Art Gallery, *English Drawings and Watercolours* 1964–65(15); Yale, *English Landscape 1630–1850* 1977(21, repr.)

Lit: Martin Hardie, *The Collector* 11 (December 1930): 185, repr. p. 183; Martin Hardie 1966, p. 85, pl. 51

Coll: Walker's Gallery, 1920, from whom bt. by Martin Hardie; Colnaghi, from whom bt. by Paul Mellon, 1961

B1977.14.4696

This sheet is dated by White to about 1785, following Martin Hardie's association of the drawing with the "blots" used to illustrate the *New Method.* Despite its size and expansive scale, however, this is not very obviously a study of that type. The brush is used to draw quite specific forms and outlines, and there is no suggestion that any part of the design is "random." Compare the technique of *The Glade*, no. 8, where a crisper, more jagged brushstroke is employed but where the general type of drawing is the same. The *Castle in a Landscape* seems later than *The Glade*, but not necessarily as late as the *New Method.* White's description of Cozens's technique in this sheet as involving "two stages, first in grey wash, and then developing and strengthening the subject in black" seems to exaggerate the artist's "system" unnecessarily: this is a simple sketch made with a brush loaded with black ink, sometimes denser, sometimes thinner: there is no sign of a preliminary "grey wash." The overworking of a darker tone on a lighter in the outline of the castle indicates a hesitancy of touch which is unusual for Cozens and makes the drawing as a whole less satisfactory than other examples of this type. Compare the distinctive use of contrasting gray and black washes in the *Fantastic Landscape*, no. 25.

18. *The Shape, Skeleton and Foliage of Thirty-two Species of Trees.* 1771 Plate 8

Lent by the Beinecke Rare Book and Manuscript Library, Yale University

This work, first published in 1771, consists of a small title-plate, 4 x 3⅛ (103 x 91), inscribed: THE/ *Shape, Skeleton and Foliage,/ of Thirty-two Species, of / TREES For the use of Painting, / and Drawing* with the date *Apr. 27* stippled below; and thirty-two small engravings, each numbered and with a brief title: *1. Aspin. 2. Pollard-Aspin. 3. Ash. 4. Abele or Poplar. 5. Beach. 6. Birch. 7. Spanish-Chestnut. 8. Horse-Chestnut. 9. Cedar. 10. Cypress. 11. Elm. 12. Lopped Elm. 13. Elder. 14. Larch-Fir. 15. Scotch-Fir. 16. Spruce. or Norway Fir. 17. Lime. 18. Holly. 19. Laburnum. 20. Laurel. 21. Oak— 22. Pollard-Oak— 23. Palm— 24. Italian-Pine— 25. Sycamore. 26. Thorn. 27. Walnut. 28. Willow. 29. Pollard-Willow. 30. Weeping-Willow. 31. Pollard Weeping Willow. 32. Yew.*

In the 1771 edition these subjects appeared in pairs; when Cozens reissued the set with some copies of the *New Method* in 1786, they were printed in groups of four, which is the layout of the uncut plates. The copy exhibited here is from this edition; it is included in an album containing the text and plates of the *New Method*, apparently presented by the artist to T. Wallace, whose name appears in the inside front cover. A label on the spine reads *Cozens on Blotting*. The copy later belonged to Mr. Ray Murphy, from whom it passed to the Beinecke Library, Yale. As Oppé notes (1952, p. 28, note), this copy has the set of *Skies* (see the *New Method*, nos. 42–61, pls. 17–36) numbered 1–20 for separate publication.

The eight full plates of the 1786 edition of the *Trees* all measure 9⅞ x 8³/₁₆ (252 x 208) and are inscribed: *Alexr. Cozens Invt. Publish'd according to Act of Parliament Jany 1.1786*. (In plates 1 through 5 Cozens is spelled "Curzon".) Plates 4 and 6 (trees 13–16 and 21–24) appear to have been engraved by a different hand from the rest. As in the *Principles of Beauty relative to the Human Head* (no. 20), the *Skies*, and the various systems of landscape composition, Cozens here attempts to codify and categorize natural forms for the benefit of the artist. The structure of the trunk and branches of each tree is indicated diagrammatically, and is surrounded by a schematic indication of the general shape and growth of the foliage. As Oppé observes, this is guidance for the draftsman who wishes to dispense with linear methods and to work broadly in washes which will give a general impression of the various species without descending to details or making niggling outlines. The system thus anticipates Cozens's preoccupations in the *New Method*, and it was wholly appropriate that these plates should have been reissued with it.

The original drawings for the project have been untraced for many years; nineteen of them, however, were attached to proofs of the engravings of the *Trees* which are included in the album now in the Hermitage (see p. 7). They are executed in brown wash, on small sheets of laid paper, as follows:

	Hermitage number	Sheet Size	
Abele (or Poplar)	44752	3⅝ x 3¹/₁₆	(92 x 78)
Pollard Oak	44753	4 x 3⅝	(102 x 93)
Pollard Aspen	44754	4 x 3¼	(102 x 82)
Oak	44755	3¾ x 3¹/₁₆	(96 x 78)
Beech	44756	4⅛ x 3	(105 x 77)
Spanish Chestnut	44757	3¾ x 2⅞	(97 x 74)
Horse Chestnut	44758	3⅝ x 3	(91 x 76)
Elm	44759	4⅜ x 2¹⁵/₁₆	(110 x 75)
Ash	44760	3⅞ x 2⅞	(99 x 74)
Lime	44761	3¾ x 2¹⁵/₁₆	(96 x 75)
Aspen	44762	4⅜ x 2⅞	(110 x 72)
Laurel	44763	4 x 3	(102 x 76)
Holly	44764	4 x 2⅞	(101 x 74)
Birch	44765	3¾ x 2⁹/₁₆	(97 x 65)
Laburnam	44766	4⅛ x 2¼	(103 x 56)
Palm	44767	4 x 2⅞	(102 x 73)
Italian Fir	44768	4⅛ x 2⅝	(104 x 66)
Cypress	44769	4⅜ x 2¼	(112 x 58)
Elder	44770	2⅞ x 3¼	(72 x 82)

When John Robert Cozens came to execute prints depicting a similar series of trees he adopted a very different approach from that of his father. His set of soft-ground etchings was published in 1789 under the title *Delineations of the general character ramifications and foliage of forest trees*, which is identical with the wording of the title of Alexander Cozens's set of trees as given in the manuscript heading to the Hermitage copy. The publication consists of much larger subjects, showing the trees in landscape settings—upland slopes of wild grandeur, broad meadows, or mediterranean coasts. The titles are: Oak, Elm, Beech, Birch, Cedar, Palm, Thorn, Aspen, Poplar, Willow, Weeping Willow, Horse Chestnut, Italian Pine & Cypress, and Fir. There exist several sets of proofs in which the outlines are enhanced with gray or gray and yellow wash, presumably added by Cozens himself, rather in the manner of the Bath prints of 1773 (nos. 75–82). These proofs are on mounts lined in soft-ground and hand-tinted. Each bears an etched signature and the titles are often added by Cozens in pencil. The published set has a more formally engraved signature and is aquatinted rather than hand-colored. Thirteen of the plates were reissued by W. H. Pyne in 1814; one set is in an album in the British Museum which also contains soft-ground etchings by Harriet Gouldsmith, an amateur obviously influenced by Cozens's plates. Her designs reproduce with variations the trees of his set but also include figures which suggest that they were executed in the first decade of the nineteenth century.

19. Close of the Day: Sunset on the Coast.
*c.*1768–75(?) Plate 23

Oil over pencil on laid paper 9⁹/₁₆ x 12¼ (243 x 311)

Inscr. on back of original mount: *Close of the Day*

Coll: Anonymous sale, Christie 4 March 1975(14); bt. by Paul Mellon

IR30/3087

One of three studies in oil on paper of these dimensions sold at auction in 1975. The sale catalogue states that they form part of a small group of oil paintings, all executed on paper. Another of the three was acquired by the Tate Gallery and is inscribed *Before Storm* on the verso. The third is now in the Stamford Museum, Palo Alto. Four smaller works in the same medium are in the Oppé collection, having been bought from the Cozens sale at Greenwood's in 1794 and passed through the hands of Dr. Curry (Sale, Sotheby March–April 1820, lot 3084) and William Mackworth Praed (see Oppé 1952, p. 83 and note). Two large oil paintings on canvas, now in the collection of H. G. Balfour, are datable to 1756 (see Leslie Parris, *Landscape in Britain*, Tate Gallery exhibition catalogue, 1973, no. 83), but the four small Oppé studies and the three sold in 1975 are difficult to date precisely. They have no topographical content and are all concerned with highly poetic or dramatic atmospheric effects. Of his own set Oppé observes (p. 84) that their "smooth workmanship may be the result of the hours spent in Vernet's studio, but there is nothing here of his laboured vivacity. It would be rash to quote any specific contemporary painters or works as having direct influence on Cozens, but models closer than Vernet's to these four paintings might be found in the series of small pictures now in the Vatican Gallery by Donato Creti, who was still living when Cozens was in Rome, or in the exquisite blue twilight background of his *Acis and Galatea* in the Palazzo Venezia. It may not be an accident that the former are eight small nocturnes showing the different phases of the moon." This implies an early date, but the extreme generalization of many of the oil studies seems more consistent with

a later period. It is possible that these works were among those exhibited at the society of Artists—see the "six small landscapes" hung with the oil paintings in the exhibition of 1768(26). An oil study of similar type was apparently shown at the Royal Academy in 1775 as *A Setting Sun* (14). The drawing of *The Cloud* in the Oppé collection (repr. Oppé 1952, pl. 21) is an analogous subject and relates to the series of sunset and sky studies in the Hermitage.

20. Principles of Beauty, relative to the Human Head. 1778

Yale Center for British Art, Department of Rare Books, L 119.6

This folio volume, published in London by James Dixwell, is dedicated by Cozens to the King, George III, whose name heads the list of subscribers. This includes the names of many members of the aristocracy and gentry; among them Edmund Burke, William Beckford, Sir George Beaumont, David Garrick, Rev. William Gilpin, Sir William Hamilton and "—Lock Esq," presumably William Lock of Norbury. Numerous artists also subscribed; notably George Barret, "—Bacon, Esq.," probably John Bacon the sculptor, Cipriani, Cosway, Flaxman, Sawrey Gilpin, James Jefferys, Thomas Major the engraver, Nollekens, Henry Pars the drawing master, Reynolds, Ramsay, John [Inigo?] Richards, William Wynn Ryland, Stubbs, West, Wilton, and Wright of Derby. This impressive list indicates the degree of respect which Cozens commanded in the art world, as well as the popularity of his services as drawing-master among the upper classes. The response was to his work rather than to his writings, which at this date consisted only of the *Essay on the Invention of Landscape Composition* of 1759 and a *Treatise on Perspective* of 1765, which were probably not widely known.

The book consists of fifteen pages of text in English, followed by fifteen pages of the same text in French "for the convenience of foreigners." (The French title page is dated 1777.) It is illustrated by nineteen plates engraved by Bartolozzi. "My doctrine," Cozens explains, "is, that a set of features may be combined by a regular and determinate process in art, producing simple beauty, uncharacterred and unimpassioned. From this, as from an harmonious and simple piece of music, many variations may be derived by certain arrangements of the features, expressive of various characters or impressions of the mind, deviating indeed from the simple principle of beauty, but not incompatible with it" (p. 2). His method is characteristically tabulated:

"First, by giving a collection of human features, separately taken, by an out-line, in profile, as large as life.

"Secondly, Tables of the combination of the features, selected from the aforesaid collection, ready for the use of composing faces . . .

"Thirdly, an example of a face in profile, drawn in out-line, according to the first table, wherein are selected those features which are expressive of simple beauty.

"And also examples of faces drawn as before and according to the rest of the tables, wherein are selected those features which are expressive of the characterised beauties.

"To each of the faces is applied a head-dress, drawn likewise in out-line, in the style of the antique, printed on a loose sheet of thin paper, through which may be seen the corresponding face."

Cozens concludes that "In considering with attention what and how many species of human character may be found to coincide with beauty, they appear to me to be sixteen in number [as Oppé

observes, sixteen is a number of almost magic potency for Cozens; cf. the *Various Species of Composition in Nature* and the *New Method*], and to come under one or other of the following denominations, viz.

The Majestic.	The Languid, or Delicate.
The Sensible, or Wise.	The Penetrating.
The Steady.	The Engaging.
The Spirited.	The Good-natured.
The Haughty.	The Timid.
The Melancholy.	The Cheerful.
The Tender.	The Artful.
The Modest.	The Innocent.

"These," he concludes, "are all the classes which come under the definition and limitation of charactered beauty, independent of passion; for . . . the passions are by no means under my contemplation at present" (p. 3).

The features of the face are then analyzed into their "Principal Variations"—four for the forehead, twelve for the nose, sixteen for the mouth, two for the chin, twelve for the eyebrow, and sixteen for the eye. The first two plates illustrate them. They are then combined and permuted to create the sixteen basic types of beauty illustrated in the plates. The obsessive analysis and categorization of something we should now regard as unquantifiable is typical of Cozens; it is also characteristic of his time; his attempt to impose a quasi-mathematical logic (with allusions to musical analogues) is somewhat similar to the even more far-reaching theories of Giles Hussey (1710–88), whose *Panharmonicon* (never published) tried to demonstrate that the human physiognomy in all its manifestations corresponds strictly to the musical scale with its tones, half-tones, and other intervallic relations. Cozens's book, it is worth noting, appeared at exactly the same moment as Johann Caspar Lavater's *Physiognomische Fragmente*, published on the continent 1775–78 but not translated into English until 1789. "A drawing of a head in red chalk" which Cozens exhibited at the Royal Academy in 1778 was very probably either one of the illustrations to the *Principles of Beauty* or a study related to the project. In 1783 the sculptor Thomas Banks (1735–1805) exhibited the *Head of a Majestic Beauty, composed on Mr. Cozens's principles* (Royal Academy, no. 386).

21. A Valley. 1775–80(?) Plate 8

Pencil with brush and brownish-gray and black ink on laid paper
9 x 12⅜ (229 x 315)

Inscr. on back of original mount: *Sketch by Cozens*

Exh: Sheffield and London 1946–47(17); Sheffield, Graves Art Gallery, *Early Water-colours from the Collection of Thomas Girtin Jnr.* 1953(14); London, Royal Academy, *The Girtin Collection* 1962(6); Reading Museum and Art Gallery, *Thomas Girtin and some of his Contemporaries* 1969(1)

Lit: F. Gibson, "Alexander and J. R. Cozens," *The Studio* (1917; repr.)

Coll: Dr. T. C. Girtin; by descent to Tom Girtin; John Baskett, from whom bt. by Paul Mellon, 1970

B1975.3.809

This type of open, airy subject seems to have become more common in Cozens's later work. It may reflect the influence of John Robert's more consciously atmospheric style, with its carefully graded contrasts of tone. The subject is drawn throughout in pencil as a

preliminary to the application of the wash—a procedure much less usual with Alexander than with John Robert.

One rather disconcerting feature of the drawing is that its mount—apparently a characteristic gray washline Cozens mount—has had the signature in the bottom left-hand corner cut out. It is not unusual for signatures to have been removed in this way so that they could be attached to the outer mat for display purposes; but one is left wondering whether there was not some other motive for its removal—it may have been the signature of a pupil rather than of the master himself, for instance. The drawing has always been accepted as being by Alexander Cozens, and there is no internal reason to question this except that it demonstrates no particular strengths; but the doubt should be recorded. A pen and ink outline drawing of what is essentially the same subject is in the Stanford Museum, Palo Alto (77.147). It varies from the Yale sheet in ways that might be considered typical of Alexander: for instance, the single detached tree at the foot of the right-hand slope is deciduous, not a conifer. The mount is signed.

22. Landscape with a Woman seated by a dark Pool. 1775–80(?) Plate 10

Brush and black and brown washes with scraping-out on laid paper prepared with a pale brown ground, circular 11 x 11 (279 x 279)

Lit: Andrew Wilton, *British Watercolours 1750–1850* (Oxford, 1977), p. 182, pl. 44

Coll: Private collection

The circular format is rare in Alexander's output, but it parallels a series of circular drawings, with literary or fantastic subjects, made by John Robert perhaps fairly early in his career (see no. 95). This drawing is based on a landscape type popularized by G. B. Grimaldi (1606–80) in his etchings; Cozens seems to have adapted one of these, retaining the composition and basic elements but substituting his own characteristic tree-types, foliage, etc. The sheet is almost didactic in its preoccupation with various contrasted technical methods, which are applied to the different surfaces and textures occurring in the scene. The use of scraping-out to obtain sparkling highlights (in the large shrub to the left) is unusual in Cozens's work and anticipates the technical experiments of the next generation of watercolorists.

23. Mountainous Landscape. *c.*1780 Plate 10

Gray and brown washes on laid paper prepared with a pale brown ground 9½ x 12½ (241 x 318)

Exh: New York, Pierpont Morgan Library, and London, Royal Academy 1972–73(27, repr.); Yale, *English Landscape 1630–1850* 1977(22, repr.)

Coll: John Baskett, from whom bt. by Paul Mellon, 1971

B1975.4.1480

White correctly associates this drawing with the type of landscape mezzotinted by Pether for the *New Method*, and he accordingly dates the sheet to about 1785. There is however no reason to suppose that Cozens made landscapes of this kind only in the final years of his life; the formula is one that he seems to have arrived at considerably

earlier; the technique of such drawings, however, clearly belongs to the latter part of Cozens's career. There is a settled, balanced, and conclusive quality to this subject which justifies White's title of "Mountainous Classical Landscape," apparently derived from Oppé's title for the work with which White compares it, the large *Classical Landscape* in Oppé's own collection (repr. Oppé 1952, pl. 7). In that case, a group of cypress trees adds to the faintly "classical" flavor; but on the whole it seems misleading to use the term "classical" in association with subjects that do not include the ruins and temples with which Cozens so frequently dotted his views. The idiosyncratic rock-forms of the Yale drawing are typical of the mature Alexander Cozens and seem to have influenced his son's treatment of non-imaginary rocks, as in the *Chiavenna* in this collection (no. 95).

24. Mountain Tops (A Mountain Study). *c.*1780(?) Plate 11

Pencil with brown and gray wash on laid paper prepared with a brown ground 9 1/16 x 12¼ (230 x 312)

Inscr. top right: 5 *100*; on artist's mount, lower left: *Alexr. Cozens*, and on back of mount: *91*

Exh: Sheffield and London 1946–47(11); Eton College 1948(5); Arts Council, *Three Centuries of British Watercolours and Drawings* 1951(48); Leicester City Art Gallery, *Sir George Beaumont and His Circle* 1953(42)

Coll: Meatyard, 1928, from whom acquired by L. G. Duke; bt. by Paul Mellon, 1965

B1977.14.5233

Duke (MS catalogue of his collection) supposed that this was "Probably a study in Elba," which Cozens visited, it is thought, during his Italian stay in 1746. Evidence for the visit consists of two drawings among the Roman studies in the British Museum, inscribed *Porto Longona in yᵉ Island Elbe* (1867-10-12-30; Binyon 27a), and *Porto Longona from . . . (illegible)* (Binyon 15a). The mountains at the left of the first of these (repr. Oppé 1952, pl. 3) bear some resemblance to the peaks in the present drawing. It has been supposed that John Robert Cozens's *View in the Isle of Elba* (versions in the Victoria and Albert Museum and elsewhere; see Hawcroft 1971, no. 9) derives from a sketch by Alexander, and indeed there is a general similarity between that composition and the Yale sheet. In any case, Cozens's intention in making this drawing was presumably to create an "abstract" view of mountains rather than a topographical record, and it is perhaps pointless to attempt to identify the scene precisely; but a comparison of the drawing with another view of peaks in the British Museum (1928-4-17-4; repr. Wilton, *British Watercolours 1750–1850*, 1977, pl. 50) derived from a blot published in the *New Method* (plate 2) indicates that this is a relatively specific exercise in landscape.

25. Fantastic Landscape. 1780–85(?) Plate 11

Brush and gray and black washes with some pencil on laid paper prepared with a buff-brown ground 12¼ x 17½ (312 x 444)

Inscr. on artist's mount, lower left: *Alexr. Cozens.*, and on back of mount: *32*

Exh: Somerville and Simpson, *English Watercolours and Drawings* 1976(9a) as "Rocky Landscape"

Coll: Somerville and Simpson, 1976; bt. by Paul Mellon, 1977

B1977.14.139

One of the most surreal and eccentric of all Cozens's imaginary landscapes, this drawing takes to an extreme his concern for the formal, abstract relationships of elements to one another and to the sheet. A more elaborate drawing that uses a similar motif of irregularly shaped, islandlike rocks seen from high above, with a low horizon and extensive sky, is the *Rocky Island* in the Whitworth Art Gallery (D26.1929, repr. Oppé 1952, pl. 24). There, flat cloud formations contribute to the overall pattern; here, the sky is blank and the "islands" float ambiguously in a misty plain. A thin pencil line ruled across the sheet indicates the horizon. The technique, involving delicate, short touches of the brush, seems to be characteristic of the last decade of Cozens's life, and a number of drawings related to the *New Method* are exectued in a similar manner.

The "New Method"

Lent by the Davison Art Center, Wesleyan University

Cozens's last publication bears the title *A New Method of assisting the Invention in Drawing Original Compositions of Landscape*; advertisements for it appeared in 1784 and it seems to have been scheduled for publication in 1785, but the title page bears no date. It appeared, at any rate, at the very end of Cozens's life, and apparently in a small edition, of which few copies seem to have survived. It consists of thirty-three pages of printed text, copies of which are in the British Museum and the Beinecke Library, Yale, with twenty-eight engraved plates as illustrations. Of these the first sixteen are full-page reproductions in aquatint of a selection of ink "Blots"; the next five are line engravings, each plate divided into four small subjects schematically illustrating different types of sky; these were originally intended as a separate publication. Plates 37 to 43 are again full-page subjects, two Blots like the previous ones, with five worked-up landscapes based on them, reproduced in a mixture of aquatint and mezzotint. Cozens employed William Pether (1731–95) to scrape the mezzotint for these plates. The technique used to reproduce the series of Blots has proved difficult to analyse; various suggestions have been put forward to account for the effects that Cozens obtains, including the theory that the plates are executed in sugar-lift aquatint (see Alan Shestack, 'Lift ground prints by Alexander Cozens', *Artist's Proof*, 8, 1968, pp.82–6). In several of the plates the aquatint tone is strengthened by local use of the etching needle or the roulette. See also Henri Zerner, 'Alexander Cozens et sa Méthode pour l'Invention des Paysages', *L'Oeil*, 136, 1966,pp.28–33.

The series of sixteen Blots with which the sequence begins corresponds, as Oppé points out (1952, pp. 70–71), at least roughly with the categories represented in the series entitled *The Various*

Species of Composition in Nature (see no. 13). At the end of the *New Method* text Cozens gives a variant list of "Descriptions of the various Kinds of Composition of Landscape," headed by a quotation from Pope:

> Those rules which are discover'd, not devis'd,
> Are Nature still, but Nature methodiz'd:
> Nature, like Monarchy, is but restrain'd
> By the same Laws which first herself ordain'd.

Cozens presents his idea as an "instantaneous method of bringing forth the conception of an ideal subject fully to the view" which will "promote original composition in painting." Just as its character is didactic, so it originated in a practical problem of the teacher: "happening to have a piece of soiled paper under my hand, and casting my eyes on it slightly, I sketched something like a landscape on it, with a pencil, in order to catch some hint which might be improved into a rule [for a pupil]. The stains, though extremely faint, appeared upon revisal to have influenced me, insensibly, in expressing the general appearance of a landscape. This circumstance was sufficently striking: I mixed a tint with ink and water, just strong enough to mark the paper; and having hastily made some rude forms with it, (which, when dry, seemed as if they would answer the same purpose to which I had applied the accidental stains of the 'forementioned piece of paper) I laid it, together with a few short hints of my intention, before the pupil, who instantly improved the blot, as it may be called, into an intelligible sketch, and from that time made such progress in composition, as fully answered my most sanguine expectations from the experiment." Cozens invoked the precedent of Leonardo for this procedure, though he claims that his own system is more convenient than searching, as Leonardo suggests, for landscapes in old walls, "which seldom occur." "A true blot," he expands, "is an assemblage of dark shapes or masses made with ink upon a piece of paper, and likewise of light ones produced by the paper being left blank. All the shapes are rude and unmeaning, as they are formed with the swiftest hand. But at the same time there appears a general disposition of these masses, producing one comprehensive form, which may be conceived and purposely intended before the blot is begun. This general form will exhibit some kind of subject, and this is all that should be done designedly." He insists that "the blot is not a drawing, but an assemblage of accidental shapes, from which a drawing may be made. It is a hint, or crude resemblance of the whole effect of a picture, except the keeping and colouring; that is to say, it gives an idea of the masses of light and shade, as well as of the forms, contained in a finished composition To blot, is to make varied spots and shapes with ink on paper, producing accidental forms without lines, from which ideas are presented to the mind. This is conformable to nature: for in nature, forms are not distinguished by lines, but by shade and colour. To sketch, is to delineate ideas; blotting suggests them." Cozens goes on to justify his system by a discussion of the creative process and the nature of genius. He then gives some practical rules: "I To make Drawing Ink." In a copy of the *New Method* that probably belonged to Beckford (Babb bequest, Beinecke Library, Yale) the following note in pen is added after this rule: "NB. This ink is fit only for making the Blot itself. India ink is far preferable for all other purposes of drawing." II To make Transparent Paper; III To form a BLOT; IV To make a Sketch from a Blot with a Hair Pencil, as a Preparation for a finished Drawing; and V To finish with a Camel's-Hair Brush, a Sketch that is made out from a Blot."

The complete text of the *New Method* is reprinted by Oppé 1952, pp. 165–87; and a detailed discussion of the book is on pp. 56–71. See also A.P. Oppé, "New Light on Alexander Cozens," *Print Collectors Quarterly* 8 (1921):62.

26. The *New Method*, plate 1: A Blot of the first kind of composition of landscape. Plate 13

Aquatint 9⁷/₁₆ x 12⅜ (240 x 315)

Inscr. top right with numeral *1*, and below: *Alexr. Cozens inv.* and *Publish'd according to act of Parliament*

This blot corresponds to the first kind of landscape composition, as described on p. 31 of the text: "Part of the edge or top of a hill or mountain, seen horizontally, the horizon below the bottom of the view. The horizon is the utmost bounds of the land of a flat country, or the sea, in an uninterrupted view of it to the sky."

27. The *New Method*, plate 2: Of the second kind. Plate 13

Aquatint 9⁷/₁₆ x 12⅜ (240 x 315)

Inscr. top right with numeral *2*

"The tops of hills or mountains, the horizon below the bottom of the view." A wash drawing of this subject is in the British Museum (1928-4-17-4), repr. Andrew Wilton, *British Watercolours 1750–1850*, 1977, pl.50.

28. The *New Method*, plate 3: Of the third.

Plate 14

Aquatint 9⁷/₁₆ x 12⅜ (240 x 315)

Inscr. top right with numeral *3*

"Groups of objects on one hand, and a flat on the other, of an irregular form next to the groups, at a moderate distance from the eye."

29. The *New Method*, plate 4: Of the fourth.

Plate 14

Aquatint 9⁷/₁₆ x 12⅜ (240 x 315)

Inscr. top right with numeral *4*

"A flat circular form, bounded by groups of objects, at a moderate distance from the eye."

30. The *New Method*, plate 5: Of the fifth.

Plate 15

Aquatint 9⁷/₁₆ x 12⅜ (240 x 315)

Inscr. top right with numeral *5*

"A narrow flat, almost parallel and next to the eye, bounded by a narrow range of groups of objects."

31. The *New Method*, plate 6: Of the sixth.

Plate 15

Aquatint 9⁷/₁₆ x 12⅜ (240 x 315)

Inscr. top right with numeral *6*

"A single or principal object, opposed to the sky; as a tree, a ruin, a rock, &c. or a group of objects."

32. The *New Method*, plate 7: Of the seventh.

Plate 16

Aquatint 9⁷/₁₆ x 12⅜ (240 x 315)

Inscr. top left with numeral *7*

"A high fore-ground, that is to say, a large kind of object, or more than one. Near the eye."

33. The *New Method*, plate 8: Of the eighth.

Plate 16

Aquatint 9⁷/₁₆ x 12⅜ (240 x 315)

Inscr. top left with numeral *8*

"A water-fall."

34. The *New Method*, plate 9: Of the ninth.

Plate 17

Aquatint 9⁷/₁₆ x 12⅜ (240 x 315)

Inscr. top right with numeral *9*

"Two hills, mountains, or rocks near each other. At a moderate distance from the bottom of the view."

35. The *New Method*, plate 10: Of the tenth.

Plate 17

Aquatint 9⁷/₁₆ x 12⅜ (240 x 315)

Inscr. top right with numeral *10*

"A track, proceeding forward from the eye, bounded by groups of objects."

36. The *New Method*, plate 11: Of the eleventh.
Plate 18

Aquatint strengthened with etching 9⁷⁄₁₆ x 12³⁄₈ (240 x 315)

Inscr. top right with numeral *11*

"Objects, or groups of objects, placed alternately on both hands, and gradually retiring from the eye. The horizon above the bottom of the view."

37. The *New Method*, plate 12: Of the twelfth.
Plate 18

Aquatint 9⁷⁄₁₆ x 12³⁄₈ (240 x 315)

Inscr. top right with numeral *12*

"A flat bounded on all sides by groups of objects."

38. The *New Method*, plate 13: Of the thirteenth.
Plate 19

Aquatint 9⁷⁄₁₆ x 12³⁄₈ (240 x 315)

Inscr. top right with numeral *13*

"A hollow or bottom."

39. The *New Method*, plate 14: Of the fourteenth. Plate 19

Aquatint, strengthened with etching 9⁷⁄₁₆ x 12³⁄₈ (240 x 315)

Inscr. top right with numeral *14*

"A close or confined scene, with little or no sky."

40. The *New Method*, plate 15: Of the fifteenth.
Plate 20

Aquatint 9⁷⁄₁₆ x 12³⁄₈ (240 x 315)

Inscr. top right with numeral *15*

"A landscape of a moderate extent between the right and left hand, the objects or groups placed irregularly, and no one predominant. The horizon above the bottom of the view."

41. The *New Method*, plate 16: Of the sixteenth.
Plate 20

Aquatint 9⁷⁄₁₆ x 12³⁄₈ (240 x 315)

Inscr. top right with numeral *16*

"An extensive country, with no predominant part or object. The horizon above the bottom of the view." Several drawings related to

this subject are known; one is in the collection of Lord Clark; another was sold at auction, Sotheby 20 July 1978 (189 repr.) as *In Calabria*.

42. The *New Method*, plate 17: First kind of composition of sky. Plate 21

Line engraving 4³⁄₈ x 6⁵⁄₁₆ approx. 113 x 160 (trimmed to edge of subject)

Inscr: *17) All plain, darker at the top than the bottom, gradually.*

43. The *New Method*, plate 17: Second kind.
Plate 21

Line engraving 4³⁄₈ x 6⁵⁄₁₆ approx. 113 x 160 (trimmed to edge of subject)

Inscr: *18) Streaky Clouds at the top of the sky.*

44. The *New Method*, plate 17: Third. Plate 21

Line engraving 4³⁄₈ x 6⁵⁄₁₆ approx. 113 x 160 (trimmed to edge of subject)

Inscr: *19) Streaky Clouds at the bottom of the Sky.*

45. The *New Method*, plate 17: Fourth. Plate 21

Line engraving 4³⁄₈ x 6⁵⁄₁₆ approx. 113 x 160 (trimmed to edge of subject)

Inscr: *20) Half Cloud half plain, the Clouds darker than the plain or blue part, & darker at the top than the bottom.*

46. The *New Method*, plate 18: Fifth. Plate 21

Line engraving 4³⁄₈ x 6⁵⁄₁₆ approx. 113 x 160 (trimmed to edge of subject)

Inscr: *21) The same as the last, but darker at the bottom than the top.—*

47. The *New Method*, plate 18: Sixth. Plate 21

Line engraving 4³⁄₈ x 6⁵⁄₁₆ approx. 113 x 160 (trimmed to edge of subject)

Inscr: *22) Half cloud half plain, the clouds lighter than the plain part, & darker at the top than the bottom.—/ The Tint twice over in the plain part, & once in the clouds.—*

48. The *New Method*, plate 18: Seventh. Plate 21

Line engraving 4⅜ x 6⁵⁄₁₆ approx. 113 x 160

Inscr: *23) The same as the last, but darker at the bottom than the top.—*

49. The *New Method*, plate 18: Eighth. Plate 21

Line engraving 4⅜ x 6⁵⁄₁₆ approx. 113 x 160 (trimmed to edge of subject)

Inscr: *24) Half cloud half plain, the lights of the clouds lighter, and the shades darker/ than the plain part and darker at the top than the bottom.—/ The Tint once over in the plain part, and twice in the clouds.—*

50. The *New Method*, plate 19: Ninth. Plate 22

Line engraving 4⅜ x 6⁵⁄₁₆ approx. 113 x 160 (trimmed to edge of subject)

Inscr: *25) The same as the last, but darker at the bottom than the top.—*

51. The *New Method*, plate 19: Tenth. Plate 22

Line engraving 4⅜ x 6⁵⁄₁₆ approx. 113 x 160 (trimmed to edge of subject)

Inscr: *26) All cloudy, except one large opening, with others smaller, the clouds/ darker than the plain part, & darker at the top than the bottom.—/ The Tint twice over.—*

52. The *New Method*, plate 19: Eleventh. Plate 22

Line engraving 4⅜ x 6⁵⁄₁₆ approx. 113 x 160 (trimmed to edge of subject)

Inscr: *27) The same as the last, but darker at the bottom/ than the top.—*

53. The *New Method*, plate 19: Twelfth. Plate 22

Line engraving 4⅜ x 6⁵⁄₁₆ approx. 113 x 160 (trimmed to edge of subject)

Inscr: *28) All cloudy, except one large opening, with others smaller, the clouds/ lighter than the plain part, & darker at the top than the bottom.—/ The Tint once over in the openings, and twice in the clouds.—*

54. The *New Method*, plate 20: Thirteenth.
Plate 22

Line engraving 4⅜ x 6⁵⁄₁₆ approx. 113 x 160 (trimmed to edge of subject)

Inscr: *29) The same as the last, but darker at the bottom than the top.*

55. The *New Method*, plate 20: Fourteenth.
Plate 22

Line engraving 4⅜ x 6⁵⁄₁₆ approx. 113 x 160 (trimmed to edge of subject)

Inscr: *30) All cloudy, except one large opening, with others smaller, the lights of the clouds lighter, & the shades/ darker than the plain part, and darker at the top than the bottom.—/ The Tint once over in the openings, and twice in the clouds.—*

56. The *New Method*, plate 20: Fifteenth.
Plate 22

Line engraving 4⅜ x 6⁵⁄₁₆ approx. 113 x 160 (trimmed to edge of subject)

Inscr: *31) The same as the last, but darker at the bottom than the top.—*

57. The *New Method*, plate 20: Sixteenth.
Plate 22

Line engraving 4⅜ x 6⁵⁄₁₆ approx. 113 x 160 (trimmed to edge of subject)

Inscr: *32) All cloudy, except a narrow opening at the bottom of the sky, with others smaller, the clouds/ lighter than the plain part, and darker at the top than the bottom.—/ The Tint twice in the opening, and once in the clouds.—*

58. The *New Method*, plate 21: Seventeenth.
Plate 23

Line engraving 4⅜ x 6⁵⁄₁₆ approx. 113 x 160 (trimmed to edge of subject)

Inscr: *33) All cloudy, except a narrow opening at the top of the sky, with others smaller,/ the clouds lighter than the plain part, & darker at the bottom than the top.—/ The Tint twice in the openings, & once in the clouds.—*

59. The *New Method*, plate 21: Eighteenth.
Plate 23

Line engraving 4⅜ x 6⁵⁄₁₆ approx. 113 x 160 (trimmed to edge of subject)

Inscr: *34) All cloudy, except a narrow opening at the bottom of the sky, with/ others smaller, the clouds darker than the plain part, and darker at the/ top than the bottom. The Tint twice over.*

60. The *New Method*, plate 21: Nineteenth.
Plate 23

Line engraving 4⅜ x 6⁵/₁₆ approx. 113 x 160 (trimmed to edge of subject)

Inscr: *35) All cloudy, except a narrow opening at the top of the sky, with/ others smaller, the clouds darker than the plain part, & darker at the top than the bottom.—/ The Tint twice over.—*

61. The *New Method*, plate 21: Twentieth.
Plate 23

Line engraving 4⅜ x 6⁵/₁₆ approx. 113 x 160 (trimmed to edge of subject)

Inscr: *36) The same as the last, but darker at the bottom than the top.—*

62. The *New Method*, plate 22: A blot. Plate 24

Aquatint strengthened with etching 9⁷/₁₆ x 12⅜ (240 x 315)

Inscr. top right with numeral *37*

63. The *New Method*, plate 23: A print, representing a sketch made out with a brush, from the preceding blot. Plate 24

Aquatint 9⁷/₁₆ x 12⅜ (240 x 315)

Inscr. top right with numeral *38*

64. The *New Method*, plate 24: A print, representing the same sketch, made into a finished drawing. Plate 24

Aquatint and mezzotint 9⁷/₁₆ x 12⅜ (240 x 315)

Inscr. top right with numeral *39*; below: *A. Cozens inv.* and *Published according to Act of Parliament, May 5, 1784.* and *W. Pether. feᵗ*

65. The *New Method*, plate 25: A blot. Plate 25

Aquatint 9⁷/₁₆ x 12⅜ (240 x 315)

Inscr. top right with numeral *40*

66. The *New Method*, plate 26: A print, representing a drawing done with a brush, from the preceding blot. Plate 25

Aquatint and mezzotint 9⁷/₁₆ x 12⅜ (240 x 315)

Inscr. top right with numeral *41*; below: *Aleᵗ Cozens Invᵗ* and *Published as the Act directs by A.Cozens July 20ᵗʰ 1785.* and *Wᵐ Pether Fecit*

67. The *New Method*, plate 27: A second drawing done from the same blot. Plate 25

Aquatint and mezzotint 9⁷/₁₆ x 12⅜ (240 x 315)

Inscr. top right with numeral *42* and below: *Alexᵗ Cozens Invᵗ* and *Published as the Act directs by A.Cozens July 20ᵗʰ 1785.* and *Wᵐ Pether Fecit*

68. The *New Method*, plate 28: A third drawing done from the same blot. Plate 25

Aquatint and mezzotint 9⁷/₁₆ x 12⅜ (240 x 315)

Inscr. top right with numeral *43*; below: *Aleᵗ Cozens Invᵗ* and *Published as the Act directs by A.Cozens July 20ᵗʰ 1785.* and *Wᵐ Pether Fecit*

The drawing of this subject was in the collection of Sir Edward Marsh and is reproduced by Oppé 1952, facing p. 92, pl. 11.

69–74. Autograph manuscripts of Alexander Cozens

These six sheets of laid paper, each measuring approximately 6¾ x 4¼ inches (700 x 110 mm), were preserved in the box which contained Cozens's Roman Sketchbook (no. 2). They are transcribed by Oppé along with the notes in the sketchbook, *Walpole Society* vol. XVI, 1927–28, pp. 91–93 (see also Oppé 1952, pp. 25–6). They evidently date from later than the sketchbook, and Oppé has suggested that they belong to the years between 1763 and 1771. References to a painting in "the Exhibition" (Letter 3) apparently shown with "a compannion" seem to point to the pair *A Landskip* and *Its Companion* shown at the Society of Artists in 1768 (36, 37), but Cozens was sending work to that exhibition from 1760 until 1771, and he occasionally submitted items in pairs; there is therefore no certainty as to the exact year of the letter. It is also clear that the letters were not written within a short time of each other, since he apologizes more than once for long delays in replying to his correspondent. This was the portrait painter Henry Hoare (1706–99), who practised much of his life in Bath, with which town the Cozens family seem to have had some connection (see nos. 75–84). Other personalities mentioned in the letters are a Mr. Crespin, who was a subscriber to the *Principles of Beauty* in 1778 (see no. 20), a Mr. Taylor, whom Oppé supposes to have been a recorded amateur, and "Mr. Bamfylde," probably Coplestone Warre Bampfylde, another amateur (see no. 145). It is possible that both were pupils of Alexander Cozens at some point, as perhaps was the "Colonel Burgoin" of sheet 5. Oppé conjectures that this was the famous "Gentleman Johnny Burgoyne" of the

American War. Letter 3 makes reference to several of Cozens's projected publications: the *Skies*, which were finally published (in a series of twenty) with the *New Method* (see p. 31); the *Trees* of 1771 and 1778 (see no. 18); and the *Species of Composition in Nature* (see no. 13). Again, no definite conclusions can be drawn from these references as to the date of the correspondence, since Cozens was obviously mulling over these "systems" for a protracted period, and they were issued at times evidently often far removed from the period of their inception. The last sheet in the group contains the transcription of a passage apparently from Captain Cook's second voyage "towards the South Pole, and round the World," published in 1777 (2 vols.). The quotation is of particular interest as it evokes a landscape typical of much of Cozens's later work—barren, mysterious, and otherworldly. It is likely that the artist drew considerable inspiration from such accounts of contemporary exploration.

69 Sheet 1, *Letter 1:*

recto:

To — Hoar Esq! Bath —

S! I take the liberty to write to you [& think it incumbent upon me *deleted*][& ought *deleted*] & should begin with the strongest apologies, to avert your just Displeasure at my Delay in sending those Drawings which you were so kind as to require on the recommendation of so generous a Friend as M! Crespin.

The [greatest *deleted*] best excuse I have S! in vindicating myself is that being so much employed in Teaching Drawing, both at Eton School & private scholars in London altho' I have a great deal of Business bespoke on my favourite Subject [of Draw making Draw *deleted*] Composition of Landscape, yet I have so little time to make Drawings especially in Winter that I am forced to solicit & rely on the utmost stretch of y! Good nature & Patience of my friends & Employers.

However, I have stole some scraps of Time in which to finish in a ve[ry?] rude manner some Drawings (not having time to put in y! Figures)

verso:

Figures) They are not all [in any series or *deleted*] in their proper order. I offer them only as some Specimens of the various kinds of Composition, which is one of the Divisions of my intended Work. They were designed in outline before I had y! pleasure of seeing M! Crespin & being so far advanced I undertook to shade them to send to you, which I indend [*sic*] in a few days.

The Plan of proceeding which I have proposed to myself with regard to my Book, is, to make Paintings of all the Examples, of the size they are to be [printed *deleted*] grav'd and when I open the Subscription, to shew at the same time, three finished Prints, one for each Division of the Book. viz. Composition, Character, & Circumstance, as Specimens of the Whole Work. And as I have lately received a Commission from a certain Nobleman to make coloured Drawings of my own Invention of a moderate convenient size. I am in some hopes of an oportunity [*sic*] to propose to his

70 Sheet 2, *Letter 2 [part of Letter 1?]:*

recto:

Mr Hoar — Bath

lay before) the Gentlemen & Ladies of your Acquaintance the Subject & Meaning of my Undertaking (as it is sketched out in that little book [M! *deleted*] which M! Crespin was so good as to leave with you) so as I might be able to judge what encouragment I might hope for at Bath. Not to offer direct Proposals or receive any Money, of y! Subscription but only to give yourself the trouble to make a Memorandum of the Names of

those Gentlemen and Ladies who [are *deleted*] might be inclined to favour such a Work. untill I shall be able next Winter to give further satisfaction by printed Proposals and some Specimens of the Examples.

[I am extremely sorry that I have not leasure at present to (address *deleted*) write a Letter to M! Crespin. *deleted*]

verso:

Mr. Hoar —Bath

lay before) the Gentlemen & Ladies [at B *deleted*] of your acquaintance [at Bath *deleted*] the Subject & Meaning of my Undertaking (as it is sketch'd out in that little book Mr. Crespin was so as I might be able to judge what encouragment I might hope for at Bath. Not to offer [etc; sense much as on *recto; all deleted*]

Be pleased Sr to present my gratefull Respects with y! enclosed to Mr Crespin [whom I have likewise sent a letter. *deleted*] and I take the liberty to desire the favour of you to present my Compliments to Mr. Taylor whom I presume you are acquainted with

71 Sheet 3, *Letter 3:*

recto:

[William *deleted*] Mr. Hoare. Bath.

Dear S!

Two of y! letters I have recd a long time ago and yet they remain unanswerd, all the hope I have of being forgiven is in the reliance [I have *deleted*] upon y! goodness & in your belief of what I have had occasion more than once to write, concerning the hurry of my business. But indeed this also may plead something for me: that The letters I have the pleasure of writing to you depend on circumstances. [if it was only to answer, I should be more punctual. *deleted*.] on the nature of the business I am engaged in & the opportunities I have to do it [in *deleted*]. If it was only to answer, I should be more punctual.

Your letter from Stourhead inform'd me of the receipt of my Picture. I return you my gratefull thanks for the trouble you gave yourself in [letting me *deleted*] writing me a letter so soon. And for the pleasure of your approbation. But I have

verso:

have) before given you an account in one of my letters, the reasons why I did not send the second Picture. [But *deleted*] Since that time, the reason of my detaining it [till now *deleted*], is, that I took the liberty to put it into the Exhibition where it has been this Month past, & after that I have been hindred by teachg & other matters, from sending it till now. In your next letter which was from Bath, according to your wonted goodness you offer me y! picture you have [for me *deleted*] to put into the Exhibition. Before I had any opportunity of writing to you I had another picture [which I put with as a compannion to this which *deleted*] which I put into the Exhibition with this that I send you. What you write of M! Bamfylde has given me great joy & satisfaction. I return him my

72 Sheet 4, *Letter 3:*

recto:

To William Hoare Esq! Bath.

Dear Sir. I recd your obliging letter some time ago, which I have not had time to answer [which *deleted*] & hope still that your goodness will excuse it. But now having broke up at Eton school, I write with the greatest pleasure to return you my thanks for the additional favours you have bestow'd upon me, in sending my book of specimens, your acceptance of y! second picture, & the payment for [them *deleted*] both the pictures. I am at present engag'd in paintg a system in 35 small pictures [for a Gentleman *deleted*]. I have finish'd about 6.

I had form'd 3 books of specimens 1st of 25 different sorts of Skies,

verso:

2 of 26 sorts of Trees. 3 of 35 Species of Composition of Lands: Shewing these books to [this *deleted*] a Gentleman one day, it induc'd him to give

me [the *deleted*] an order to finish so many pictures as might include all the three books. My reason S.! of mentioning this to you is that I should be extremely happy if you should come to Town that you will be pleas'd to favour me with a visit, & to that I might have [the pleasure of *deleted*] your opinion & assistance in this my attempt.

73 Sheet 5

recto:

attempt) I return my gratefull thanks for the offer of your service, when I have have [*sic*] fix'd my proposals, which with pain I think it is [unaccountably *deleted*] strangely put off from the time I intended, but the constant flow of business & circumstances bair down all my intentions with resistless force. Now I think that I cannot publish y.ᵉ Proposals till next winter. I am Sir y.! most hum & ob.! Serv!
<div align="right">Alex.ʳ Cozens</div>

Letter 4:

verso:

Colonel Burgoin

 West side of Grosvenor Square Mr Cozens presents his Respects to Col Burgoin. He is [not sure *deleted*] in doubt whether Colonel Burg— means Tomorrow or [the *deleted*] Tuesday Sevenight that M.! Cozens is to have the honor to meet the Colonel at the Horse-guards. M.! Cozens begs to know

74 Sheet 6

recto:

Prevailing Objects–Barren. [?]
towards the South Pole. The Bay of S.! Barbara, or Cape Desolation. From Cap. Cooks Voyage Vol. 2.

 — I have before observed that it is the most desolate coast I ever saw. It seems composed of rocky mountains without the least appearance of vegetation. These mountains terminate in horible precipices, whose craggy summits spire up to a vast hight, so that hardly any thing in Nature can appear with a more barren

verso:

& savage aspect, than / the whole of this country. The inland Mountains were covered with snow, but those on the Sea-coast are not.
[*upside down, below*] of hand) feeble state of exis-

John Robert Cozens

75–82. Eight Views of Bath. 1773 Plates 28–31

South View of Bath; The Crescent; The North Parade; The Circus; Queen Square; The South Parade; The New Bridge; The City of Bath taken from the London Road

Etching with gray monochrome wash applied by hand, on laid paper, each approx. 9¹/₁₆ x 13⁷/₁₆ (230 x 340), excluding etched washline border; all trimmed within the platemark

Each inscr. with title and, lower right: *Jnº Robᵗ Cozens*, and lower center, *Publish'd according to Act of Parlᵗ Nov.30.1773* (two plates, *The New Bridge* and *Bath from the London Road*, have *Parliamᵗ* for *Parlᵗ*; and *The North Parade* has *Nov* [blank] *1773*)

Lit: Oppé 1952, p. 108

Coll: Anonymous sale, Sotheby Belgravia 25 May 1979 (262); bt. by Paul Mellon

IR303/1-8

Oppé describes these views as "crudely outlined," and says that they were "clearly intended to be worked up in color, as are the two sets which have so far been seen." Since this set is worked up in monochrome only, it is not certain whether it is one of the two to which Oppé refers. It is possible that the gray wash was intended as underpainting for watercolor. Oppé infers from their rarity that the publication was unsuccessful. The somewhat fussy topographical content of the plates is far removed from Alexander Cozens's work, though there are passages, especially in the skies, which suggest his influence. The view of the Circus recalls the views of London Squares made by Edward Dayes in the 1780s. What is most striking about these designs is their ambitious range, including figures, animals, complex recession (as in the *City of Bath from the London Road*) and irregular compositions (especially the *Crescent*). They are completely free from the pictorial rules and devices with which Alexander Cozens circumscribed landscape design. See also nos. 83, 84 and 85.

83. Bristol Hot Wells. *c.*1773 Plate 32

Pen and brown ink on thin laid paper approx. 5 x 9 (128 x 228)

Inscr. upper right: *Bristol Hot Wells.* and upper left: *1 sun misty But yᵉ body of it very bright / 2* [illeg.] *Tendᵗ from yᵉ Sun / 3 yᵉ edges of yᵉ hills faintly mark'd, all in Mist Pretty warm but greyish/ 4 Green field in yᵉ sun / Tendᵗ Grey upon it* and with corresponding numbers in the drawing

Coll: C.L.N. Miles, Esq.; sale, Sotheby 19 July 1979 (28)

B1979.29.1

See no. 84.

84. The Banks of the Avon at Hotwells(?)
*c.*1773 Plate 32

Pen and black ink on tracing paper approx. 6¼ x 19⁷/₁₆ (159 x 265)

Inscr. upper left: *1 Reflection of yᵉ L: mist / 2 all in mist — / 3 pearly — / 4 mist — / 5 Green L right (?) / 6 greyish / 7 B: green ;* and above: *all yᵉ Trees in a warm Mist & all Tender green Nothing (?) light / on yᵉ Distant Trees Accept* [sic] *Nº 2* and with corresponding numbers in the drawing

Coll: C. L. N. Miles, Esq; sale, Sotheby 19 July 1979(28)

B1979.29.2

There is no obvious stylistic foundation for the attribution of these two drawings to John Robert Cozens, though we know that he worked in the Bath area (see nos. 75–82). However, the systematic way in which the observations are recorded is strongly redolent of Alexander Cozens's methods, while the handwriting in which they are set down is very close to that of John Robert's sketchbooks and tracings. Despite their crudeness, these sketches betray a greater intensity of purpose and even a more prehensile technique than the Bath etchings, and they may date from a year or two after 1773 on that account.

Daniel Lerpinière (1745–85)
after John Robert Cozens

85. The Castle in the Isle of Lundy 1775 Plate 32

Engraving 3¹⁵/₁₆ x 5¹⁴/₁₆ (99 x 150)

Inscr. below: *11 Octᵗ 1775.* and *S.Hooper Excᵗ* and *DL.* with title and *Plate I*

Lit: Oppé 1952, p. 95; Francis Hawcroft, "A Watercolour Drawing by Alexander Cozens," *Burlington Magazine* 102 (1960): 486.

Yale Center for British Art, Department of Rare Books, Abbey S.42

Published in volume 4 of Francis Grose's *Antiquities of England and Wales*, which first appeared in six volumes, 1773–87; this copy is from the new edition of 1815. Grose notes that "This View, which represents the West Aspect, was drawn Anno 1775." A second plate of Lundy Castle which "shews a near View of it," also noted as having been drawn in 1775, was engraved by Sparrow and dated *Janʸ 18ᵗʰ 1776.* Both Oppé and Hawcroft assume that it was Alexander Cozens who made these designs; Grose's own note makes it clear that the artist is John Robert Cozens: in his Preface to the fourth volume, he says, "The two Views of the Castle in Lundy Island were taken by Mr. Cozens, Junior, a young Painter, who promises fair to be better known to the Public." Like the Bath views, these topographical subjects do not eschew the familiar refinements of the genre—figures are introduced into both designs—but they conform with the simple directness and lack of sophistication that is typical of all Grose's illustrations. The original drawings are lost.

The Payne Knight Set of Swiss views

The following five drawings are sheets from a series recording a journey in Switzerland in 1776. It is known that Cozens traveled to Italy in that year, and these subjects must have been gathered en route. They provide evidence of a fairly typical traveler's itinerary; Cozens entered Switzerland at Geneva, made an excursion along the north side of the lake, including a visit to the Lac des Joux, but continued his journey southeast through Sallanches to Chamonix and over the Col des Montets to Martigny; thence apparently to Bex, l'Aigle, Chateau d'Oex, and over the mountains to Spiez and Interlaken. If we assume that no excursions were made, the drawings

record an itinerary through Grindelwald and over the Grosse Scheidegg to Meiringen. There seems to have been an excursion a little way up the Haslital, but the journey proceded next over the Brunig pass into Unterwalden, taking in Engelberg and going on to Lucerne. After exploring Lake Lucerne and its environs Cozens crossed to the Canton of Glarus, drawing in the Lintal and on the Klöntalersee. He then took the Splügen route to Chiavenna and Como. Such a tour, taking in many of the most famous tourist attractions of Switzerland, was probably not made by Cozens on his own, and it has always been supposed that he traveled as the companion of Richard Payne Knight, since Payne Knight owned an album of these drawings inscribed "Views in Swisserland, a present from R. P. Knight, and taken by the late Mr. Cozens under his inspection during a Tour in Swisserland in 1776." Oppé hesitates to accept this (long-lost) inscription as evidence, but there is little reason to doubt that it tells the truth. Payne Knight was certainly in Italy shortly afterward, though there is no record of an association between him and Cozens there. Henry Angelo quite independently states that Payne Knight "took [Cozens] with him to Switzerland to make drawings" (*Reminiscences*, vol. 2, 1884 ed., p. 126). According to Roget (*History of the Old Water-Colour Society*, 2 vols., London 1890, bk. 1, chap. 6, p. 61) the album passed from Payne Knight to the collection of John Towneley. It contained fifty-seven drawings; twenty-four of these are now in the British Museum. Others are scattered widely; there are examples in the Victoria and Albert Museum, the Tate Gallery, the Fitzwilliam Museum, the Cecil Higgins Art Gallery, and the Rhode Island School of Design. A group of six similar drawings, in slightly different format (approx. 7 x 10 in.) in the Lupton collection at Leeds, consists of views from the Via Mala down to Como on the Splügen route (Bell and Girtin, nos. 45–48, 50, 51). These were presumably done at the same time as the rest, or at least belong to the same tour, but are in a rather different style, looser and more fluid in drawing. See the view at *Chiavenna*, no. 95. Opinions as to the function of the series as a whole have been divided. While they are rather simply presented, with economical means and quiet effects, the drawings are too elaborate and carefully executed to have the character of sketches made on the spot. They bear little resemblance to the work that Cozens was doing in Rome two years later (see nos. 91 and 92), and so it seems likely that they belong to the year 1776. They may have been worked on as a set for presentation to Payne Knight after Cozens arrived in Rome, or perhaps during the journey. In this case, the artist would have been working from a set of sketches made probably in pencil; these have not survived.

86. The Lake of Geneva from the Canton of Berne. 1776 Plate 33

Pencil, gray and brown washes with some pen on laid paper 9½ x 14 (241 x 357)

Inscr. verso: *The Lake of Geneva from the Canton of Bern* and *August 18 1776 / No 6* and *2*

Exh: B.F.A.C. 1916 (72); B.F.A.C. 1923 (68)

Lit: Bell and Girtin, no. 2

Coll: Richard Payne Knight; John Towneley, sale, 1–15 May 1816(394) bt. Woodburn; Hon. Rowland Allanson-Winn; Herbert Horne; Asa Lingard; Alan G. Agnew; Mrs. Desmond Whitaker; Agnew, from whom bt. by Paul Mellon, 1965

B1975.4.1105

No finished work derived from this study is known, but the subject was copied by a member of Dr. Monro's group in a drawing formerly in the collections of Herbert Horne and Asa Lingard. This was exhibited with the original at the B.F.A.C. in 1923 with an ascription to Turner which cannot at present be substantiated. Bell and Girtin describe it as "Monro School." The Yale Sheet is the earliest of the Payne Knight group to bear a specific date, though Bell and Girtin catalogue the view of *Geneva from the North West* in the Victoria and Albert Museum (D.709) before this on the ground that Payne Knight and Cozens passed through Geneva prior to traveling eastward along the northern shore of the lake. Another drawing in the series which probably shows the same lake is now in the Tate Gallery (T985, Bell and Girtin, no.3).

87. Between Chamonix and Martigny. 1776

Plate 33

Pencil, pen and brush and gray and brown wash on laid paper 9⅜ x 14⅛ (238 x 358)

Inscr. verso: *Between Chamouny & Martinach / August 30 1776 / No 16* and *Savoy 8*

Exh: B.F.A.C. 1916(70); B.F.A.C. 1923(64, repr. pl. XXXIX); Victoria, Canada, Art Gallery of Greater Victoria, *British Watercolour Drawings in the Collection of Mr. and Mrs. Paul Mellon* 1971(9)

Lit: Bell and Girtin, no. 8; Hawcroft 1971, p. 13

Coll: Richard Payne Knight; John Towneley, sale, 1–15 May 1816(394) bt. Woodburn; Hon. Rowland Allanson-Winn; Herbert Horne; Sir Edward Marsh; Asa Lingard; Alan G. Agnew; Mrs. Desmond Whitaker; Agnew, from whom bt. by Paul Mellon, 1965

B1975.4.1103

Three finished watercolors by Cozens based on this study are known: in the Victoria and Albert Museum (158-1881; repr. Martin Hardie 1966, pl. 114); in the Leslie Wright Collection (repr. Wilton, *British Watercolours 1750–1850* [1977],pl. 51); and in a private Scottish collection. The young Turner copied the study for Monro in about 1795. The subject is often known as "The Aiguille Verte."

88. Upon the Aare between Unterseen and the Lake of Brientz. 1776 Plate 34

Pen and brush and blue and gray washes over pencil on laid paper 9⅝ x 14⅛ (236 x 362)

Inscr. verso: *Upon the Aare between Unterseven & the Lake of Brientz* and *15*

Exh: B.F.A.C. 1916(76); B.F.A.C. 1923(66)

Lit: Bell and Girtin, no. 17

Coll: Richard Payne Knight; John Towneley, sale, 1–15 May 1816(394) bt. Woodburn; Hon. Rowland Allanson-Winn; Herbert Horne; Sir Edward Marsh; Asa Lingard; Alan G. Agnew; Mrs. Desmond Whitaker; Agnew, from whom bt. by Paul Mellon, 1965

B1975.4.1104

A copy of this composition by a member of Monro's circle, perhaps Turner, was exhibited with the original at the B.F.A.C. in 1923(67). This is now in the Pantzer collection, Indianapolis. No finished

watercolor of the subject by Cozens himself is known. Bell and Girtin point out that the peaks seen beyond the tower of Unterseen church are those of the Niessen and the Fremberghorn. The introduction of a figure into the composition is unusual for the Payne Knight series.

89. Interlaken. 1776 Plate 35

Pen and gray ink and gray and brown washes over some pencil on laid paper 9⅛ x 13⅞ (234 x 354)

Inscr. verso: *From the Road between the Lake of Thun & Underseen* and *16*

Exh: London, Royal Academy, *The Girtin Collection* 1962(23)

Lit: Hawcroft 1971, p. 14, no. 3

Coll: Richard Payne Knight; John Towneley, sale, 1–15 May 1816(394) bt. Woodburn; Hon. Rowland Allanson-Winn; Agnew 1957, from whom bt. by T. Girtin; Tom Girtin; John Baskett, from whom bt. by Paul Mellon, 1970

B1975.3.1000

This drawing was not known to Bell and Girtin, who inferred its existence however from the drawing of the same subject in the British Museum, Salting Bequest (1910-2-12-242; Bell and Girtin, no. 15 and pl. IIB; Hawcroft 1971, no. 3). It evidently belongs to the Payne Knight series, being executed in precisely similar style, with the usual fold down the center of the sheet. The title adopted here retains Bell and Girtin's naming of the scene ("looking up the Lauterbrunnen valley, peaks of the Jungfrau group in the distance") for the sake of clarity, but the subject should really be renamed according to Cozens's inscription on the verso. Other views at Unterseen (or Interlaken) are Bell and Girtin, nos. 16, 17 (see no. 88); *From the Bridge at Unterseen* (Bell and Girtin, no. 16) is now at the Rhode Island School of Design (Catalogue Selection I, no. 18).

90. The Fall of the Reichenbach. 1776 Plate 35

Pen and black ink and gray, greenish and blue washes on laid paper 9⁵⁄₁₆ x 7⅛ (237 x 181)

Inscr. verso: *5th View upon yͤ Riquenbac* and *24*

Exh: B.F.A.C. 1923 (87, repr. pl. XL)

Lit: Bell and Girtin, no. 23

Coll: Richard Payne Knight; John Towneley, sale, 1–15 May 1816(394) bt. Woodburn; Hon. Rowland Allanson-Winn; Herbert Horne; Edward Marsh; Archdeacon Smythe; Viscount Eccles; John Baskett, from whom bt. by Paul Mellon, 1969

B1975.4.199

The format of this sheet is exactly half of the usual large sheet on which the Payne Knight series are mostly executed. A few other examples of a similar size occur. A Monro school copy of this subject is in the Turner Bequest, TB CCCLXXIV–5; it is possibly by Turner himself. It is one of a set of five such copies of views of the fall of the Reichenbach, and there can be little doubt that Cozens's great interest in this subject stimulated Turner's own response to it. He produced two major watercolors of it (Wilton, nos. 367, 396). Cozens made a series of studies of the fall, of which Bell and Girtin list seven, noting that two others are missing. The series of numbers on the versos which is followed by Bell and Girtin leads to some confusion, as they recognize. The first view (Bell and Girtin, no. 20) is num-

bered 20 (BM 1900-4-11-14); the second (Bell and Girtin, no. 21) is numbered 21 (BM 1900-4-11-23; repr. C. Monkhouse, *The Earlier English Watercolor Painters*, 2nd. ed. London, 1897, facing p. 104); the third is numbered 22 (Rhode Island School of Design; cat. no. 19, repr. pl. IVa); the fourth (Bell and Girtin, no. 22, BM 1900-4-11-22) is numbered 23. The Yale drawing catalogued here is inscribed *5th View* and bears the next number, 24. The sixth view is BM 1900-4-11-31 (Bell and Girtin, no. 24, no number recorded). The seventh view, which should be numbered 26, would have to share this number with the sixth; it is missing. The eighth view is numbered 27 (Bell and Girtin, no. 25, BM 1900-4-11-30); the ninth view, apparently inscr. *ninth & lowest view* (Bell and Girtin, no. 26) is numbered 28, and previously belonged to Herbert Horne and Edward Marsh. A further drawing in the British Museum, is catalogued by Bell and Girtin (no. 31) as "Near the Valley of Ober-Hasli," and numbered 33; but is also identified as BM 1900-4-11-29, which is now known as "View on the Reichenbach," and seems to be numbered not 33 but *20*, as is the first view. None of these subjects duplicates any other, as far as can be ascertained.

91. Tivoli. 1778 Plate 36

Pen and black ink and watercolor over pencil on laid paper 13 x 19¼ (330 x 489)

Inscr. on the artist's mount in pen and brown ink, lower left: *J.R.Cozens Rome 1778.* and in pencil: *Tivoli*

Exh: Cambridge, Fitzwilliam Museum, *Drawings by the Early English Water-colourists* 1920(42); B.F.A.C. 1923(38, repr. pl. XX); Newcastle, Laing Art Gallery 1924(15); Tokyo, Institute of Art Research 1929; Amsterdam, Stedelijk Museum, *British Art* 1936(208); Paris, Louvre, *La Peinture Anglaise* 1938(191); Paris, Orangerie, *Le Paysage Anglais* 1953(37); Sheffield, Graves Art Gallery, *Early Water-colours from the Collection of Thomas Girtin Jnr.* 1953(15); London, Royal Academy, *The Eighteenth Century* 1954–55(531); Leeds City Art Gallery, *Early English Watercolours* 1958(22); London, Royal Academy, *The Girtin Collection* 1962(13); Victoria and Albert Museum, *The Englishman in Italy* 1968; Reading Museum and Art Gallery, *Thomas Girtin and some of his Contemporaries* 1969(9)

Lit: Bell and Girtin, p. 24 and no. 135, pl. Xa; Oppé 1952, p. 137, pl. 33

Coll: Charles Fairfax Murray; Thomas Girtin 1920; Tom Girtin; John Baskett, from whom acquired by Paul Mellon, 1970

B1975.3.978

Bell says that this drawing is "obviously an experiment," influenced by the adventurous watercolor procedures of Ducros. Oppé draws attention to the "vivid almost turquoise-blue colouring" of Cozens's work of the late 1770s, which is "best seen" in this drawing, whose "hasty touch and free brushwork alone among Cozens' drawings gives an impression of having been coloured on the spot." Since the drawing is inscribed *Rome* it is more probable that Cozens colored and finished it in his rooms in Rome than out of doors—and Oppé's suggestion is made more unlikely by the thoroughly schematic coloring. Although the actual shades of green and brown used here are not quite those of Cozens's work subsequently, they approach the general range of his typical coloring and reflect less any direct observation of the appearance of things than the artist's usual aim to establish a mood. The use of pen to outline forms can be related to the technique of the Payne Knight drawings (see nos. 86–90 above), though here the somewhat rough, angular manner of those studies is replaced by tighter, more elegant handling. The drawing represents

a logical stage in Cozens's development: the pencil underdrawing is somewhat tentative, lacking the fluency of the artist's later work. If, as seems likely, the initial motive was taken down on the same sheet as the finished work, then this is a drawing which unites the spontaneity and directness of the Payne Knight group with the more elaborate technique and atmospheric effect of the later finished watercolors. In the future, Cozens was to make his finished drawings almost exclusively from already existing studies kept separately (for the most part in sketchbooks), so that this combination of methods was not to recur. In this sense, the sheet is indeed an "experimental" one, and the judgment is confirmed by the "unfinished" quality of much of the drawing, especially in the lower right-hand corner. This lack of resolution is remedied in the works that come later.

92. The Galleria di Sopra, Albano. 1778(?)
Plate 36

Pencil and watercolor on laid paper 14¼ x 20¹³/₁₆ (363 x 529)

Inscr. lower left: *AC.* (monogram), and on an early mount, not in the artist's hand: *Cousins.*

Exh: Victoria, Canada, Art Gallery of Greater Victoria, *British Watercolour Drawings in the Collection of Mr. and Mrs. Paul Mellon* 1971(10); Yale, *English Landscape 1630–1850* 1977(74, repr. pl. XII)

Lit: Martin Hardie 1966, frontispiece

Coll: Manning Galleries, from whom bt. by Paul Mellon, 1966

B1975.4.1904

Bell and Girtin record four separate subjects with the title 'View on the Galleria di Sopra above the Lake of Albano'; types A and B (nos. 152, 153) being represented by drawings dated 1778. Type A exists in two versions: one (repr. B.F.A.C. 1923, pl. XXII) was on the London art market in 1976; the other, not in Bell and Girtin, is in a private American collection (repr. *The Manning Gallery 1953–1966*, 1966, p. 11); type B exists in two versions, one now in the collection of the National Gallery, Melbourne (repr. Munich *Zwei Jahrhunderte Englische Malerei*, 1979–80, no. 108); there are four drawings of the subject of type C (Bell and Girtin, no 154), among which one is in the Williamson Art Gallery, Birkenhead, and another in the Oppé collection (repr. Bell and Girtin, pl. XVa). A further subject (type D) is Bell and Girtin, no. 155, and was in Sir Thomas Barlow's collection (repr. Hawcroft 1971, no. 38). Of these, the version of type C in the Oppé collection is unfinished. This type is most like the Yale drawing in having the plunge down toward the Campagna on the right instead of the left, with the contorted branches of a tree against the sky above it. But the Yale sheet does not correspond with any of the types recorded by Bell and Girtin and is considerably more unfinished than the Oppé example. It presents problems in that it cannot be read coherently in its rough state, and some ambiguities are insoluble. The most vertical of the tree trunks, for instance, seems to disappear behind another trunk which is considerably further away from the eye, while its bole is abruptly halved, partly by the more distant trunk and partly by the gray wash representing the road that winds past it. These unresolved elements, together with the treatment of the foliage and the general use of wash, suggest that the drawing was done at a time not far removed from the view of Tivoli, no. 91. A date of about 1778 is confirmed by the dates inscribed on the other *Galleria di Sopra* drawings.

This version of the subject, and the Oppé version, link the theme of the series with that of the famous Lake of Albano drawings (see no. 93), another sequence of roughly the same date, in which the motif of the goatherd driving his flock is used repeatedly. It occurs here in a more tentative form, the figures outlined in pencil and touched palely with a little red color. More usually the *Galleria di Sopra* subjects include figures of a more idyllic and leisured cast. The urgency of the group in the Yale version perhaps reflects Cozens's intention to depict a storm in the sky to the right: rainclouds are seen in the distance, and the trees seem to be swaying to a rising wind.

93. The Lake of Albano and Castel Gandolfo. *c.*1779 Plate 37

Watercolor over pencil on wove paper 17½ x 25¼ (445 x 642)

Exh: Messrs. Agnew 1967(49); New York, Pierpont Morgan Library, and London, Royal Academy 1972(60, repr.); Yale, *English Landscape 1630–1850* 1977(73 repr.)

Lit: A. J. Finberg, "The Development of British Landscape Painting in Watercolours," *The Studio* (Winter 1917–18), repr. pl. 2; Bell and Girtin, no. 147v; Hawcroft 1971, p. 19, no. 28

Coll: C. Morland Agnew; C. Gerald Agnew; D. Martin Agnew; Messrs. Agnew, from whom bt. by Paul Mellon, 1967

B1977.14.4635

Bell and Girtin recorded seven versions of this subject (the last [vii in the following list] appears in the Supplement); Hawcroft lists a total of nine. These are: i in the Fitzwilliam Museum; ii in the Tate Gallery (repr. Hawcroft 1971, pl. 28); iii in the Ashmolean Museum (repr. Bell and Girtin, pl. XIVb); iv Whitworth Art Gallery, Manchester; v Yale (the present drawing); vi Yale (no. 134 below); vii Leeds City Art Gallery (repr. Oppé 1952, pl. 41); viii formerly in the collections of Leslie Wright and Mrs. Dorian Williamson; ix was in the collection of H. G. Balfour. A tenth version has recently come to light; it is considerably smaller than the rest, measuring 362 x 530 mm. None of these various sheets is dated, but they all seem to derive from a pencil outline study on a large sheet in the Soane Museum Album (no. 14; Bell and Girtin, supplement no. 149b). This study seems to have provided the basis for a further subject, of which only one version is recorded (Victoria and Albert Museum, Dyce 705, repr. Martin Hardie 1966, pl. 115). Bell also associates it with the closer view of Lake Albano in the Girtin collection (Bell and Girtin, no. 149; repr. B.F.A.C. 1923, pl. XXXVIII), which is compositionally similar to sheet 2 in the Soane Album, apparently a view on Lake Nemi. The problem of dating this long series of variants and repetitions has not been tackled, though White says that the work under discussion is "a more highly finished and probably later repetition of [no. 134]." He adduces as further evidence the fact that no. 134 "is much freer in execution, and the artist has not always followed his pencil underdrawing when applying watercolor afterwards. Moreover, the color is fresher, and the subtly varying tones from the use of a restricted palette provide a greater contrast between the receding planes of the landscape. The present drawing [that is, no. 93] is more consciously pictorial. . . ." These observations are reasonable but they have led to the wrong conclusions. The richness and power of effect achieved in the present drawing are typical of the artist's first finished watercolors of the Italian stay of 1776–79, dependent as they are on a very careful and gradual building up of tonal resonance by means of tiny strokes which ultimately dictate the forms of the masses they create. The slight pencil underdrawing is tentative and lacks rhythm, whereas in no. 134 the easy, rhythmic formulas of foliage etc. are much in evidence through a more transparent wash and looser accretion of brushstrokes. That style of outlining in pencil was fully evolved by the time of Cozens's second tour to Italy

and is to be found in the traced outlines of the Beaumont album (see p. 43 below). Earlier, the technique had not been mastered; Cozens's outline drawing was more exploratory and nervous. It is to be found, reinforced with pen, in the *Tivoli* (no. 91), while hesitant and unformed outlines beneath a richly built-up mass of brushstrokes are to be found in the *Lake and Town of Nemi*, no. 94. The increase in mechanical skill, combined with a loss of overall intensity, clearly bespeaks progress from original idea to copy and repetition. The sheet under discussion is particularly remarkable for the effect of sparkling reflections from the foreground bank, an intricate and "Claudian" device that looks forward to the more facile techniques of John Glover (1767–1849). Altogether, this drawing is the richer, more densely worked and less schematic of the two Yale versions. There is greater variety of color; while the treatment of foliage is quite different—more minute and flecked, as opposed to the fan-shaped outlines of the other. The filtering of light through the trees at the lower left is a hazy mist, whereas in no. 134 it is a formula of thinner gray wash. The distant tower in the center of the composition is in a plane of warm rich gray contrasted with other planes of subtly varied color; in the other everything is more easy and obvious. The clouds are shadowed with fine striations of dark gray, not, as in no. 134, left as pale areas. But in both the pivotal central motif is the same: the white and yellow of cloud and sky beneath the arching bough remains Cozens's seminal idea, which he presents in each case as forcefully as possible.

94. The Lake and Town of Nemi.

*c.*1779 Plate 38

Watercolor over pencil on wove paper 14⅜ x 20⁹/₁₆ (362 x 520)

Exh: London, Grosvenor Galleries, *Water-colour Drawings by deceased Masters of the British School* 1877–78(41); London, Whitechapel Art Gallery 1906(47); London, Grafton Galleries, *Exhibition of Old Masters* 1911(177); London, Tate Gallery 1921; B.F.A.C. 1923(54 as "The Lake of Albano and Monte Cavo," repr. pl. XXXI); Amsterdam, Stedelijk Museum, *British Art* 1936(203); Manchester, Whitworth Art Gallery, *Watercolour Drawings by J. R. Cozens and J. S. Cotman* 1937(70); Paris, Louvre, *La Peinture Anglaise* 1938 (193); Paris, Orangerie, *Le Paysage Anglais* 1953(38); Sheffield, Graves Art Gallery, *Early Water-colours from the Collection of Thomas Girtin Jnr.* 1953(21); London, Royal Academy, *The Eighteenth Century* 1954–55(525); Manchester, Whitworth Art Gallery, *Alexander and John Robert Cozens* 1956(41); Norwich Castle Museum, *Eighteenth-century Italy and the Grand Tour* 1958(21); Leeds City Art Gallery, *Early English Watercolours* 1958(21); London, Royal Academy, *The Girtin Collection* 1962(14); Reading Museum and Art Gallery, *Thomas Girtin and some of his Contemporaries* 1969(7); New York, Wildenstein, *Romance and Reality* 1978(22; repr. pl. 43)

Lit: Cosmo Monkhouse, *The Earlier English Water-Colour Painters,* 2d ed. (London, 1897), p.40, repr.; T. Ashby, "Topographical Notes on Cozens," *Burlington Magazine* 45 (1924): 194; Bell and Girtin, no. 144v, repr. pl. XIIIa; Oppé 1952, pp. 148–49; Hawcroft 1971, p. 19, no. 26

Coll: Dr. T. C. Girtin; by descent to Tom Girtin; John Baskett, from whom bt. by Paul Mellon, 1970

B1977.14.361

A study of this subject in pencil, with some blue watercolor, is sheet 3 of the Soane Museum Album. Other finished watercolors based on the study are dated 1778 (collection of Sir Edmund Bacon), 1779 (Wright collection, Birmingham Museum and Art Gallery, repr. Andrea Rose, *English Watercolours and Drawings: The J. Leslie Wright Bequest,* 1980 p. 24, no. 22), and 1791 (Birmingham Museum and Art Gallery; exh., Hawcroft 1971, no. 26). Another (Bell and Girtin, no. 144 iv) was in the F. G. Nettlefold collection (repr. Grundy, *Catalogue of . . . the Nettlefold Collection,* 1933, vol. 1, opp. p. 170); Bell and Girtin record their doubt that the "traditional" reading of a date on this version as 1776 is correct (the inscription is not recorded by Grundy). It seems clear that the date of the earliest versions of the subject is 1778, and since the Yale drawing is perhaps the finest of the group it should perhaps be placed first in date. With its sombre, twilight coloring and nervous massing of tones it is close to the early *Lake Albano* (no. 93); its extremely restricted palette, relying heavily on black and dark grays, though considerably removed from the bright color of the *Tivoli* of 1778 (no. 91) places it in the first and finest group of Roman watercolors. Ashby, in changing the identification of the subject from the traditional "Lake of Albano and Monte Cavo" (with the convent of Palazzuola), noted that the long arcade which is so prominent in the design is an invention. This is confirmed by the Soane sketch, which Ashby did not know and which does not include the arcade. There is a reminiscence of this subject in an etching in the British Museum (1867-12-14-401), there ascribed to Alexander Cozens, which is unquestionably in the typical drawing style of John Robert, though Oppé (1952, p. 115) suggests that it may be an imitation by a follower. This is implausible, given the fluency and conviction of the needling. The plate is engraved with the name *Cousens* as is a second plate of similar size showing the Castel Sant' Angelo in Rome. This, however, is in a very different style and is more likely to be the work of Alexander (see no. 3). The Yale watercolor has been called "the best known of all [Cozens's] drawings"; its exhibition history substantiates that claim though the *Lake Albano* and *Galleria di Sopra* series would seem more instantly identifiable with his typical style. The brooding dimness of the subject renders the *Nemi* one of the most strikingly personal and unexpected of his works, while its successful exploration of the effect of plunging the eye steeply down a foreground cliff anticipates compositional ideas favored by Turner. Compare the view of the same scene by Jakob Philipp Hackert, no. 147.

95. Near Chiavenna in the Grisons. *c.*1779 Plate 38

Watercolor over pencil on wove paper 16¹³/₁₆ x 24⁷/₁₆ (426 x 621)

Exh: Manchester, Whitworth Art Gallery, *Watercolour Drawings by J. R. Cozens and J. S. Cotman* 1937(82); London. Messrs. Agnew, *Loan Exhibition of Watercolour Drawings by John Robert Cozens* 1947(1); New York, Pierpont Morgan Library, and London, Royal Academy, *English Drawings and Watercolors 1550-1850* 1972(62 repr.); Yale, *English Landscape 1630-1850* 1977(71, repr. pl. LXXXVI)

Lit: Bell and Girtin, no. 47 ii

Coll: F. J. C. Holdsworth; C. Morland Agnew; Hugh L. Agnew; Lady Mayer; Agnew, from whom bt. by Paul Mellon, 1971

B1977.14.4634

This is the only finished watercolor of the subject that is recorded. It is based on a study in the Lupton collection, Leeds City Art Gallery (13.86/53), which is inscribed with the location as given in the title, and must have been made during or immediately after the journey through Switzerland in 1776 (see p. 38). In developing the study as a large watercolor Cozens has altered the forms of the rocks in a highly

idiosyncratic way, giving them angular shapes strongly reminiscent of his father's work. This composition could indeed be one of Alexander's abstract fantasies and is among the few works of John Robert to reflect clearly his influence. The height of the distant mountain and the scale of the whole design are exaggerated; the dark, cavernous scene has been compared with other subjects treated by John Robert, including the various versions of the *Grotto in the Campagna* (Bell and Girtin, no. 134 and pl. IXb, and Hawcroft 1971, no. 21) and the British Museum's *Mount Etna from the Grotta del Capro* (Payne Knight Bequest, Oo.4–38), which was worked up from a drawing by Charles Gore and exploits a moonlight effect. All these subjects were probably executed during or shortly after Cozens's first visit to Italy; the Gore drawing, which served as the basis for his *Grotta del Capro*, is dated 1777, and it is to be presumed that Cozens made his initial outline sketch from it (Soane Museum Album, no. 13) while he was in Rome and perhaps finished the watercolor there as well (see Oppé 1952, p. 110). This rather contradicts the conclusion reached by Oppé that Cozens and Payne Knight ceased to be closely associated (p. 109); Payne Knight continued to commission work (asking Cozens to use notes made by Gore on the Sicilian journey), though it is true that not much of this was completed, and the bulk of the Sicilian material was worked up in England by Thomas Hearne (see no. 163). The "grotto" and "cavern" drawings of these years may also be related to a separate set of subjects by Cozens, the three roundels which appear to represent scenes from an Inferno—torrents of water and rising flames among constricting patterns of subterranean rock. Two have single figures, infernal angels apparently, while the third seems to require such an addition. Oppé (p. 126) conjectures that Cipriani was responsible for these and points out that Beckford employed Cipriani to illustrate some of his writing. He inclines, however, to associate the group with the roundel of *Hannibal* usually dated to the year in which the painting of the same subject was exhibited in London, 1776 (see Introduction, p. 9). Here already the angular rock formations of *Chiavenna* are prominent. See remarks on this under no. 135.

96. On the Lake of Nemi. 1780–83 Plate 39

Pencil and watercolor on laid paper 8³⁄₁₆ x 11⅞ (209 x 301)

Exh: Washington, National Gallery of Art, *English Drawings from the Collection of Mr. and Mrs. Paul Mellon* 1962(21); Richmond, Virginia, Museum of Fine Arts, *Painting in England, 1700–1850* 1963(64); New York, Pierpont Morgan Library, and London, Royal Academy, *English Drawings and Watercolors 1550–1850* 1972–73(63, repr.); Yale, *English Landscape 1630–1850* 1977(75, repr.)

Lit: Bell and Girtin, no. 142 and pl. XIIa

Coll: Sir Thomas Barlow; by descent Sir Thomas D. Barlow; Colnaghi, from whom bt. by Paul Mellon, 1961

B1975.4.1482

The warm dark coloring of this sheet suggests that it belongs with the drawings of Cozens's first Italian visit, ca. 1779–80, though the rather stylized pencil outlines on which it is based are more typical of the second tour. It does not appear to have been copied or to derive from any other version of the subject. Bell and Girtin point out that its size (unusually small for a finished watercolor by Cozens) indicates that it is part of a series, of which some items are dated 1780 while one, on similar paper to this, must have been executed after 1783. White associates the subject with a pencil drawing in the British Museum (1938-4-19-1) which is inscribed *Part of Nemi from*

the Banks of the Lake and dated *Septᵣ 1777*; this shows only the tops of the cliffs with their trees and buildings and is in fact very different from the finished design in important respects, though the central group of buildings is the same in both works. A watercolor by a member of Dr. Monro's circle in the Leeds City Art Gallery (Lupton collection, repr. Bell and Girtin, pl. XIIb) combines features of both Cozens's outline sketch and his watercolor.

The Beaumont Album

Nos. 97–128 in this exhibition are taken from an album of 215 drawings known as the "Beaumont Album" since it was in the family of Sir George Beaumont (see no. 167) from about the time of J. R. Cozens's death until 1967, when it was acquired by Paul Mellon. It had for some years been deposited on loan in the British Museum Print Room. Beaumont may have bought it at a sale of the artist's effects in 1794; he was intimately concerned in the measures taken to provide for Cozens and his family after his mental collapse and so would have had plenty of opportunity to become possessed of such an item. The album was discovered at the Beaumont family seat, Coleorton Hall, Leicestershire, in 1926 by the Hon. Andrew Shirley and Thomas Girtin. Its pages are watermarked *1794*, which precludes the possibility of the album having been assembled by Cozens himself. The drawings were mounted haphazardly without regard to chronology or any other sequence. Many of the sheets are of thin paper which has been used for tracing the outlines of drawings made elsewhere—notably in the Beckford sketchbooks. These are seven surviving books of drawings made during Cozens's Italian visit of 1782–83. They passed into Beckford's possession, presumably about the time of Cozens's mental failure, and remained with his descendants until sold by the Duke of Hamilton at auction in 1973 (see below). Their contents are catalogued by Bell and Girtin, though not in a continuous sequence corresponding to the order of the drawings in the books. The Sotheby sale catalogue supplied reproductions of all the drawings.

Some of the tracings in the Beaumont album have been varnished, presumably to preserve the drawings and not, as has been thought, to render the paper transparent enough to trace through, since the varnish can be removed by washing while the pencil drawing is left securely behind on the paper. Some sheets are of thicker paper and are also varnished. Oppé recognized three clearly separable groups of drawings. The largest is that of the tracings from the Beckford sketchbooks, including all the subjects from the first three and the last two books, but only some from book 4 and two from book 5. These tracings were presumably made at some point shortly after Cozens's return to England late in 1783. They have been given that date for convenience but they could obviously have been done later; White suggests that Cozens copied them when the books were handed over to Beckford, so that he could continue to use the designs. Unfortunately the date of that transaction is not known. A second group of tracings is distinguished by the letters "K.K." inscribed on every sheet, together with numbers from 1 to 39. The initials have not been deciphered. One drawing of this series is an English subject (no. 102). In general, the style of these tracings is clumsier than that of the "Beckford" group, and they all date from somewhat earlier no doubt. Since many of them are derived from Italian subjects which Cozens almost certainly drew on the spot they cannot belong to the period before the first continental tour, unless,

as seems possible, they are traced from drawings by John Robert's father, made when he was in Rome in 1746; this would explain the unexpected mood of fantasy found in some of the subjects (e.g., nos. 97, 99). There are strong suggestions of the early technique of Alexander Cozens in a tracing such as the *Rocky ravine* (no. 105). Only one drawing in the album is dated; it is not a tracing, but a sketch made on the spot at Terracina in 1777 (see no. 125). Oppé placed this drawing with the third series, a group of subjects very often on rather thicker paper, usually varnished, and considered by Bell and Girtin to be by a different hand, less free and assured. Oppé felt that the presence of this sketch of Terracina confirmed the authenticity of the rest, but this does not seem to be a logical conclusion, since it is on different paper and has no particular stylistic resemblance to them. The dated sheet is certainly by Cozens, but it cannot prove or disprove the authorship of the others, and the uncertainty recorded by Bell and Girtin remains. Some of the subjects in this third category were copied by Dr. Monro's pupils (see p. 59), but Cozens himself seems never to have made watercolors from them. Three are inscribed "from C. Gore Esq" (see no. 100), and so the series obviously belongs with the output of the associates of Payne Knight and Gore in Italy in 1776–77. Bell and Girtin traced a route recorded in these drawings from Lyons through Pont de Beauvoisin and Saint Thibaut de Coux, Chambéry, Montmelian, Maltaverne, Aiguebelle, La Chapelle, and Saint Jean de Maurienne to the Mont Cenis. It is possible that this route was followed in reverse by Cozens when he returned from Italy in 1779 (he went different ways on all the other occasions that he traveled to or from Italy); but, as Bell and Girtin pointed out, the inscriptions on the drawings suggest that the journey was being made from north to south since the towns are always mentioned in that order. Others in the series are views along the Mediterranean coast from Genoa to Leghorn, which was perhaps Cozens's route to Rome in 1776; but there are others inscribed *Monaco* (B1977.14.4531,4544) which suggest that the voyage started at Marseille, which is incompatible with the route taken through Switzerland by Payne Knight. These tracings are executed in a rather sharp, tight manner, with disjointed strokes of the pencil, angular rather than flowing. The handwriting of the inscriptions is similar to Cozens's, though slightly tighter than usual. On balance it seems probable that they are his own work, though perhaps traced at a different time and under different circumstances from the others.

There are a few sheets in the album unrelated to these sequences; they are tracings which have been redrawn in reverse on the backs of the sheets, in pencil or red chalk, and worked up with a pencil; it has long been noted that they have the appearance of preparatory drawings for soft-ground etchings. Only recently, however, has a print of one of these subjects come to light (see no. 128). Its existence suggests that other plates were completed, making a series of Italian views analogous to the etched plates made, for instance, by William Marlow (1740–1813) during his stay in Italy in the 1760s. The process of soft-ground etching did not come into vogue until the 1770s; John Robert employed it again in his series of studies of trees (see comments under no. 18).

See Bell and Girtin, pp. 6–8; Oppé 1952, p. 124, note; Yale, *English Landscape 1630–1850*, 1977, pp. 47–8, no. 76; and Sotheby, London, Sale Catalogue of the *Seven Sketchbooks of John Robert Cozens*, 29 November 1973, with an Introduction by Anthony Blunt.

97. An Obelisk with roofs and trees in the distance. *c*.1780 Plate 40

Pencil on laid paper 5^1/$_{16}$ x 5^{15}/$_{16}$ (129 x 150)
Inscr. top right: *KK/34*
Album no. 8
Lit: Bell and Girtin, no. 129
B1977.14.4419

98. Broken Side of the Amphitheatre at Rome. *c*.1780 Plate 40

Pencil on white laid paper, varnished 6^5/$_{16}$ x 10 (160 x 254)
Inscr. top left: *Broken Side of ye Amphitheatre Rome* and *KK/28*
Album no. 10
Lit: Bell and Girtin, no. 112
B1977.14.4421

99. Distant view of an imaginary city. *c*.1780 Plate 40

Pencil on laid paper 5¾ x 7⅜ (147 x 187)
Inscr. top right: *KK/1*
Album no. 6
Lit: Bell and Girtin, no. 172 (as "Classical Composition")
B1977.14.4417

100. Fanale di Villa Franca. *c*.1780 Plate 58

Pencil on laid paper 4⅝ x 7^7/$_{16}$ (118 x 189)
Inscr. recto: with title; and verso: *Traced from a sketch of /C. Gore Esqr*
Album no. 13
Lit: Bell and Girtin, no. 57
B1977.14.4423

The basis for the Monro school copy, no. 168. This is one of the three subjects in the Beaumont album which are annotated with Charles Gore's name as the artist of the original from which they were traced. They are among the drawings which may be in a hand other than that of J. R. Cozens.

101. A waterfall. *c*.1780 Plate 41

Pencil on white laid paper, varnished 8⅝ x 6½ (218 x 162)
Inscr. verso: *KK 9*
Album no. 19
Lit: Bell and Girtin, no. 174
B1977.14.4430

102. The Roman Arch at Canterbury. *c*.1780(?) Plate 41

Pencil on laid paper 8⁵/₁₆ x 9⁹/₁₆ (210 x 242)

Inscr. lower left: with title, and top right: *KK /6*

Album no. 33

Lit: Bell and Girtin, no. 446

B1977.14.4444

Bell and Girtin point out that this is the only English subject in the Beaumont album and suggest that it may be the earliest work by Cozens in their catalogue; i.e., that it preceded the continental tour of 1776. Its style, however, is consistent with other tracings of the *KK* series which were evidently done after the first Italian journey and he may well have made the drawing in England between the two Italian tours, or indeed even later; the style of the drawing in the tracing is consistent with that of others done about 1780.

103. Castel Gandolfo. *c*.1780 Plate 42

Pencil on laid paper 5⅛ x 7⅜ (130 x 187)

Inscr: *Castel Gondolfo* and top right: *KK /11*

Album no. 29

Lit: Bell and Girtin, no. 150

B1977.14.4440

A composition very much in the manner of Alexander Cozens's landscape designs in the Roman sketchbook (no. 2), though the scene is recognizable as a view across Lake Albano, as the inscription suggests. A large watercolor of the view across the lake, though without Castel Gandolfo, is in the Victoria and Albert Museum (D.710), Bell and Girtin, no. 146, repr. *Burlington Magazine* 45 (1924), pl. 195.

104. In the Garden of a Villa. *c*.1780 Plate 42

Pencil on white laid paper, varnished 5⅜ x 6⅜ (136 x 162)

Inscr: *KK 30*

Album no. 31

Lit: Bell and Girtin, no. 127

B1977.14.4442

105. A rocky ravine. *c*.1780 Plate 42

Pencil on laid paper 10⁵/₁₆ x 7 (262 x 178)

Inscr. top right: *KK /13*

Album no. 34

Lit: Bell and Girtin, no. 176

B1977.14.4445

106. Waterfall at Terni. *c*.1780 Plate 43

Pen and black ink on thin laid paper 9⁵/₁₆ x 7 (235 x 177)

Inscr. with title

Album no. 71

Lit: Bell and Girtin, no. 92

B1977.14.4482

107. The Convent of --------- at Vietri. *c*.1783 Plate 44

Pencil on white laid paper, varnished 9¹⁵/₁₆ x 7⁷/₁₆ (252 x 188)

Inscr. with title and: *Sepᵗ 24*, and top right: *43*

Album no. 43

B1977.14.4454

A tracing from the drawing in the Beckford sketchbooks, III, 13, Bell and Girtin, no. 272; a finished watercolor of the subject was owned by Beckford, and a Monro school copy is in the Turner Bequest, TB CCCLXXIV-11.

108. Convent of S. Martino and Castello di Sant'Elmo from the Mole, Naples. *c*.1783 Plate 44

Pencil on white laid paper, varnished 6¾ x 11⅜ (171 x 289)

Inscr: *Convent of Sᵗ Martini & the Castle of Sᵗ Elmo, from the Mole/Naples Octᵗ 16* and *52*

Album no. 42

B1977.14.4453

Traced from a sheet in the Beckford sketchbooks, III, 22 (Bell and Girtin, no. 280).

109. Italian landscape. *c*.1780 Plate 43

Pencil on white laid paper, varnished 6⅝ x 8¾ (168 x 222)

Inscr. top left: *KK /12*

Album no. 40

Lit: Bell and Girtin, no. 175

B1977.14.4451

A reminiscence of the Roman landscapes made by Alexander Cozens in 1746, this drawing also seems to reflect the influence of some French draftsmen—particularly, perhaps, Watteau.

110. Naples from Sir William Hamilton's Villa, Portici. *c*.1783 Plate 45

Pencil and red chalk on laid paper 7⅜ x 10⁷/₁₆ (188 x 265)

Inscr: *Naples from Sir W. Hamilton's Villa Portici*

Album no. 49

Lit: Bell and Girtin, no. 240

B1977.14.4460

The subject is traced in reverse from a sketch in the Beckford books, II, 9, which is dated 19 August [1782] and inscribed with notes identifying features in the view. This and nos. 126, 127 and 128 are studies made in preparation for etchings; see no. 128. A finished watercolor of the subject is in the Victoria and Albert Museum (Hawcroft 1971, no. 54, repr.).

111. At Portici. *c.*1783 Plate 45

Pencil on white laid paper, varnished 7⅜ x 9⅝ (187 x 244)

Inscr: *At Portici—August 9—evening.* and top right: *5*

Album no. 59

B1977.14.4470

A tracing from the drawing in a Beckford sketchbook, II, 6.

112. Monte Circeo from the road between Terracina and Villetri. *c.*1783 Plate 45

Pencil on white laid paper, varnished 6³⁄₁₆ x 9⁹⁄₁₆ (157 x 243)

Inscr: *Monte Circello from the road between Terracina & Veletri - Dec.ʳ 9* and top right: *22*; lower right: *B5*

Album no. 94

B1977.14.4505

Traced from the drawing in the Beckford sketchbooks, V, 24 (Bell and Girtin, no. 347), which is inscribed similarly.

113. The Pagliaro in the Myrtle plantation at Sir William Hamilton's Villa, Portici. *c.*1783 Plate 46

Pencil on white laid paper, varnished 5⅞ x 9¹¹⁄₁₆ (149 x 245)

Inscr: *The Pagliaro in the Myrtle Plantation at S.ʳ W Hamilton's Villa Portici / August—30—* and lower right: *20*

Album no. 102

B1977.14.4513

A tracing from the drawing in the Beckford sketchbooks, II, 22 (Bell and Girtin, no. 251), which is similarly inscribed but with *Myrtle Grove* for *Myrtle Plantation*. Another *pagliaro*, or thatched hut, is the subject of a finished watercolor in the Victoria and Albert Museum (Bell and Girtin, no. 307; Hawcroft 1971, no. 67, repr.).

114. Part of Padua from the walls. *c.*1783 Plate 46

Pencil on white laid paper, varnished 7¾ x 10¹⁄₁₆ (196 x 255)

Inscr: *Part of Padua from the walls — the mountains of the Tirol*

— / *June 18* and top right: *18*

Album no. 117

B1977.14.4518

A tracing from the drawing in the Beckford sketchbooks, I, 20 (Bell and Girtin, no. 214), which was worked up into a finished watercolor now in the Tate Gallery (T 983, Hawcroft 1971, no. 48, repr.).

115. Cypress in the garden of the Franciscans at Salerno. *c.*1783 Plate 47

Pencil on white laid paper, varnished 12⅜ x 7⅜ (321 x 189)

Inscr: *Cypress in the Garden of the Franciscans — Salerno / near 800 years old / Sept.ʳ 22.* and top right: *39*

Album no. 118

B1977.14.4529

A tracing from a drawing in the Beckford sketchbooks, III, 8, verso —9 (Bell and Girtin, no. 268). A Monro school copy of the subject is in the Turner Bequest, TB CCCLXXV–9.

116. From Mirabella the Villa of Count Algarotti on the Euganean Hills. *c.*1783 Plate 46

Pencil on white laid paper, varnished 7⁵⁄₁₆ x 9⅞ (186 x 251)

Inscr: *From Mira-bella — the Villa of Count Algarotti — / on the Euganean Hills — 10 Miles from Padua / June 19.* and top right: *20*; in the drawing: *wood with houses interspers'd; wood*

Album no. 127

B1977.14.4538

Traced from a drawing in one of the Beckford sketchbooks, I, 22, which is similarly inscribed (Bell and Girtin, no. 216). A finished watercolor of the subject is in the Victoria and Albert Museum (120-1894; Hawcroft 1971, no. 49, repr.).

117. Near Aiguebelle. *c.*1783 Plate 47

Pencil on white laid paper 7³⁄₁₆ x 9⅞ (182 x 250)

Inscr: *Near Aguebelle — Oct.ʳ 22.* and top right: *9*; also, in various places: *wood*

Album no. 122

B1977.14.4533

Traced from a drawing in one of the Beckford sketchbooks, VII, 10 (Bell and Girtin, no. 422), which is similarly inscribed.

118. From the top of the Arena, Verona. *c.*1783 Plate 47

Pencil on white laid paper, varnished 7³⁄₁₆ x 9¾ (183 x 249)

Inscr: *From the Top of the Arena — Verona — June 10.* and top right: *15*

Album no. 134

B1977.14.4545

Traced from a drawing in one the Beckford sketchbooks, I, 17 (Bell and Girtin, no. 210), which is similarly inscribed.

119. The Wall of Naples near Ponte Nuovo. *c.*1783 Plate 48

Pencil on white laid paper, varnished 5¹⁵/₁₆ x 9⁹/₁₆ (150 x 243)

Inscr: *Wall of Naples near Ponte Nuovo Octr 19* and *59*

Album no. 139

B1977.14.4550

Traced from a drawing in one of the Beckford sketchbooks, III, 29 (Bell and Girtin, no. 293), which is similarly inscribed. A Monro school copy is recorded by Bell and Girtin, who state that it is now known only through a further copy by Alexander Monro in the Girtin collection.

120. Near Raito on the Gulf of Salerno. *c.*1783 Plate 48

Pencil on thin white laid paper, varnished 7½ x 9¹⁵/₁₆ (190 x 252)

Inscr: *Gulf of Salerno Septr 26* and top right: *37*

Album no. 150

B1977.14.4561

Traced from a drawing in one the Beckford sketchbooks, III, 7 (Bell and Girtin, no. 265), which is similarly inscribed, with the addition of *Near Raito* and a note indicating the site of Paestum. A finished watercolor of the subject was in the Beckford sale, lot 45, bt. Hoare, and described as "spirited."

121. In the Tyrol. *c.*1783 Plate 48

Pencil on white laid paper 6¾ x 9¹⁵/₁₆ (171 x 252)

Inscr: *Tirol — June 5* and top right: *3*, below: *short grass enamell'd with flowers.* and *snow*; also *Larch firs*

Album no. 155

Lit: Bell and Girtin, no. 196

B1977.14.4566

A tracing from a drawing in one of the Beckford sketchbooks, I, 3, which lacks all the inscriptions except *In the Tirol* and the date.

122. Grotto di Posilippo. *c.*1783 Plate 49

Pencil on thin white laid paper 9½ x 6⅞ (241 x 175)

Inscr: *Grotta de Paussilippo — Octr 12* and top right: *51*

Album no. 164

B1977.14.4575

A tracing from a drawing in one of the Beckford sketchbooks, III, 21 (Bell and Girtin, no. 279), which is similarly inscribed. The sense of the original drawing is lost in the pure outline of the tracing: there, the washes indicate that the small opening at the bottom center is at the other end of the tunnel-like grotto, while the left-hand wall faces the viewer, with shadow cast obliquely across it.

123. At Portici *c.*1783 Plate 49

Pencil on white laid paper, lightly varnished 6¹¹/₁₆ x 10⅝ (169 x 269)

Inscr: *At Portici — Sept! 6* and *Granatello*

Album no. 161

B1977.14.4572

A tracing from a drawing in one of the Beckford sketchbooks, II, 27 (Bell and Girtin, no. 256), which is inscribed: *On the Sea Side at Portici.* A Monro school copy is recorded by Bell and Girtin (John Drinkwater, sale, Christie 16 February 1934, lot 38).

124. Vietri and Raito. *c.*1783 Plate 49

Pencil on white laid paper, varnished 7½ x 16¼ (190 x 413)

Inscr: *Vietri & Raito — Sept! 20* and top right: *34*; squared and numbered along top and bottom edges

Album no. 178

B1977.14.4589

A tracing from a drawing in one of the Beckford sketchbooks, III, 3 verso-4 (Bell and Girtin, no. 262; repr. pl. XXb), one of the grandest of the sketches of 1782, with much use of dark wash. It is similarly inscribed. A finished watercolor of the subject is in the Barnsley Art Gallery. The view is similar to one of which Cozens made many versions, based on the Beckford sketch, III, 11 (Bell and Girtin, no. 270, repr. pl. XXIIa).

125. From the Inn at Terracina. *c.*1783 Plate 51

Pencil on white laid paper, varnished 7⅜ x 9⅞ (187 x 250)

Inscr. with title and: *July 5*, and top right: *29*

Album no. 201

Lit: Bell and Girtin, p. 55, no. 228

B1977.14.4612

A tracing from a drawing in one of the Beckford sketchbooks, I, 31 (Bell and Girtin, no. 228), inscribed *Near Terracina.* Compare the earlier drawing of the same view, also in the Beaumont album though not a tracing, dated 1777 (Bell and Girtin, no. 96, album no. 194). See Cozens's finished watercolor, no 129.

126. On the Coast of Salerno. *c.*1783 Plate 50

Pencil 7½ x 9¹¹/₁₆ (190 x 245)

Inscr. below: with title traced through in reverse from verso; verso: the same design, traced in reverse, and title

Album no. 210

Lit: Bell and Girtin, p. 60, no. 274

B1977.14.4621

The original sketch of this subject is in one of the Beckford sketch-books, II, 15. It is inscribed *On the Gulf of Salerno near Vietri* with the date *Sept* 27 (Bell and Girtin, no. 274). Two finished watercolors of the subject are known; one is in the Whitworth Art Gallery, Manchester (D17.1950; Hawcroft 1971, no. 59); the other is in the Metropolitan Museum of Art, New York (07. 283. 3). In this tracing the subject has been reversed; like nos. 110, 127, and 128, it is a preparatory study for an etching, though it lacks the red chalk outline characteristic of those drawings; see no. 128.

127. Isola Borromea, Lago Maggiore.
*c.*1783 Plate 50

Pencil and red chalk 7³⁄₄ x 9¹¹⁄₁₆ (197 x 246)

verso: the same subject in reverse; pencil

Album no. 215

Lit: Bell and Girtin, p. 77, no. 413

B1977.14.4626

Like nos. 110, 126, and 128 this is a preparatory drawing for a soft-ground etching, though no print of the subject is known. See no. 128. The red chalk outline has been traced (in reverse) from a drawing in one of the Beckford sketchbooks, VII, 1 (Bell and Girtin, no. 413), which is dated *Oct* 10 1783. Three finished watercolors of the subject are known; see Hawcroft 1971, no. 88; the work cata-logued there is repr. Sotheby 24 November 1977, lot 109.

128. Ariccia. *c.*1783 Plate 50

Pencil and red chalk 7¹¹⁄₁₆ x 9¹⁄₁₆ (195 x 230)

verso: the same design in reverse; pencil; inscr: *Larici near Albano*

Album no. 212

Lit: Bell and Girtin, no. 156

B1977.14.4623

Although the four tracings, nos. 110, 126 - 128, from the Beaumont Album have long been regarded as preparatory drawings for soft-ground etchings, no impressions of prints of any of the subjects have hitherto been identified. However, a soft-ground etching of this subject, *Ariccia*, has recently come to light; it was discovered in Paris and is now in a private collection in the U.S.A. It reproduces the subject as drawn on the verso of this sheet, which is clearly the correct sense as it is the verso which bears the title. The exhibited side shows the subject in reverse. The print is the same size as the drawing and seems to have been traced directly from the recto. It is trimmed to the edge of the subject and has no title. The existence of similar soft-ground etchings of the other three subjects in the series can be inferred, though the date at which the group was executed is doubt-ful. The plates were most probably made either during the Italian visit of 1782 - 3, or very shortly afterwards. Bell and Girtin suggest (no. 157) that another of the Beaumont tracings (Album no. 11) is a study of the dome of the church at Ariccia. It is numbered "K K 7," which indicates that it probably belongs to the first Italian tour rather than the second. An oil painting of Ariccia measuring 15⁵⁄₁₆ x

21³⁄₁₆, in an English private collection, follows the composition of the etching subject fairly closely, though while the buildings are disposed as in the print the arrangement of the repoussoirs corre-sponds more nearly to that of the reversed design. There is no other evidence that it is by John Robert Cozens.

129. A View from the Inn at Terracina, looking towards the rock pillar of the Pesco Montano.
1783(?) Plate 51

Watercolor over pencil on wove paper 10⁵⁄₁₆ x 14⁵⁄₁₆ (261 x 370)

Inscr. on old label (not the artist's hand): *at Terracina* —

Exh: B.F.A.C. 1923(26); Aldeburgh, Legion Hall, *English Draw-ings, 1700–1850* 1964(13)

Lit: Bell and Girtin, no. 228; Oppé 1952, p. 143 note

Coll: William Beckford, sale, Christie 10 April 1805(47); Sir Charles Robinson; Victor Rienaecker; Squire Gallery, 1934, from whom bt. by L. G. Duke; Van Oss; sale Christie 1944 bt. Sagers; anonymous sale Sotheby 20 November 1963(50) bt. Colnaghi, from whom bt. by Paul Mellon

B1975.4.1691

At Beckford's sale in 1805 three views of Terracina were disposed of. Lot 12 was called a "View of Part of Terracina", lot 47 a "View of Terracina - a grand and highly finished Drawing" and lot 71 simply "View at Terracina." These are respectively Bell and Girtin nos. 229, 228, and 230, and no. 229 is stated by them to be based on a sketch on p. 32 of the first of the Beckford sketchbooks, showing "The town on the hill-side against a stormy sky." If the Yale sheet is indeed to be identified with the "grand and highly finished Drawing" of lot 47, it must have lost much of its quality through fading, since it now seems lacking both in grandeur and finish, though it is still a work of great subtlety. It is based on a sketch in a Beckford sketchbook (I, 31), a tracing from which is exhibited here (no. 125). Cozens had already drawn the same view in 1777 (Beaumont album, B1977.14.4605), though giving it a somewhat different appearance and introducing a coach and horses at the foot of the Pesco Montano. A Monro school copy of the subject is in the Turner Bequest, TB CCCLXIII–59.

130. Monte della Madonna near Arqua.
1783(?) Plate 53

Pencil and watercolor on laid paper 10³⁄₁₆ x 14³⁄₄ (260 x 375)

Inscr. on back of original mount in pen and brown ink (not the artist's hand): *Monte della Madonna near Arqua the residence of Petrarch* and, in another hand, in pencil: *Cozens*

Exh: Cambridge, Fitzwilliam Museum, *Drawings by the Early English Water-colourists*, 1920(41); Tokyo, Institute of Art Re-search, 1929(repr. pl. XI); London, Royal Academy, *The Girtin Collection* 1962(21)

Lit: Bell and Girtin, no. 219; Oppé 1952, p. 114 and note

Coll: William Beckford, sale, Christie 10 April 1805(41) bt. Hoare; Dr. T. C. Girtin; Mrs. Rogge, by whom presented to Thomas Gir-tin; by descent to Tom Girtin; John Baskett, from whom bt. by Paul Mellon, 1970

B1975.3.1001

Cozens's pencil outline drawing of this subject, washed with grey, is on f.25 of the first Beckford sketchbook; it is inscribed *Monte della Madonna near Arqua the Residence of Petrarch — Euganean hills* and dated *June 19*. In the album of tracings the subject (no. 199) is titled: *Monte della Madonna near Arqua the residence of Petrarch from the Hill the Convent surrounded by fir & cypress Euganean Hills/ June 19*; it is also inscribed with the number *23*. The finished watercolor is typical of the most richly worked of the set of drawings that Cozens completed for Beckford from his notes in the sketchbooks; it makes use of a coarse laid paper that is found in many examples from the series, though uncommon elsewhere in his output. The coloring, especially the warm, dense blue, is exceptionally powerful, an indication that the influence of Hackert was still at this date strong. Oppé objects that the inclusion of snow-covered peaks in this view results from a failure of memory on Cozens's part; but it is surely more likely to be a deliberate heightening of the landscape effect.

131. The Lake of Vico between Rome and Florence. 1783(?) Plate 53

Pencil and watercolor on laid paper 10⅛ x 14¹³/₁₆ (257 x 376)

Inscr. verso in pen and brown ink (not the artist's hand): *Lake of Vico. Between Rome and Florence.*

Exh: London, Tate Gallery, 1920; London, Royal Academy, *The Girtin Collection* 1962(22)

Lit: Bell and Girtin, no. 163

Coll: William Beckford, sale, Christie 10 April 1805(11) bt. anonymously; Thomas Girtin; by descent to Tom Girtin; John Baskett, from whom acquired by Paul Mellon, 1970

B1975.3.1002

Very close in type to the *Monte della Madonna*, no. 130, this drawing nevertheless displays striking variations from it in technique and mood. The pencil outline is much more pronounced, marking a shift away from the most strongly atmospheric works of Cozens's first style. The paper is much smoother than that of *Monte della Madonna*, and the even surface is exploited in the creation of extremely softly blended tertiary washes. These are in contrast with the firm and vivid blue that dominates the other sheet. The repoussoir that forms an impenetrable barrier across the view, beyond which everything is presented in simplified though subtly modulated washes, recalls the compositional procedures of Alexander Cozens; Alexander's practice is also suggested by the more linear treatment of cloud-forms (compare the shifting, elusive cloud patterns of no. 130).

132. The Parco degli Astroni. 1783(?) Plate 54

Pencil and watercolor on laid paper 10¼ x 14⅜ (260 x 371)

Inscr. on the back of original mount in pen and brown ink (not the artist's hand): *In the Astruni near Naples* and, in another hand, in pencil: *by Cozens Jnr.*

Exh: New York, Pierpont Morgan Library, and London, Royal Academy, *English Drawings and Watercolors 1550-1850* 1972-73(64, repr.)

Lit: Bell and Girtin, no. 313

Coll: William Beckford, sale, Christie 10 April 1805(82), bt. anonymously; Thomas Monro, sale, 2 August 1833(33; lot of three items), bt. Money; C. S. Bale, sale, Christie, 13 June 1881 (23); Prof. E. Davison Telford, sale, Sotheby 14 March 1962(62, repr.), bt. Colnaghi, from whom bt. by Paul Mellon

62/11/1/37

A more elaborate composition than the *Lake of Vico* or even the *Monte della Madonna* (nos. 131 and 130), this sheet is nevertheless one of the same series with them. It is similar in size and seems to have been executed at about the same date. In the fourth of the Hamilton Palace sketchbooks (ff.24–32) there are eight views in or near the Parco degli Astroni; one, f.24 (Bell and Girtin, no. 311), is inscribed *Astruni — The Crater of a Volcano* and *The King's hunting place for wild Boars*. It shows a view not unlike that of the present drawing and is annotated *The woods that are tinted — Ilex dark gn/The woods below oak & chestnut-brown & bright orange / The intervals between the wood light coloured earth*. The sketch on f.26 (Bell and Girtin, no. 313 repr.) provided the basis for the Yale drawing; it is annotated *Light Earth — no verdure* (in the foreground); *all bare earth — light Colour* (the rocks above, at right) and with the names of trees—*Ilax; Chesnut*. It also bears the date *11 November*. All the Astroni sketches are dated 11 November or 14 November (1782). In developing the subject, Cozens peopled the scene with figures appropriate to the "king's hunting place," and brought the whole composition to a level of finish that is high for the Beckford series, which is distinguished for its use of allusive, atmospheric washes and, often, rough paper (see no. 130), combined with an absence of human activity that results in a strong emphasis on sensuous effects of light and quiet, elegiac mood. The crispness of handling and bright, direct treatment of this sheet lend it a fresh and somewhat unexpected character.

133. The Lake of Nemi. c.1783–85 Plate 54

Pencil and watercolor on laid paper 14⅝ x 21¹/₁₆ (372 x 535)

Exh: Washington, National Gallery of Art, *English Drawings from the Collection of Mr. and Mrs. Paul Mellon* 1962(22); Richmond, Virginia, Museum of Fine Arts, *Painting in England, 1700-1850* 1963(63)

Coll: Sir Thomas Barlow; by descent to Sir Thomas D. Barlow; Colnaghi, from whom bt. by Paul Mellon, 1961

B1975.4.1481

At least three versions of this subject are known. One is recorded by Bell and Girtin (no. 143) as belonging to Mrs. Arthur Clifton. This may be identifiable with a sheet, dated on the reverse of the mount *1790*, which was on the London art market in 1979 (Leger Galleries, *A Selection of Oil Paintings and English Watercolours*, November-December 1979, no. 11, repr.). The third version is a drawing formerly in the collection of Dr. John Percy and now in the Victoria and Albert Museum (143-1890; Bell and Girtin, no. 437). This is severely faded and its authenticity has been questioned, but there seems every reason to accept it on the evidence of the pencil outlines, which are typical of Cozens's drawing in the mid-1780s. The Yale drawing has been called *Lake Albano*, but the subject is evidently a view of Lake Nemi with Monte Circeo in the left distance and Genzano to the right. The tower on the cliff at the left appears in *The Lake and Town of Nemi*, no. 94. The vigorous rhythms of the foliage in the central trees, together with the rich coloring and

well-defined pencil work, suggest a date either during or, more probably, soon after the second Italian visit.

134. The Lake of Albano and Castel Gandolfo.
c.1783–85 Plate 37

Pencil and watercolor on wove paper 17 x 24⅜ (432 x 619)

Inscr. lower left: *Jno Cozens* (partially trimmed off)

Exh: London, Grafton Gallery, *Old Masters* 1911(174); London, Tate Gallery, *The Romantic Movement* 1959(401); London, Royal Academy, *The Girtin Collection* 1962 (16); Yale, *English Landscape 1630–1850* 1977(72 repr.)

Lit: Bell and Girtin, no. 147 vi; Hawcroft 1971, p. 19, no. 28

Coll: Dr. T. C. Girtin; by descent to Tom Girtin; acquired by Paul Mellon, 1970

B1977.14.360

A repetition of the subject of no. 93, this version affords a comparison between Cozens's style during his first Italian tour and that of the period about his second visit. It is difficult to determine whether this work was executed before or after that journey, especially since it retains much of the mood of the earlier drawing it reproduces. For a full discussion of the stylistic differences between the two and for a list of other versions, see no. 93. The inscription in the lower left corner was possibly added by another hand. A label on the old frame is transcribed as follows: "This drawing by John Cozens, of Lac d'Albano, 15 miles S.S.E. of Rome, belongs to George Wyndham Girtin, grandson of the celebrated artist, Thomas Girtin—April 1857."

135. The Pays de Valais. c.1780–85 Plate 35

Watercolor over pencil, with some touches of red-brown ink or bodycolor on laid paper 14⅛ x 20½ (362 x 520)

Exh: Washington, National Gallery of Art, *English Drawings from the Collection of Mr. and Mrs. Paul Mellon* 1963(23); Richmond, Virginia, Museum of Fine Arts, *Painting in England, 1700–1850* 1963(65); Aldeburgh, Legion Hall, *English Drawings, 1700–1850* 1964(12); Colnaghi, London, and Yale University Art Gallery, *English Drawings and Watercolours from the Collection of Mr. and Mrs. Paul Mellon* 1964–65 (25, repr.) New York, Pierpont Morgan Library, and London, Royal Academy, *English Drawings and Watercolors 1550-1850* 1972–73(61); Yale, *English Landscape 1630–1850* 1977(70, repr.)

Lit: Hawcroft 1971, p. 13, no. 2

Coll: Col. W. Littlewood, C.M.G.; Agnew, 1961; acquired through Colnaghi by Paul Mellon

B1975.4.1920

There are two studies for this composition; one is a large, relatively well developed pencil study in the Soane Museum Album, no. 15. It is inscribed *Approach to Martinach Pais de Vallais August 30 – 1776* and signed by Cozens, who noted on the back of the sheet a list of the names, presumably, of patrons who had commissioned finished watercolors of the subject. They are: *Sr R. Hoare, Mr Wigstead, Mr Chalie, Mr Walwin, Mr Windham, Mr Sunderland, Dr Chelsum,* and *Sir Frederick Eden.* The last name seems to have been added later,

and, as Bell and Girtin note, the list may have been compiled gradually over a period, probably after Cozens's return to London in 1779. The other study is a monochrome ink and wash drawing in the Lupton collection, Leeds City Art Gallery (13.88/53), which is inscribed *Pais de Vallais,/ near the Lake of Geneva.* Bell and Girtin list five finished watercolors of the subject, one of which was in the Newall sale, Christie 13 December 1979(23, repr.); others are property of the National Trust, Stourhead (this [Bell and Girtin, no. 12iii] is the drawing commissioned by Sir Richard Colt Hoare as mentioned in Cozens's list); two are in the Birmingham City Art Gallery (one repr. B.F.A.C. 1923, pl. XXXIV, the other Leslie Wright collection; Bell and Girtin, no. 12 iv, vi); Bell and Girtin, no. v is in the Fitzwilliam Museum, Cambridge, repr. *The Studio* (1917), p. 15. With the exception of the Colt Hoare drawing at Stourhead, none of these versions has been traced back to its first owner on Cozens's list. On account of their dark coloring it may be that the Stourhead and Fitzwilliam versions are the earliest of the series. The pale coloring of the Yale version is unlike these or the rich dark palette of *Lake Albano* (no. 93) and other early Italian watercolors. The effect of the sun's rays is less emphatic than in other versions. Technically, however, the work is still loose and exploratory, lacking the formulas of, say, the Newall version, which would appear to have been done later. Like the *Chiavenna* (no. 95), this subject contains echoes of Cozens's Hannibal drawing, notably in the screen of foreground firs with the flat plain beyond.

136. The Bay of Naples from Capodimonte.
1790 Plate 55

Pencil and watercolor on wove paper 14⁹⁄₁₆ x 21 (370 x 533)

Inscr. on artist's mount, lower left: *J.Cozens 1790* and on back of mount: *Part of the Bay of Naples—*

Exh: London, Messrs. Agnew, *34th Annual Exhibition of Watercolour Drawings* 1900(49); Bristol City Art Gallery 1906(196)

Lit: Hawcroft 1971, p. 28, no. 70

Coll: James Orrock, from whom bt. by Agnew, 1899; Francis J. Fry; Lewis Fry; Agnew, from whom bt. by Paul Mellon, 1970

B1977.14.6131

Two other versions of this subject are known: a rather larger sheet in the British Museum (Henderson Bequest, 1878-12-28-9) and a smaller one in the National Gallery of Ireland (William Smith Gift, 2068). These were catalogued by Bell and Girtin (no. 325), to whom this version was not known. No preliminary sketch of the subject has survived. This drawing is a representative example of Cozens's reworking of Italian motifs after his return to England: the rendering of foliage has become schematic, with a characteristic alternation of black or gray with a dry green in fanlike clumps. The pencil outlines are fluent and clearly defined and are allowed to contribute detail through the thin washes. Cozens employs a slightly dry brush in hatching darker tones over light ones in the foreground to attain a sense of textural variety and sparkle but in other respects his handling is quieter, less emphatic and rhythmic than in the drawings of the mid-1780s.

137. London from Greenwich Hill.
*c.*1791 Plate 56

Pencil and watercolor on wove paper 14⅞ x 21 (378 x 533)

Exh: Yale, *English Landscape 1630–1850* 1977(77, repr. pl. LXXXIX)

Coll: Lt-Col. A. E. Jelf-Reveley; sale Christie 6 June 1972(98, repr.)

B1977.14.4703

Five other versions of this subject are recorded: one was in the collection of the Hon. Lady Ford and was sold at Christie's, 7 March 1972(78; repr.); another is in a private collection, London (Bell and Girtin, no. 441 i and ii); a third was listed by Bell and Girtin (no. 441, supplement) as being in the collection of Mr. William Wingfield; this third drawing was sold at Christie's 18 June 1980 (94 repr.); and a fourth is mentioned by Hawcroft (1971, p. 34, no. 94) as being in the collection of Mr. H. G. Balfour. The fifth (Hawcroft 1971, no. 94, repr.) is in the Courtauld Institute of Art. The first of these is signed and dated *1791*. The Yale drawing was unrecorded until its appearance in the saleroom in 1972. Apart from variations in the foreground staffage, especially the disposition of the deer, all these versions are much alike, and they were all presumably executed at about the same time, since Cozens probably ceased to work in 1792 or at the latest 1793. This drawing, however, has some features of particular interest. It is surrounded by a ruled pencil border, and the irregular edge of the sheet outside the upper pencil line bears traces of a gray wash, which may indicate that another subject had been painted on the other half of the sheet. The same upper borderline is marked off regularly at points 5 cm (1¹⁵⁄₁₆″) apart, presumably because this second, detached drawing was squared for copying onto another sheet. The divisions may apply to the drawing of *Greenwich* but this seems unlikely since they do not occur on any of the other ruled edges. This evidence of his method of work when making copies does not seem to have been noted in any other context.

138. The Thames from Richmond Hill.
*c.*1791 Plate 56

Pencil and watercolor on laid paper 14¼ x 20¾ (361 x 526)

Exh: Norwich, *English Watercolours 1750–1820* 1955(23)

Lit: Williams 1952, pl. LXXI, no. 146; Oppé 1952, p. 152

Coll: Edward Croft-Murray; Geoffrey Cooke, from whom bt by Paul Mellon, 1962

B1975.4.1903

Technically this sheet is close to the views of Greenwich of about 1791 (see no. 137) and to some of the late repetitions of Italian subjects; it is one of the small group of English views that Cozens made toward the end of his life. Oppé considered that in this drawing Cozens "recovered his power of weaving a composition into flat landscape—'without any predominant feature' as his father put it—in an evanescent atmosphere under a limitless sky." It is a rare experiment with a low horizon uninterrupted by verticals or diagonals, recalling the broad panoramas of the Dutch topographers of the seventeenth century and at the same time anticipating the romantic revival of such compositions at the hands of Bonington. The scene was to be a favorite of Turner's.

Pupils, Associates,
and Other Contemporaries

François Vivares (1709–80)

139. Landscape with a man driving a mule.
1739 Plate 2

Etching on laid paper, trimmed to edge of subject 3¼ x 5⁷⁄₁₆ (82 x 137)

Inscr. lower left: *Vivarez in. scul.*

B1977.14.14226

Attributed to Henry Roberts (died before 1790)

140. Landscape with animals beneath a rugged cliff. *c.*1745(?) Plate 2

Etching on laid paper, trimmed to edge of subject 4⅝ x 5¾ (117 x 146)

Inscr. verso: *Bolognese*

B1977.14.14438

These two etchings come from an album of over 200 miscellaneous prints bound in green vellum and dated *1739*. With the exception of a group of subjects by or after William van de Velde, Hollar, Berghem, and le Clerc, most of the items are small imaginary landscapes executed in the first half of the eighteenth century. Many are by Vivares and some of these are dated between 1739 and 1750. Vivares came to England from the south of France in 1727 and was assistant in London to the French engraver J. B. C. Chatelain (ca.1710–71). No. 139 comes from a set of views published by Vivares in 1739; it is a conventional scene derived from the long tradition of Flemish and Dutch landscape prints, which provided models for many of Alexander Cozens's drawings of 1746. No. 140 is characteristic of a more romantic landscape type, derived from the paintings of such artists as Paul Bril (1554–1626), with fantastic rock forms enlivened with bosky foliage and imaginary buildings. These were all elements that found their way into Cozens's mature work.

Anonymous *c.*1740

141. View of the ruined temple of Minerva Medica with Santa Maria Maggiore beyond.
Plate 2

Pen and brown ink with gray and some brown wash, squared in pencil and indented for transfer, on laid paper 11⅜ x 18½ (290 x 470)

Coll: Dilettante Society(?); Messrs. Maggs, 1959; Messrs. Stonehill, New Haven, from whom bt. by Paul Mellon, 1960

B1977.14.19451

An example of the type of Italian view that was distributed through the medium of engraving in the early eighteenth century—this drawing is squared and incised with a sharp point along its principal outlines to facilitate transfer to an engraver's plate. It is typical not only of the landscape compositions handed down among Italian and visiting foreign artists, heavily influenced by the Bolognese school, but also of the stylistic mannerisms that Cozens adopted and converted for his own use. Both the disposition of formal elements—trees, ruins, foreground, and sky—and the artist's shorthand for foliage can be seen to reappear again and again in Cozens's experiments of the Roman stay. The fine pen outlines are also characteristic of this phase of his development.

This drawing comes from a group of views, mostly in Greece and the Levant, which has no known provenance before 1959. It includes drawings that appear to have been used for engraved illustrations in publications of the Dilettante Society, London.

James Deacon (*c.* 1728–50)

142. Rocky landscape with classical buildings.
1745–50 Plate 2

Pen and black ink and wash over pencil on laid paper 7³⁄₁₆ x 9⅛ (182 x 231)

Coll: Iolo A. Williams; Colnaghi, from whom bt. by Paul Mellon, 1964

B1977.14.5653

Some confusion exists between the James Deacon who was responsible for this drawing and his son, also James Deacon, known for his woodcuts after old master drawings published in Charles Rogers's *Collection of Prints, in Imitation of Drawings*, 1778. Deacon the elder, known in his own day as a miniaturist, died in 1750 as one of the victims of the "gaol fever" which killed the occupants of a courtroom at the Old Bailey when the windows were opened to admit the noxious air from Newgate Prison across the street. He thus died young, at about the age of twenty-two, and his work is extremely rare. A pair of portraits executed in pencil and gray wash in the British Museum show the marine painter Samuel Scott (1703–72) and his wife; Deacon was evidently a member of the lively circle that formed round that artist (see the British Museum catalogue, *Portrait Drawings XV–XX Centuries*, 1974, no. 166). Other landscapes by him are in the Oppé collection and in the Cottonian Collection, City Museum and Art Gallery, Plymouth, which owns three of his drawings. Two of the Cottonian drawings are loosely related to the present sheet, and one of them is perhaps the finished work for which this is a preparatory study. It is executed in the same media but with greater finish; several figures are introduced. The style of the drawing suggests a connection with George Lambert (1710–65), which would be expected from Deacon's association with Scott, a friend of Lambert's. It is therefore hard to understand why it has been dated as late as ca. 1775, a period at which this type of formal classical landscape composition, an important influence on Alexander Cozens's development in the 1740s, had gone out of favor (see Mary Peter, "Old Master Drawings—VIII: Four Drawings from the Cottonian Collection, Plymouth," *Apollo* (January 1957):18). The assumption has been, however, that since the Plymouth drawing belonged to Charles Rogers, it must be the work of the James Deacon who engraved for him in the 1770s and whose career is otherwise uncharted. It is reasonable, however, that Deacon the younger would have presented his patron with examples of his father's work; and the gray monochrome wash of the landscape drawings is in accord with the medium of the British Museum Scott portraits, which are themselves of a quality that would lead us to expect fine work from

the young artist. A date of 1745 has been associated with the Yale sheet, and it may be correct; but the assured technique both here and in the related drawings would argue unusual precocity in a boy of seventeen.

Richard Wilson (1714–82)

143. Italian landscape with a canal and distant buildings. *c.*1753(?) Plate 3

Pencil on laid paper 7¹⁵/₁₆ x 11¾ (202 x 296)

Coll: Thomas Edmond Lowinsky, from whom bt. by Paul Mellon, 1975

B1977.14.6029

If this drawing is indeed by Wilson, as the foreground figures and the detail of the sarcophagus would suggest, it is an uncharacteristic example of his style. The drawing of the distant buildings and of the foliage of the trees is exceedingly neat, almost tentative in handling. Notwithstanding, there is a delicacy of touch that is quite consistent with Wilson's vision, and the whole composition has something of the blend of immediacy and artificiality typical of him. It would appear to be a study made early in his stay in Italy, when the novelty of the place and of his role as landscapist was still causing him hesitation. The pencil style is not far removed from that of Alexander Cozens in his sketchbook (no. 2), and the faint outline of the far mountains is close to the formulas that Cozens employs in his imaginary subjects (e.g., no. 7).

Alexander Runciman (1736–85)

144. Landscape with a temple on a hill above a lake. *c.*1767(?) Plate 5

Watercolor on laid paper 5⅞ x 7½ (136 x 190)

Inscr. lower center: *A R* (monogram)

Verso: red chalk study of rocaille mouldings

Exh: London, Anthony Reed Gallery, and New York, Davis & Long Company, *English Sketches and Studies* 1978(20)

Coll: The Hon. Lady Inglis; Anthony Reed, from whom bt., 1979

B1979.1.3

One of three studies from the same source, and an example of a large group of landscape drawings by Runciman which are thought to have been done early on in his stay in Rome (1767–71). They "document his sensitive response to the Italian scene" (Nancy L. Pressly, *The Fuseli Circle in Rome* [Yale, 1979], p. 7) and so can be seen as emerging from a stimulus parallel to that which produced the Roman drawings of Cozens in 1746. In fact, however, there is no necessity for these landscapes to have been made in Italy, for they partake of the stylized and entirely formal understanding of classical scenery current in England in the 1740s and 50s. One might adduce the further influence of Roman mural decorations, but it is unlikely that Runciman saw or was interested in such things at this date. The most remarkable feature of these drawings is their complete independence of the pen outline and their consequent delicacy of atmosphere, achieved by an almost oriental use of wash. In this respect they

are very different from the characteristic drawings of Runciman's Roman period, which are executed in pen and ink, often with decidedly linear treatment (see Pressly, op. cit., pp. 9–11).

Coplestone Warre Bampfylde (1720–91)

145. Crowcombe Court, Somerset.

*c.*1775 Plate 27

Pencil, with gray and brown washes and pen and gray ink; a pencil line ruled down the center of the sheet 11¹¹/₁₆ x 18¼ (295 x 463)

Inscr. verso: *Crowcombe*

Coll: Messrs. Grinke and Rodgers, London, from whom bt. by Paul Mellon, 1968

B1975.4.1452

Bampfylde was a gentleman of property from Hestercombe in Somerset whose work appeared in the London exhibitions between 1763 and 1783. In addition to topography he submitted landscapes with classical themes and storm effects, demonstrating a wide range of interests. There is nothing to connect him with Alexander Cozens except the incidental reference in one of Cozens's letters to William Hoare of Bath (see no. 71), and it can only be by inference that the 'Mr. Bamfylde' referred to there can be identified with the amateur artist. But it seems highly likely that it is so; and that Bampfylde, knowing Cozens, took at least some lessons from the celebrated teacher. As Williams points out (1952, p. 232), the most obvious influence on Bampfylde's topography is that of Paul Sandby (1730–1809); but the similarity is perhaps due rather to the family resemblance of so much topographical drawing of the period. In fact, Bampfylde's work is distinguished by a freedom and compositional dignity rare in an amateur, and it is possible that he owed these qualities to the instruction of Cozens. In this typical example, his use of a monochrome wash to convey space and atmosphere, especially in the loosely brushed trees and the distant gray slope, may well have been suggested by Cozens. Another drawing by Bampfylde in the Yale Center for British Art (B1975.4.1000) shows a scene at Stourhead (also mentioned by Cozens in a letter to Hoare): a group of trees by a wall, with an urn and a distant church tower. It is in chalks on blue paper in the manner of Gainsborough and exhibits similar powers of generalization.

Charles Gore (1729–1804)

146. Lago Fucino. 1776 Plate 52

Watercolor over pencil with pen and black ink on laid paper; three strips of paper glued together 8³/₁₆ x 35¹³/₁₆ (208 x 906)

Inscr. above: *Lago fucino d'apres Mr Swinburne a Rome 1776.* and *Monte Velino, Albi & Avezzano near the Lake of Fucino, Mr Swin*[cut]; and below, left: *Monte Velino* and *Avezzano.*

Coll: Anonymous sale, Sotheby 19 July 1973(71), John Baskett, from whom bt. by Paul Mellon

B1975.3.162

This sheet was one of a parcel of thirteen studies by Gore sold anonymously in 1973. Although Gore was an amateur his work as a draftsman has always been highly regarded. His relationship with

Payne Knight and almost certainly with Cozens after their arrival in Rome has been discussed by Bell and Girtin, pp. 9–11. As Goethe, with whom Gore was intimate, noted in his *Philippe Hackert, Biographische Skizze, meist nach dessen eigenen Aufsatzen entworfen . . .* (Tübingen, 1811), Gore and Hackert worked extensively together, and Gore made copies of Hackert's drawings. This example is not after Hackert but from a drawing by "Mr Swinburne"— perhaps Henry Swinburne (1743–1803), who was in Italy in the 1760s and again from 1776 to 1779. Swinburne's *Travels in the Two Sicilies, 1777–1780* was issued in two volumes in 1783 and 1785. A collection of Italian views in watercolor by him, some dated 1785–89 and 1792, was sold at auction in 1979 (Sotheby, 22 November, lots 65–67, 69–71). The fluent use of wash and occasional pen outline in Gore's copy are characteristic of his drawing style and evince a highly developed sensitivity to space and atmosphere, though technically his work has little in common with the professionals, Hackert and Cozens, with whom he came into contact.

Jakob Philipp Hackert (1734–94)
147. Lake Nemi. 1776 Plate 39

Watercolor with pen and black ink on laid paper 13½ x 17¹³/₁₆ (344 x 457)

Inscr. top left: *Lac de Nemi*; lower center: *Ph. Hackert. f. 1776* and verso, in an early hand: *Lake of Nemi by Philip Hackart*[sic] *1776* and *in Italy States of the Church*

Exh: Norwich Castle Museum, *Eighteenth-century Italy and the Grand Tour* 1958(30); Leeds City Art Gallery, *Early English Watercolours* 1958(60)

Lit: Oppé 1952, p. 142 note

Coll: A. P. Oppé, by whom given to Thomas Girtin, 1925; by descent to Tom Girtin; John Baskett, from whom bt. by Paul Mellon, 1970

B1975.3.960

Hackert's role in the development of watercolor in England is an important one, and it may be said to have entered upon its most significant phase in the year of this drawing, 1776, when in all probability he met John Robert Cozens newly arrived in Rome with his patron Richard Payne Knight, and in the company of Charles Gore (see no. 146); and they certainly met in Naples in 1782. It has even been suggested by Oppé that this drawing is in some way related to Cozens's view of the *Lake and Town of Nemi* (no. 94), which presumably dates from a year or two later. The point of view, and indeed the whole composition, is much the same, though Cozens's elimination of the pictorial formalities of left-hand repoussoir and foreground figures immediately gives his drawing a boldness and grandeur that Hackert cannot match. Hackert is also content with even, sunny lighting that contrasts markedly with Cozens's somber atmosphere. Technically, however, the German offers an important precedent in the handling of landscape masses seen across a wide space: he treats these not as broad washes but as areas fragmented by light and texture so that tones are built up, rather analogously to aquatint process, more or less heavily as the forms are closer to or further from the eye. It is typical of the German tradition of draftsmanship to which Hackert belonged that he added a pen outline to these fragmented touches, defining each tree in the view; Cozens, by omitting this, liberated himself from the topographical conventions of the eighteenth century to produce some of the

first true romantic landscapes in watercolor. Compare also the work of Jacob More (no. 148).

Jacob More (1740–93)
148. Terracina. 1778 Plate 51

Watercolor over pencil on laid paper 14⅜ x 19⅞ (366 x 504)

Inscr. on the artist's mount: *A VIEW at TERRACINA* and *Jacob More Rome 1778*

Exh: Norwich Castle Museum, *Eighteenth-century Italy and the Grand Tour* 1958(39)

Coll: L. G. Duke; bt. by Paul Mellon, 1973

B1977.14.5480

More, who was trained in Scotland and taught by Alexander Runciman (see no. 144), went to Rome in 1773 and came under the influence of Hackert, whose work clearly influenced the execution of this watercolor (compare no. 147). Like Cozens, More evidently stayed at the inn at Terracina and made sketches from it; his view is almost identical to Cozens's own (no. 129), though in handling it betrays a greater dependence on his continental models. In particular, compare the treatment of the wooded cliff here with similar passages by Hackert. The carefully posed and outlined figures recall the work of Claude-Joseph Vernet, an important influence on More as he was on many landscape artists of the time (see James Holloway and Lindsay Errington, *The Discovery of Scotland* [Edinburgh, 1978], p. 48).

Anonymous, *c*.1780
149. General View of Naples. Plate 52

Pencil with brush and gray wash on laid paper; the sheet folded down the center 6¹/₁₆ x 17½ (154 x 444)

Inscr. verso: *Naples*

Exh: London, Royal Academy, *The Girtin Collection* 1962(12)

Coll: Dr. Thomas Monro; Alexander Monro; Hector Monro; Miss Le Geyt, from whom acquired by Thomas Girtin, about 1929; Tom Girtin; John Baskett, from whom bt. by Paul Mellon, 1970

B1975.3.1003

Although this drawing, a two-page spread from a sketchbook, has presumably always passed as a study by John Robert Cozens, to whom it was attributed when it came into this collection, it seems to have few of the characteristics of his work. It is evidently a drawing of the period and may well be by an English artist, but the pencil outlines are quite unlike those typical of Cozens. It would also be difficult to point to an example of his use of monochrome wash as flat and insensitive as this. There are panoramas of Naples (from Sir William Hamilton's Villa at Portici, certainly not the point of view for this sheet) in the Beckford sketchbooks, II, 8, 9, which afford adequate comparison and confirm that Cozens is not the author. On the whole the quality of the drawing is not very high; but it may perhaps be by some such artist as John "Warwick" Smith (see no. 162).

Richard Cooper the younger
(*c*.1740–1814)

150. Landscape composition. *c*.1780(?) Plate 10

Pen and brown ink and wash on laid paper, the design in a drawn oval divided into quarters by ruled pencil lines 7 3/16 x 8 3/4 (183 x 224)

Inscr. lower right: *RCooper d* and *14/-*; lower left, in pencil: *Am . . . side*(?)

Verso: Two landscape compositions in pen and brown ink and wash, one of them apparently a copy of a Dutch seventeenth-century river scene; and an architectural detail in pencil

Coll: L. G. Duke; Colnaghi, from whom bt. by Paul Mellon, 1964

B1977.14.5224

Cooper, the son of an engraver, studied in Paris and went to Italy about 1770. He exhibited drawings after paintings by old masters at the Academy in 1778, immediately after his return to London, and this study appears to be a sketch of the composition of a landscape painting, apparently showing an Italian scene. The drawings on the verso of the sheet are also probably copies from paintings by other artists. The oval composition on the recto is perhaps taken from Joseph Wright of Derby (1734–97), who executed a number of Italian scenes in this format in the early 1780s (see Benedict Nicolson, *Joseph Wright of Derby*, 2 vols. [London, 1968], pls. 233–35). In its concern with expressing the essentials of a formally organized landscape in monochrome washes, the study shows Cooper rehearsing many of the themes that preoccupied Alexander Cozens. The oval format was favored by the Rev. William Gilpin for many of the illustrations to his Picturesque guide books, notably the *Observations on the River Wye*, 1782 (see no. 152). A more finished drawing by Cooper is no. 151.

Richard Cooper the younger
(*c*.1740–1814)

151. Classical landscape with temples and a ruined aqueduct. *c*.1785(?) Plate 10

Pen and gray ink and brown wash over pencil on laid paper 10 15/16 x 17 1/8 (278 x 435)

Coll: Iolo A. Williams; Colnaghi, from whom bt. by Paul Mellon, 1964

B1977.14.5754

Seven drawings of Italian subjects, or copies from Italian paintings, were exhibited by Cooper at the Royal Academy in 1778. Thereafter he did not show work based on his Italian experiences, but it is likely that a drawing such as this constitutes a recollection of Italy rather than a record or a fantasy made while he was there. As Williams (1952, p. 77) noticed, the slightly stiff mannerism by which Cooper renders foliage and other outlines with a reed pen seems to be derived from Canaletto; the total effect of a drawing such as this is not unlike that of John Robert Cozens's Payne Knight series (nos. 86–90); but the mood of refined and somewhat abstracted classicism has more affinities with the work of Alexander, as does the characteristic use of brown wash. A companion drawing is also in the Yale Center for British Art, B1977.14.5753. In the 1780s Cooper became drawing

master at Eton, but it is not known whether he assisted Cozens there or merely succeeded him to the position. See also no. 150.

The Rev. William Gilpin (1724–1804)

152. Mountainous landscape with two figures overlooking a lake. *c*.1780–90(?) Plate 10

Pencil and gray wash with pen and brown ink on wove paper 7 1/4 x 10 5/16 (184 x 263)

Coll: Artist's sale, Christie 6 June 1804(?); Martin Hardie, 1925; Colnaghi, from whom bt. by Paul Mellon, 1961

B1977.14.5901

Gilpin became famous for his formulations of the theory of the Picturesque, especially in his *Observations on the River Wye, and Several Parts of South Wales . . . relative chiefly to Picturesque Beauty* (London, 1782) and *Observations, relative chiefly to Picturesque Beauty, made in the Year 1772, On several Parts of England; particularly the Mountains, and Lakes of Cumberland and Westmoreland*, 2 vols. (London, 1786). Gilpin's starting point was that of the tourist, not that of the artist, but like Alexander Cozens he had a thoroughly didactic approach and his attempts to categorize types of landscape share Cozens's preoccupation with the quantifiable in nature. The numerous plates with which he illustrated his books reflect this similarity of attitude, for they are, like Cozens's drawings, monochrome arrangements of predetermined landscape elements, disposed according to carefully codified pictorial rules. Williams (1952, p. 235) records a drawing by Gilpin in his own collection inscribed "A Blot" which presumably reflects Cozens's influence. As an amateur, Gilpin did not achieve the expressive heights of Cozens in his drawings, which are somewhat perfunctory and crudely mechanical; they embody a theory without going beyond it to the universals that the theory seeks to contain. The subject matter of this drawing may have been derived from Gilpin's experience of the River Wye, but in the process of submitting the original data to Picturesque rules any sense of an individual place has been lost. For a more effective treatment of Wye scenery, see Hearne's *Goodrich Castle*, no. 163.

Thomas Gainsborough (1727–88)

153. Wooded landscape with shepherd and sheep. *c*.1765–70 Plate 12

Pen and brown ink with gray wash and varnish (modern resin?) on laid paper 6 15/16 x 9 3/16 (177 x 233)

Collector's mark of John Deffett Francis, lower left

Exh: Richmond, Virginia, Museum of Fine Arts, *Painting in England, 1700–1850* 1963(63)

Lit: John Hayes, *The Drawings of Thomas Gainsborough*, 2 vols. (London and New Haven, 1971), no. 303, pl. 276

Coll: John Deffett Francis; P. O'Byrne, sale, Christie 3 April 1962(70, repr.); bt. Colnaghi, from whom bt. by Paul Mellon, 1962

B1975.4.1199

Gainsborough's approach to the making of landscape drawings was similar to that of Alexander Cozens not only in his use of standard elements which he arranged and rearranged but in his methods and techniques. The varnish used on this drawing lends it much the same flavor that many of Cozens's studies using varnish have. The calligraphic freedom of Gainsborough's pen outlines also bears a resemblance to the free sketching procedures of Cozens. The principal difference between the two artists in works of this type and scale lies in Gainsborough's reliance on the observed landscape of rural southern England, while Cozens depends on the formal elements made familiar through engravings after Italian (especially Bolognese) landscape paintings of the seventeenth century. See also no. 154.

Thomas Gainsborough (1727–88)

154. Wooded landscape with castle.

c.1785 Plate 12

Black and white chalks with stump on blue laid paper 10⅜ x 12⅞ (263 x 327)

Exh: Washington, National Gallery of Art, *English Drawings from the Collection of Mr. and Mrs. Paul Mellon* 1962(34); Yale, *English Landscape 1630–1850* 1977(34, repr. pl. LXV)

Lit: John Hayes, *The Drawings of Thomas Gainsborough*, 1971, no. 806, pl. 234

Coll: Anonymous sale, Sotheby 15 April 1953(6), bt. Colnaghi; William Selkirk, sale, Sotheby 3 May 1961(87), bt. Colnaghi, from whom bt. by Paul Mellon

B1975.4.1520

An example of Gainsborough's latest style of landscape study, this sheet contrasts markedly with an earlier one, no. 153. The tendency to generalize, to become more abstract, is discernible in all its elements; the representation of nature has ceded almost entirely to the construction of a pictorial statement out of formalized, "abstract" components. Although this drawing is not varnished uniformly like no. 153, it eschews color, a fact that emphasizes its preoccupation with abstraction and brings it close in type (though not in accomplishment) to the work of William Gilpin (see no. 152). It is likely that Cozens had a considerable influence on Gainsborough's attitude to his drawings in the later part of his career (see Hayes, pp. 14, 28, 61). A drawing in the Oppé collection, inscribed *From Gainsbro'* (repr. Hayes, pl. 422) is attributed to Cozens, but there seems little stylistic evidence for this; the idea was perhaps suggested by the fact that the drawing is varnished. Oppé (1952, p. 26) proposes a possible connection between the two artists at Bath.

Pupil of Alexander Cozens

155. A Road in a Mountain Landscape.

c.1780(?) Plate 26

Brush and black and gray washes on laid paper prepared with a brown ground 11¼ x 14³⁄₁₆ (285 x 361)

Coll: The Mount Trust, sale, Christie 14 November 1972(96), repr.

B1975.4.1803

In this sheet the typical elements of Cozens's landscape formula are deployed somewhat mechanically; the design might have derived from one of the thumbnail patterns in the seven "cloaths" of "Principles of Landskip" in the British Museum album. Although the tree- and rock-types are more or less in conformity with those to be found in Cozens's characteristic work, they are slackly drawn and messily washed. The recession so vital to the effect of Cozens's views, and of which he was such a master, is crudely handled here. The cloud-forms, almost invariably of great delicacy and poetic significance in Cozens's drawings, are mere blotches. Compare the crisp and purposeful achievement of diverse effects in the *Mountain Tops*, no. 24. Although it has hitherto been considered to be by Cozens himself, it seems that this drawing must be the work of a pupil; indeed, while retaining many features obviously taken from Cozens, it approaches the vagueness and even the technique of William Gilpin (see no. 152). It may be compared with two drawings in the British Museum album of Cozens studies, 1888-1-16-8, ff. 5, 34, which are too weak to be by Alexander.

Hon. Mary Harcourt, later Countess Harcourt (d. 1833)

156. An arch in the vault of an overgrown ruin.

c.1780(?) Plate 26

Brush and brown wash on laid paper prepared with a varnished ground 9 x 11⁷⁄₁₆ (229 x 291)

Coll: Iolo A. Williams; purchased from his family, 1970

B1977.14.5674

Two drawings by Mrs. Harcourt in the Leeds City Art Gallery (14.145/73 and 14.146/73) are of scenes near her home at St. Leonard's Hill, Windsor; one of them is dated 1783. She was the daughter of the Rev. William Danby and was married first to Thomas Lockhart; in 1778 she became the wife of William Harcourt, who succeeded his brother as third Earl of Harcourt in 1809. At some time probably shortly after her second marriage she began to take drawing lessons from Alexander Cozens, whose teaching she assiduously followed, as is borne out by a letter from her to William Beckford dated 4 September 1781 (published in Oppé 1952, p. 34): "I rejoice that Cozens is with you. I hope that you will restore him to such health by good air and the pleasure he will enjoy in being with you, that I shall have his society some hours of every week in London for many years to come. Tell him I am six hours of every day following his instructions. I would give him half I am worth if he could give me his genius also." A visitor to her workroom at St. Leonard's Hill in 1786 was impressed by "the number of large and excellent drawings she has executed, for she has drawn all the districts visible from Leonard's Hill, and in addition, those from which this noble country house can be seen. They are all half a royal folio in size, so masterly in execution, that I was unjust enough to marvel how a lady could attain such a high degree of finish and so selective a vision" (see Clare Williams, trans., *Sophie in London 1786*, 1933). She exhibited landscapes (without specific titles) at the Royal Academy in 1785 and 1786. Horace Walpole admired her work. After Cozens's death her husband acquired numerous drawings of his at auction, and she sent money to the widow of John Robert when funds were being raised to support her (see Oppé 1952, p. 119). The attribution of this drawing to Mrs. Harcourt was presumably made by Iolo Williams, though he does not mention her in his book. Its

technique is modelled on that of some of Alexander Cozens's late studies; for example, the *Tree* in the British Museum (1941-12-11-717). The similarity of the treatment of foliage with that in the *Lake Morat* (no. 157) clearly establishes this artist as the author of a group of drawings hitherto accepted as being by Alexander (see nos. 157–59).

Hon. Mary Harcourt, later Countess Harcourt (d. 1833)

157. Lake Morat from Avenches.

c.1780 (?) Plate 27

Brush and brown wash with some pencil on laid paper prepared with a dark red-brown varnished ground 8½ x 10¾ (216 x 273)

Inscr. top right: *lake Morat from Avench[es]* and, on the artist's mount in two different hands, top left and lower right corners: *Lake Morat*

Exh: Sheffield and London 1946(16) as by Alexander Cozens

Lit: Williams 1952, p. 37; Oppé 1952, p. 96

Coll: Dr. T. C. Girtin; by descent to Tom Girtin; John Baskett, from whom bt. by Paul Mellon, 1970

B1975.3.814

This drawing has been accepted without question hitherto as the work of Alexander Cozens; its inscription in the top right corner, as well as its technique, relate it to the "Rhone" group (see nos. 158 and 159). Even more than these, however, it is clumsy and tentative in handling, though the articulation of the landscape itself is moderately satisfactory and the whole design one that Cozens might have invented. The inscription is not apparently in Cozens's hand. A comparison with no. 156, by Mary Harcourt, convincingly shows that she was responsible for this drawing, for the two sheets share a characteristic mannerism in the delineation of foliage and the rendering of tree trunks. While it is possible that it was executed at the same time as nos. 158 and 159, this subject is not a scene on or near the Rhone. Lake Morat is the Murtensee, between Basel and the Lake of Neuchâtel in northwest Switzerland. Avenches, a small town to the southwest of the lake, should not be confused with Avranches in Normandy.

Hon. Mary Harcourt, later Countess Harcourt (d. 1833)

158. Tournon opposite to Taint on the Rhone.

c.1780(?) Plate 27

Brush and black-brown ink with dark red-brown varnish 5¾ x 10 (146 x 254)

Inscr. top right: with title

Exh: B.F.A.C. 1916(17); Sheffield and London 1946-7(14); Sheffield, Graves Art Gallery, *Early Water-colours from the Collection of Thomas Girtin Jnr.* 1953(15); London, Royal Academy, *The Girtin Collection* 1962(7)

Lit: *Illustrated London News*, 28 December 1946 (repr.); Williams 1952, p. 37; Oppé 1952, pp. 24, 96

Coll: Dr. T. C. Girtin; by descent to Tom Girtin; John Baskett, from whom bt. by Paul Mellon, 1970

B1975.3.810

This and nos. 157, 159 belong to a small group of drawings hitherto attributed to Alexander Cozens but executed in a distinctive manner unlike his familiar style. The group consists of six drawings in all, three of which are inscribed with a topographical note like this one. Others are in the collections of the late E. H. Coles and of D. L. T. Oppé. Oppé (1952, p. 96), believing them to be by Cozens, conjectured that the group was of early date on account of the relative crudeness of the technique: "Cozens may have attempted to become more factual," he suggests, "but he has only succeeded in becoming more imaginative." It is difficult to concur with this judgment. That the drawings are rather crude is undeniable and this is explained by the inscription, which indicates that they are by the same hand as no. 156.

Hon. Mary Harcourt, later Countess Harcourt (d. 1833)

159. On the Rhone. *c*.1780(?) Plate 27

Pencil, gray and brown wash on laid paper prepared with a dark red-brown varnished ground 6¹⁵⁄₁₆ x 11⅜ (177 x 269)

Inscr. on the back of the artist's mount: *On the Rhone*

Exh: Sheffield and London 1946-7(15, repr. pl. 2); Sheffield, Graves Art Gallery, *Early Watercolours from the Collection of Thomas Girtin Jnr.* 1953(15); London, Tate Gallery, *The Romantic Movement* 1959(396); London, Royal Academy, *The Girtin Collection* 1962(9)

Lit: F. Gibson, "Alexander and J. R. Cozens," *The Studio* (1917, repr.); Oppé 1952, p. 96, pl. 15; Williams 1952, p. 37

Coll: Dr. T. C. Girtin; by descent to Tom Girtin; bt. by Paul Mellon, 1970

B1975.3.811

One of the 'Rhone' group of drawings hitherto attributed to Alexander Cozens (see nos. 157 and 158). Oppé's description (1952, p. 96) of the technique of the group is puzzling. He says they are 'unique . . . in method, for all the drawings are brushed with grey-black ink on paper which has been varnished after the drawing was completed, and has acquired a darker tone than usual in Cozens' drawings . . .' It is difficult to agree with this analysis, despite the obviously strange dark brown tonality. In all the three examples at Yale, there is evidence that the detail of the subject matter was drawn in with a brush and black or brown ink *over* the varnish, following Cozens's usual procedure. The gummy glitter of the ink used in drawing is still clearly visible, which it would not be if it were overlaid with a darkened varnish, which has its own tendency to glitter in places. In his Sheffield/Tate catalogue, Oppé described the technique of the series as consisting of 'brown and black washes on varnished paper', and this seems accurate. The Girtin collection catalogue says 'indian ink on oiled paper'.

Joseph Farington (1747–1821)

160. Landscape with trees by a lake.

1780s(?) Plate 34

Pen and gray ink, squared in pencil on laid paper 4⅞ x 6⅞ (125 x 175)

Coll: as for no. 161

B1977.14.5811

Joseph Farington (1747–1821)

161. Palace on a cliff above a river.

1780s(?) Plate 34

Pen and gray ink, squared in pencil on laid paper 4⅞ x 6¼ (125 x 160)

Coll: The artist's family; sale, Puttick and Simpson, December 1921; Martin Hardie; Colnaghi, from whom bt. by Paul Mellon, 1961

B1977.14. 5812

Farington, a pupil of Richard Wilson (see no. 143), inherited from his master a sense of the formal qualities of landscape which enabled him to give his somewhat pedestrian topographical views a dignity and poise that raises them above much other work of the same type. In studies such as these his instinctive concern with the harmonious assembly of landscape elements can be seen at work; at the same time his fluid and highly professional penwork is in evidence. Farington seems to have learned how to use the pen with an even, rhythmic jauntiness from Canaletto, whose pen and wash views were well known in London after his stay there in the 1740s. There is, too, a strong possibility that the style reflects the influence of Benjamin West, with whom Farington's brother George worked about 1770. The pen technique in these drawings is not unlike that of the *Study of Trees* dated 1786 in the Whitworth Art Gallery, Manchester (repr. in Bolton Museum and Art Gallery, *Joseph Farington* exhibition catalogue, no. 30), and they may date from about that time; but Farington's style did not change markedly over the years and it would be rash to attempt a close dating. While they are compositionally akin to the formal landscapes of Alexander, their penwork is reminiscent of the Payne Knight drawings of John Robert Cozens (see especially no. 86).

John "Warwick" Smith (1749–1831)

162. Salerno. *c.*1785(?) Plate 52

Pencil and watercolor on laid paper 13⁵⁄₁₆ x 20⅛ (339 x 511)

Inscr. lower left: *IS* (monogram) and on back of original mount: *Salerno*

Exh: Richmond, Virginia, Museum of Fine Arts, *Painting in England, 1700–1850* 1963(410)

Coll: Walker's Galleries, 1961; Colnaghi, from whom bt. by Paul Mellon, 1962

B1975.4.1612

Smith arrived in Italy under the patronage of the Earl of Warwick in the same year as Cozens, 1776, and entered the group of English artists in Rome of which Cozens was certainly a member by the end of that year (see Thomas Jones ,"Memoirs", p. 53). He returned to England through Switzerland in the company of Francis Towne (1739 or 1740–1816). His work has generally been seen as undergoing a radical change under the influence of Towne and his friend William Pars (1742–82), so that the works he produced at the time of his return to England are very different from those of the pre-Rome period. In drawings like this he appears to be absorbing the lessons of Cozens also: the restricted color and spacious view suggest that Smith had seen drawings executed by Cozens in England after the first Italian tour. This would mean that Smith's drawing was not done in Italy but was worked up from notes later. The rather schematic treatment and the lack of immediacy in the rendering of this atmospheric subject would argue a similar case.

Thomas Hearne (1744–1817)

163. Goodrich Castle on the Wye.

*c.*1785(?) Plate 39

Pencil and watercolor on wove paper 8⅞ x 12⁵⁄₁₆ (225 x 312)

Inscr. on back of original mount: Goodrich Castle—Hearne —No. 23

Exh: London, Royal Academy, *The Girtin Collection* 1962(33); Reading Museum and Art Gallery, *Thomas Girtin and some of his Contemporaries* 1969(10)

Coll: Palser Gallery, 1936, from whom acquired by Thomas Girtin; by descent to Tom Girtin; John Baskett, from whom bt. by Paul Mellon, 1970

B1975.3.1027

Although Hearne never traveled abroad himself, he was involved in the activities of Gore, Payne Knight, and Hackert (see nos. 146 and 147) when Payne Knight asked him to make finished watercolors of subjects sketched by Gore during their tour to Sicily in 1777. These drawings are now in the British Museum (Binyon nos. 16–26). Hearne was therefore almost certainly able to study the work of Hackert at least in a few examples; and he would no doubt have been interested in the Italian subjects that John Robert Cozens was producing after his return from Italy in 1779. This sheet seems to reflect the influence of both artists in a marked degree, employing as it does the dappled and fragmented tonality of Hackert together with the resonant coloring of Cozens. Hearne's sense of the structure of natural forms, always strong, is expressed as usual in a soft but decisive pencil outline which is slightly more emphatic than Cozens's but does not approach the systematic outlining practiced by Hackert. The sweeping rhythms of this design may also owe something to the example of Cozens, though Hearne does not attempt his highly personal interpretation of subject matter. He remains a topographer, though in an example like this he rises above his habitual mode.

Thomas Sunderland (1744–1823)

164. The Head of Ullswater, with Patterdale Lodge. *c*.1790 Plate 57

Watercolor over pencil on laid paper 23¹³/₁₆ x 33¹/₁₆ (608 x 840)

Coll: Sir Everard Ratcliffe, Bt., sale, Christie 14 November 1972(89, as John Robert Cozens; repr.)

B1977.14.304

Since its appearance at auction in 1972 this large drawing has been attributed, apparently without question, to John Robert Cozens. While it is manifestly executed in his style, it is however rather a stiff pastiche of his manner than an authentic example of it. Comparison with the *Landscape* by Thomas Sunderland, no. 165, shows that both in drawing and coloring it is compatible with his known work, and there seems no reason to doubt that Sunderland is the author. This is perhaps his most ambitious piece and shows Cozens's influence more consistently than any other example. It supplies exceptionally good evidence that Cozens and Sunderland were in direct contact in the late 1780s, as tradition maintains, and there is a strong possibility that the pupil worked on this drawing directly under Cozens's supervision. See Randall Davies, "Thomas Sunderland 1744–1823, Some Family Notes," *The Old Water-Colour Society's Club Annual* 20(1942):31–39.

Thomas Sunderland (1744–1823)

165. Landscape (in the Lake District?). *c*.1790 Plate 57

Pencil and watercolor with black ink on wove paper 12⅜ x 17½ (315 x 444)

Exh: Reading Museum and Art Gallery, *Thomas Girtin and some of his Contemporaries* 1969(11)

Coll: The artist's family; Randall Davies; Agnew, 1948; Thomas Girtin; Tom Girtin; bt. by Paul Mellon, 1970

B1975.3.991

An unusual drawing which is of interest because it provides a link between the familiar style of Sunderland's characteristic work (no. 166) and the elaborate Cozens-inspired technique of no. 164. Here the warm greens of the large drawing and some of its stylized treatment of foliage are combined with the loose outlines and fresh penwork of his typical output. The use of black ink to strengthen areas such as the foliage of the trees at the right is oddly reminiscent of Cozens's practice in the drawing of *Tivoli* of 1778 (no. 91).

Thomas Sunderland (1744–1823)

166. Landscape at Ambleside. *c*.1800(?) Plate 57

Pencil, pen and brown ink, and gray wash on wove paper 13 x 17¹³/₁₆ (330 x 455)

Exh: London, Royal Academy, *The Girtin Collection* 1962(29)

Coll: Dr. John Percy; Randall Davies; Thomas Girtin; Tom Girtin; bt. by Paul Mellon, 1970

B1975.3.989

A representative example of the type of drawing usually associated with Sunderland, this sheet is not immediately reminiscent of the work of John Robert Cozens, though some of its features can be seen to derive from him when the drawing is compared with nos. 164 and 165. The looser pen outlines of this presumably later manner also recall those of Joseph Farington (see nos. 160, 161), with whom Sunderland is also known to have been acquainted. Farington worked in the Lake District in 1776–80, and may have taught Sunderland. There is also, however, a resemblance between these monochromatic views of Sunderland and the Payne Knight set of drawings that Cozens produced in 1776 (nos. 86–90).

Sir George Howland Beaumont (1753–1827)

167. Welsh Landscape. *c*.1800(?) Plate 27

Pen and brush and black ink with white bodycolor on blue laid paper 8¹¹/₁₆ x 11¾ (221 x 299)

Coll: Agnew, from whom bt. by Paul Mellon, 1963

B1975.4.1008

Beaumont is said to have been one of the favorite pupils of Alexander Cozens at Eton, where he was at school from 1764 to 1771. The style of his drawings, which he produced in large quantities throughout his life, reflects the influence of Wilson and Gainsborough (see nos. 143, 153, 154) as a rule; but this example, with its schematic use of ink washes, is reminiscent of some of the technical devices of Cozens, especially those of his later work. The composition as a whole bears a resemblance to the blot designs in the *New Method* (see nos. 26–68). At the same time, the sense of space that is evoked suggests affinities with John Robert Cozens, whom Beaumont knew in Rome and to whose fund he subscribed in the 1790s. See Oppé 1952, p. 113; Felicity Owen, "Sir George Beaumont and the Contemporary Artist," *Apollo* (January, 1969), pp. 106–111; and Leicester Museum and Art Gallery, *Sir George Beaumont of Coleorton, Leicestershire* (n.a.).

The Monro "Academy"

Dr. Thomas Monro (1759–1833) was Physician to Bethlehem Hospital. In February 1794 John Robert Cozens was put into his care "with no expectation of his recovery," according to Farington (*Diary*, 23 February 1794), "as it is a total deprivation of nervous faculty." During the time that Monro occupied this position he obtained temporary possession of many of Cozens's drawings; in particular, it seems, of the tracings that Cozens had made from his sketches in Italy (see p. 43). Monro was an avid collector of works of art and assembled a representative group of watercolors by the major British artists of the period; his sale at Christie's on 26 June 1833 included works by Marlow, Hearne, Wheatley, Girtin, Cozens, Webber, Rooker, Sandby, and many others. It was, however, only for a short period in the mid-1790s that he had access to the quantity of Cozens subjects that he put to such memorable use in his

"Academy." This was an informal meeting of young artists invited by Monro to his house at 8, Adelphi Terrace. It was "like an Academy in an evening. He has young men employed in tracing outlines made by his friends &c.—Henderson, Hearne &c. lend him their outlines for this purpose" (Farington, *Diary*, 30 December 1794). John Henderson, a neighbor of Monro's in Adelphi Terrace, was another enthusiastic amateur who got young artists to copy for him; Hearne (see no. 163) was a well-established topographer. The most celebrated of Monro's "pupils" at this period were Turner and Girtin, who reported to Farington in 1798 that they "were employed by Dr. Monro 3 years to draw at his house in the evenings. They went at 6 and staid till Ten. Girtin drew in outlines and Turner washed in the effects. They were chiefly employed in copying the outlines or unfinished drawings of Cozens &c &c of which Copies they made finished drawings. Dr. Monro allowed Turner 3s 6d each night.—Girtin did not say what He had" (Farington, *Diary*, 12 November 1798). The students were placed two to a desk, facing each other and sharing a candle. Later, many men destined to be famous passed through the "Academy": Cotman, Varley, de Wint, and William Henry Hunt among them. (See Victoria and Albert Museum, *Dr. Thomas Monro and the Monro Academy*, exhibition catalogue, 1976.) A mass of surviving drawings which are executed in a distinct and readily recognizable "Monro style" testify to the considerable activity of this establishment. They are executed in washes of blue and gray, sometimes with ochre and green, over pencil outlines and cover a wide range of quality. It has proved difficult to identify the various hands which must have been involved; Monro's children, especially the gifted Henry (1791–1814) may have been responsible for some, though presumably at a slightly later date; artists like William Alexander (1767–1816) and Henry Edridge (1769–1821) must also have made drawings of this type. In addition, the work of an established draftsman like Edward Dayes (1763–1804), whose drawings Monro used as models, can be confused with the essays of the "Academy." Dayes in his turn had pupils and imitators, like the amateur antiquarian James Moore (1762–99), whose efforts are sometimes not unlike "Monro school" work.

While some of the subjects used in the exercises at Adelphi Terrace are easily traced to sources in Cozens's sketchbooks or tracings, there are many which cannot be identified, and it is clear that Monro used other material very like Cozens's in its continental subject matter. Since the pupils were almost invariably working from outlines and tracings, they would not have had much opportunity to imitate Cozens's coloring and watercolor technique, but it is obvious that they were well aware of his finished work, which they would have looked at with interest elsewhere and examples of which Dr. Monro could no doubt show them. A drawing such as the view *Near Grindelwald* (no. 170) raises the question whether Monro did not make a practice of borrowing works by Cozens in other collections, for it is copied directly from one of the Payne Knight series, which in all probability were in Payne Knight's possession at the time. See Oppé 1952, pp. 169–70.

Monro School: Anonymous

168. Fanale di Villa Franca. *c.*1795 Plate 58

Blue and gray washes over pencil on wove paper 4⅞ x 7⅜ (123 x 188)

Inscr. verso: with title, which also appears on a label from the original mount

Exh: Whitechapel Art Gallery, *Turner* 1953(128; as by Turner)

Coll: Thomas Griffith; by descent to his granddaughter, from whom bt. by L. G. Duke, 1926; Colnaghi, from whom bt. by Paul Mellon, 1973

B1977.14.5164

This subject is known only in one of the Beaumont tracings (no. 100), an outline taken from Charles Gore. The drawing has always been considered to be the work of Turner, and with some justification since Thomas Griffith was a close associate of Turner's in the artist's later years and bought some drawings at Monro's sale in 1833. Nevertheless it is hard to reconcile this sheet with Turner's style in the mid-1790s; and the writing on the verso is certainly not his. Compare *From the Isola Borromea*, no. 175, and *Near Stirzing*, no. 169, for examples of his manner at this time. The rather cold grays and blues of this sheet are reminiscent of the monochrome work of Edward Dayes.

Monro School: Thomas Girtin and J. M. W. Turner

169. Near Sterzing, Tyrol. *c.*1795 Plate 58

Pencil and watercolor on wove paper 6⁷⁄₁₆ x 9⅛ (167 x 232)

Coll: Agnew; Thomas Girtin, 1954; by descent to Tom Girtin; John Baskett, from whom bt. by Paul Mellon, 1970

B1975.3.889

This sheet is almost certainly an example of the joint work which Girtin and Turner did for Monro from the "Beaumont tracings." A sketch of the subject is in one of the Beckford sketchbooks (I, 10; Bell and Girtin, no. 203) and is inscribed *Near Strizengen Tirol—June 7*. The tracing (not recorded by Bell and Girtin, though numbered by Bell in the album *181*) is B1977.14.4592. A watercolor of the subject is in the Bacon collection (Bell and Girtin, no. 203).

Monro School: Thomas Girtin and J. M. W. Turner(?)

170. Near Grindelwald. *c.*1796 Plate 58

Pencil, with blue and gray washes on wove paper 9⅝ x 14⅞ (243 x 377)

Exh: B.F.A.C. 1923(65); John Mitchell & Son; Drapers' Hall; St. Helier, Jersey, Barreau Art Gallery, *A Loan Exhibition of English Watercolour Drawings* 1970–71(59, repr.)

Coll: The Earl of Warwick; Thomas Halsted; Henry Harper Benedict; John Mitchell & Son, from whom bt by Paul Mellon, 1975

B1975.3.1246

This subject is copied from one of the drawings of Cozens's 1776 tour with Payne Knight, Bell and Girtin, no. 18 i (repr. pl.III(a)), in the Victoria and Albert Museum (Dyce 711); a finished watercolor of the subject (Bell and Girtin, no. 18 ii) is in the Ashmolean Museum, Oxford. Technically this copy is very close to the view *On the banks of the Lago di Como* (no. 171).

Monro School: Thomas Girtin and J. M. W. Turner(?)

171. On the banks of the Lago di Como.
c.1796 Plate 59

Pencil with blue, gray, and brown washes on wove paper 14⅛ x 9¾ (358 x 247)

Inscr. verso with title and *7*

Exh: London, Messrs. Agnew, *Thomas Girtin* 1953(19)

Lit: H. W. Underdown, *Five Turner Water-colour Drawings* (privately printed, 1923); T. Girtin and D. Loshak, *The Art of Thomas Girtin* (London, 1954), p. 204, repr. pl. 106

Coll: Dr. Thomas Monro, sale, Christie 26–28 June, 1–2 July 1833(105?), bt. Moon, Boys & Graves; Dr. Pocock; H. W. Underdown; L. G. Duke; Thomas Girtin; by descent to Tom Girtin; John Baskett, from whom bt. by Paul Mellon, 1970

B1975.3.1220

This subject has been known as "In the Via Mala," under which title it was catalogued by Girtin and Loshak; they considered it to be the work of Girtin alone, but there is every reason to suppose that the drawing is a collaboration between Girtin and Turner. It is very close in style to the view *Near Grindelwald* (no. 170), which has been universally accepted as the work of Turner, though the pencil underdrawing is perhaps weaker in this sheet. The title given here is that inscribed on the back of the drawing, which was presumably taken from the original of which it is a copy. This may well have been, like *Near Grindelwald*, one of the Payne Knight set of drawings of 1776, though it is no longer traced, so that the title would have been Cozens's own.

Monro School: Thomas Girtin and J. M. W. Turner(?)

172. In the Via Mala. *c*.1796 Plate 59

Pencil with blue and gray washes on wove paper 15¹⁵⁄₁₆ x 9⅝ (380 x 245)

Inscr. verso: *Bridge & hollow rock/over the Rhine in/ the Via Mala/ between Coire & Chiavenna in the Grisons* and *48*

Lit: H. W. Underdown, *Five Turner Water-colour Drawings* (privately printed, 1923, repr.); T. Girtin and D. Loshak, *The Art of Thomas Girtin* (London, 1954), p. 204

Coll: Dr. Thomas Monro, sale, Christie 26–28 June, 1–2 July 1833(105?), bt. Moon, Boys & Graves; Dr. Pocock; H. W. Underdown; Walker's Gallery; L. G. Duke; Thomas Girtin; by descent to Tom Girtin; John Baskett, from whom bt. by Paul Mellon, 1970

B1975.3.1218

Like no. 171 this sheet was accepted by Girtin and Loshak as wholly the work of Girtin. It is less successful than that drawing, especially in the rendering of the fir trees in the upper left; but the coloring is identical to it and may well be Turner's. No source has been traced for the subject, but like nos. 171 and 173 it may derive from a lost drawing from the Payne Knight set.

Monro School: J. M. W. Turner(?) (1775–1851)

173. Near Chiavenna. *c*.1796 Plate 59

Pencil with blue and gray washes on wove paper 14⅞ x 9⁷⁄₁₆ (378 x 240)

Inscr. verso: *Near Chiavenna/Grisons* and *52; 6*

Exh: Sheffield, Graves Art Gallery, *Early Water-colours from the Collection of Thomas Girtin Jnr.* 1953(40); London, Royal Academy, *The Girtin Collection* 1962(30); Reading Museum and Art Gallery, *Thomas Girtin and some of his Contemporaries* 1969(28)

Lit: H. W. Underdown, *Five Turner Water-colour Drawings* (privately printed, 1923); T. Girtin and D. Loshak, *The Art of Thomas Girtin* (London, 1954), p. 204

Coll: Dr. Thomas Monro, sale, Christie 26–28 June, 1–2 July 1833(105?), bt. Moon, Boys & Graves; Dr. Pocock; H. W. Underdown; L. G. Duke; Thomas Girtin, 1928; by descent to Tom Girtin; John Baskett, from whom bt. by Paul Mellon, 1970

B1975.3.1219

No original study of this subject by Cozens or another artist has been traced, though one might compare, for example, the Beaumont tracing of a bridge and cascade, B1977.14.4445 (no. 105 in this catalogue). On the analogy of nos. 171 and 172 it is most likely to be a copy from one of the lost drawings of the Payne Knight set. Girtin and Loshak considered this sheet to be wholly the work of Girtin after Cozens, though they did not identify the source precisely. The free round forms of the bushes on the hillside and the loose blobs of modulated light and darker toned wash by which they are articulated seem typical of Turner's style in this kind of drawing; the pencil underdrawing is less consistently Turnerian, however, than the handling of the washes.

Monro School: Thomas Girtin(?) (1775–1802)

174. Rocca del Papa, with Monte Cavo.
c.1796 Plate 60

Pencil and watercolor on wove paper 6⅝ x 9¼ (168 x 236)

Inscr. verso: *Monte cava*

Exh: London, Messrs. Agnew, *Thomas Girtin* 1953(20); London, Royal Academy, *The Girtin Collection* 1962(25)

Lit: T. Girtin and D. Loshak, *The Art of Thomas Girtin* London 1954, p. 205

Coll: Dr. Thomas Monro, sale, Christie, 26–28 June, 1–2 July, 1833(81?) bt. Hixon; Dr. Pocock; A. J. Finberg; Thomas Girtin; by descent to Tom Girtin; John Baskett, from whom acquired by Paul Mellon, 1970

B1975.3.840

While this subject does not occur in the Beckford sketchbooks nor in the Beaumont album, it is evidently taken from one of the missing sketches of Cozens's second stay in Italy. As usual with Monro school copies, there has always been uncertainty as to whether it is

the work of Girtin or of Turner; Dr. Pocock recorded on a label that Ruskin had pronounced it "quite pure and lovely" as a Turner; Girtin and Loshak, however, consider it to be by Girtin and to date from 1796. This seems to be a correct assessment.

Monro School: J. M. W. Turner(?) (1775–1851)

175. From the Isola Borromea—Lago Maggiore. *c.*1795 Plate 60

Pencil and watercolor on wove paper 5¾ x 9¹/₁₆ (148 x 230)

Inscr. verso: *56(?)*

Coll: Martyn Gregory, from whom bt. by Paul Mellon, 1971

B1975.4.1425

The original of this copy was perhaps a tracing, now lost, from the Beaumont series; but it might have been taken directly from the drawing in the Beckford sketchbook, VII, 2, which is inscribed *From the Isola Borromea—Lago Mago.* A finished watercolor by Cozens of the subject belonged to Beckford and is now in the Oppé collection (Bell and Girtin, no. 414). The soft, warm color and easy suggestion of luminous space indicate that Turner is the copyist, and it is unlikely that the delicate pencil outline beneath the wash is the work of another hand; compare the bolder use of pencil in nos. 170 and 171.

Monro School: Thomas Girtin and J. M. W. Turner(?)

176. Buildings overlooking water—near Naples(?) *c.*1796 Plate 60

Pencil with gray and blue washes on wove paper 10¼ x 14¾ (263 x 375)

Coll: John Baskett, from whom bt. by Paul Mellon, 1969

B1975.4.1422

In handling and especially in the pencilwork, this study is comparable with the views on the Splugen route, nos. 171–173, which appear to be copies from lost drawings from the Payne Knight series. This subject is also untraced in its original version and has hitherto been known simply as "Italian landscape." It is possible that it shows buildings at Capodimonte or Posilippo; compare pages in the Beckford sketchbooks, III, 22,23 and V, 3 verso-4, and it may therefore derive from a subject noted in one of the missing books. The size of the sheet, however, suggests that it was taken from a more finished drawing.

Joseph Mallord William Turner (1775–1851)

177. Tivoli with the Temple of the Sybil and the Cascades. *c.*1796 Plate 61

Pencil and watercolor on wove paper 16½ x 21⅝ (419 x 550)

Coll: William Leaf, sale, Christie 7 May 1875; bt. Agnew; Mrs. Reiss; by descent to Stephen Reiss; Agnew, from whom bt. by Paul Mellon, 1970

B1977.14.356

Both in its subject matter and in its treatment this drawing is typical of the work that Turner did for Dr. Monro about 1796. It does not, however, seem to derive from any subject noted by John Robert Cozens and presumably relies on a drawing by some other artist, perhaps Jakob Philipp Hackert (see no. 147). It is one of the grandest and most convincing of the numerous "copies" that Turner made at this time, and in the rendering of the spray of the fall anticipates his virtuoso treatment of such themes later in his career.

Index

Numbers refer to Catalogue entries

Plates

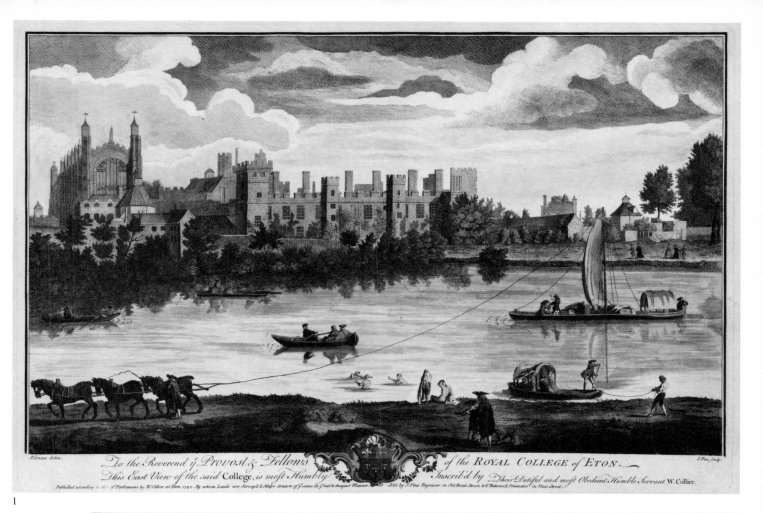

To the Reverend ỷ *Provost* & *Fellows* of the ROYAL COLLEGE of ETON.

This East View of the said College, is most Humbly Inscrib'd by Their Dutiful and most Obedient Humble Servant W. Collier.

Published according to Act of Parliament by W. Collier at Eton. 1742. By whom Lands are Surveyd & Maps drawn of ỷ same in ỷ best & cheapest Manner. Sold by J. Pine Engraver in Old Bond Street, & T. Bakewell, Printseller in Fleet Street.

A. Corens delin.

J. Pine sculp.

1

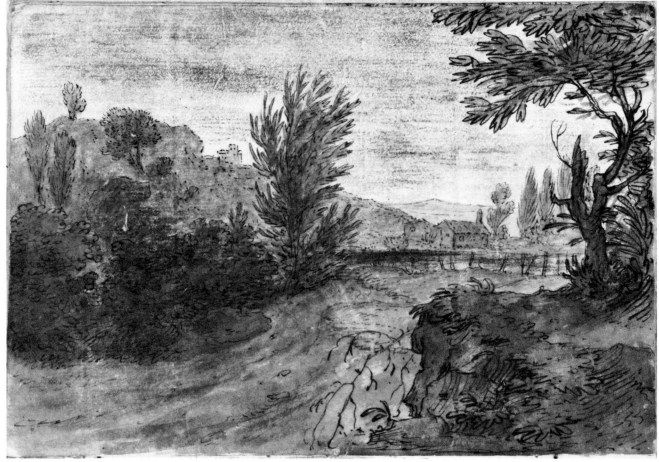

2 (p. 86 *verso*)

Plate 1

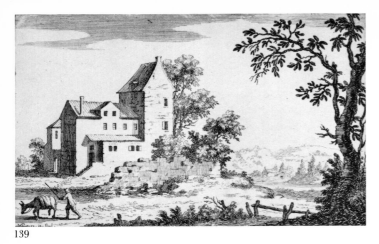

139

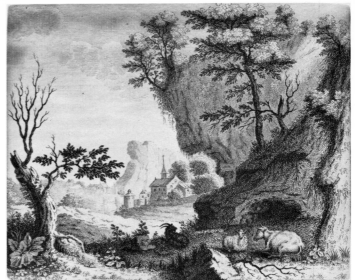

140

141

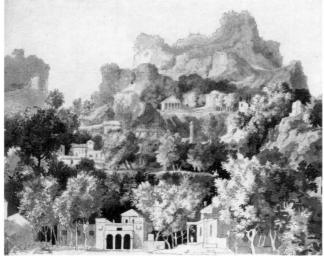

142

Plate 2

3

143

4

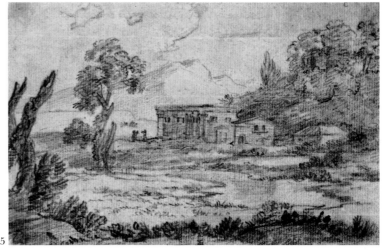

5

Plate 3

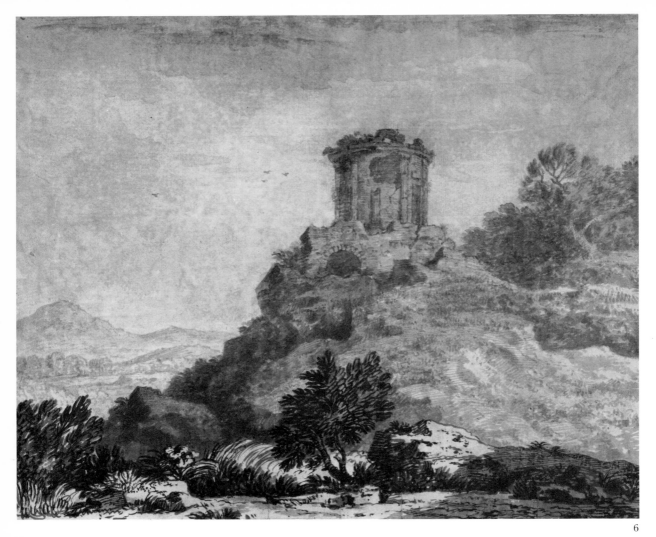

6

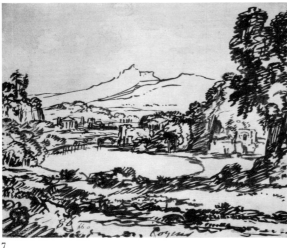

7

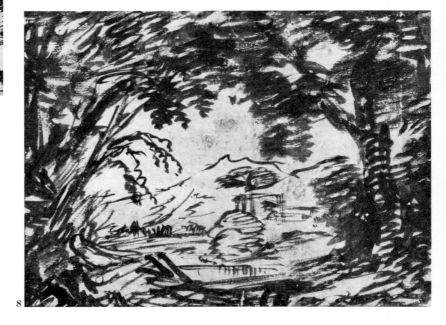

8

Plate 4

9

144

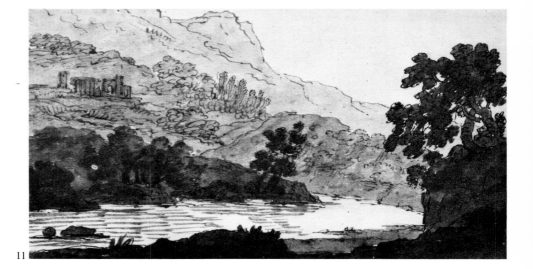

10

11

Plate 5

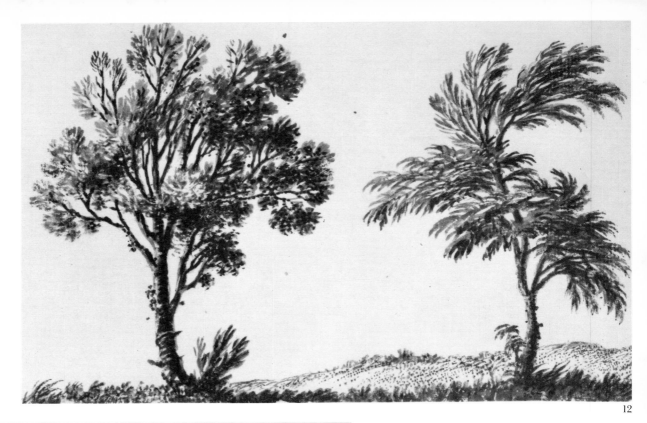

12

13

14

15

Plate 6

16

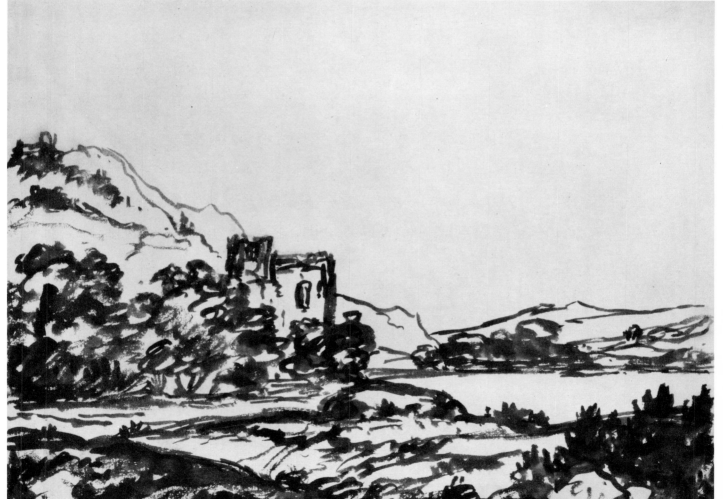

17

Plate 7

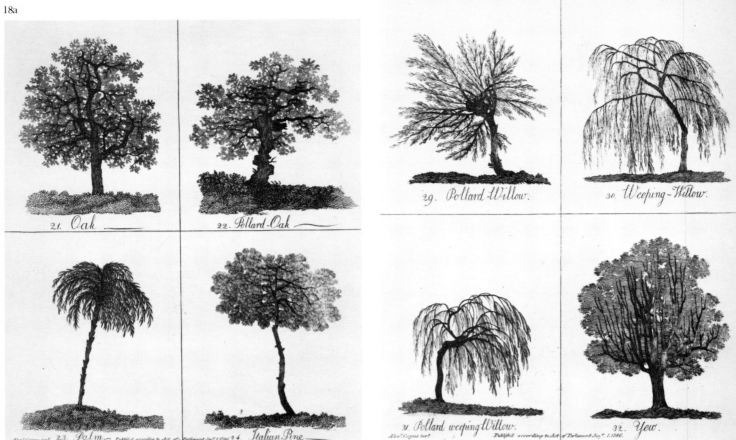

21. Oak

22. Pollard-Oak

29. Pollard Willow.

30. Weeping-Willow.

Alex.r Cozens inv.t 23. Palm. Publish'd according to Act of. Parliament Jan.y 1.1786. 24. Italian Pine.

31. Pollard weeping Willow.

32. Yew.

Alex.r Cozens inv.t Publish'd according to Act of Parliament Jan.y 1.1786.

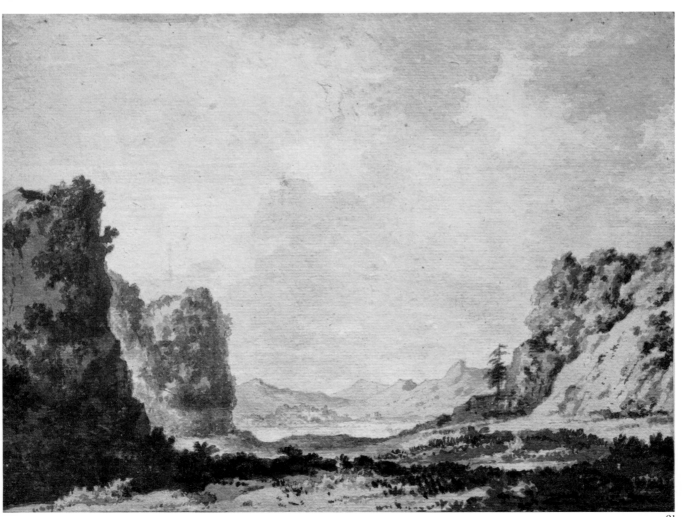

Plate 8

150

151

152

Plate 9

22

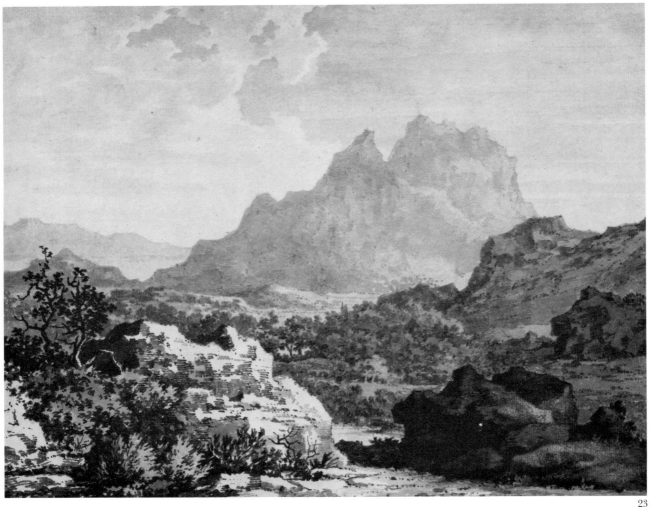

23

Plate 10

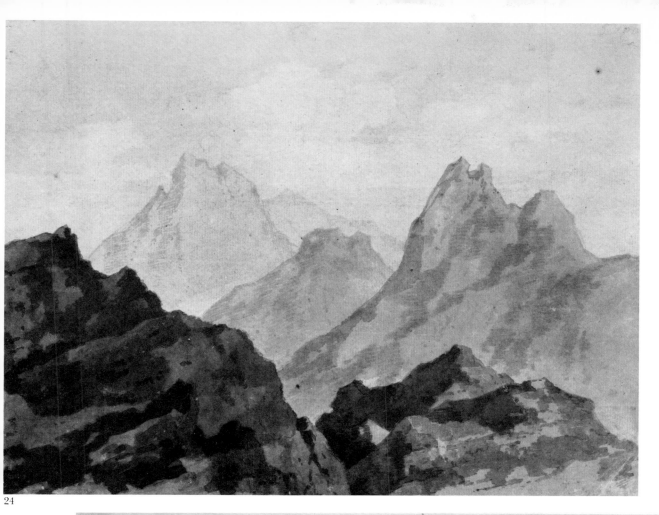

24

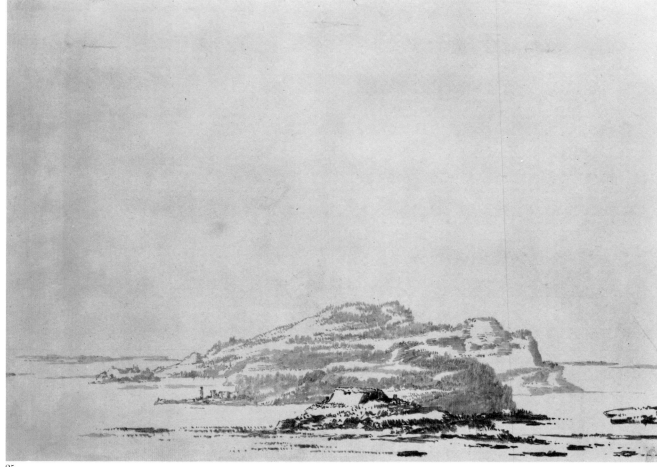

25

Plate 11

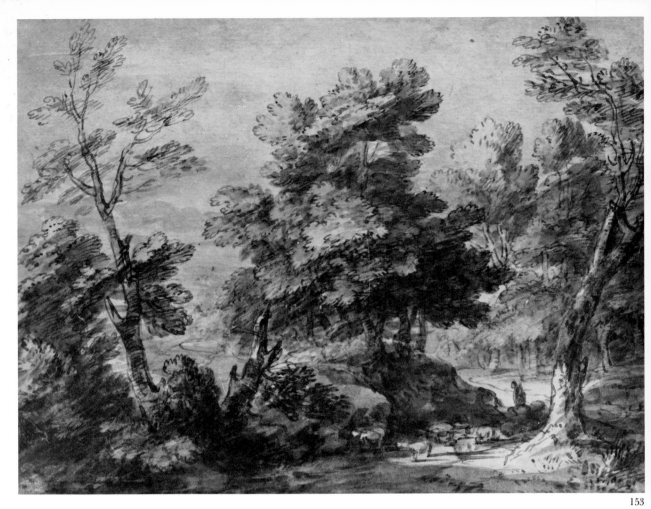

153

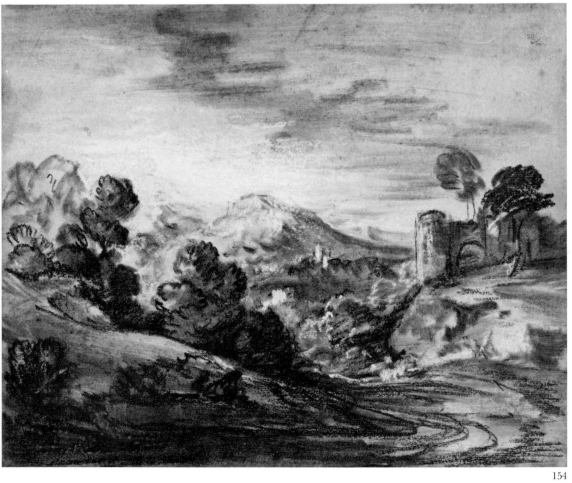

154

Plate 12

1

Alex.ᵗCozens inv. Publifh'd according to Act of Parliament.

26

2

27

Plate 13

28

29

Plate 14

5

30

6

31

Plate 15

7

32

8

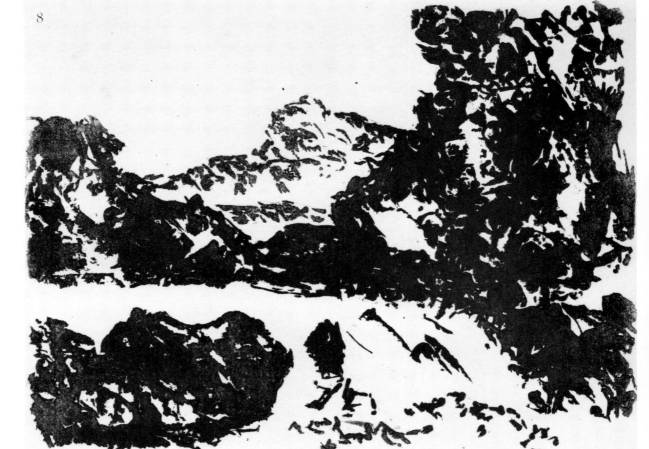

33

Plate 16

9

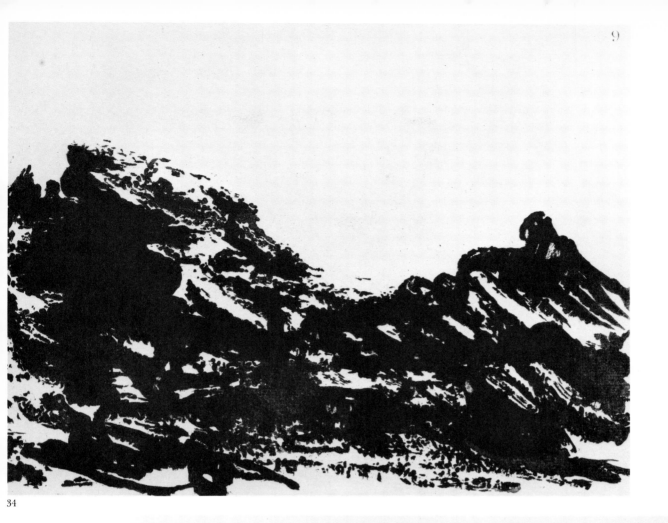

34

10

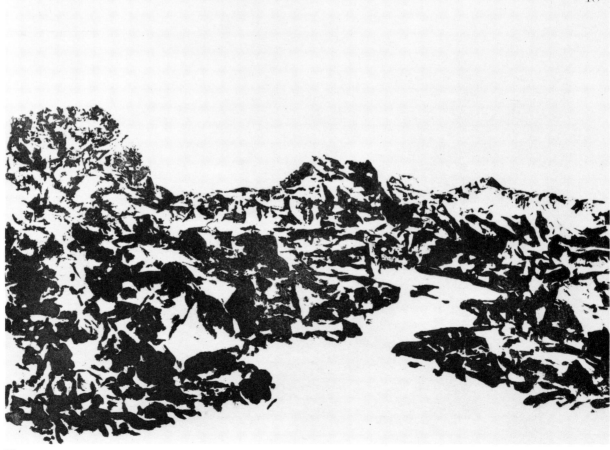

35

Plate 17

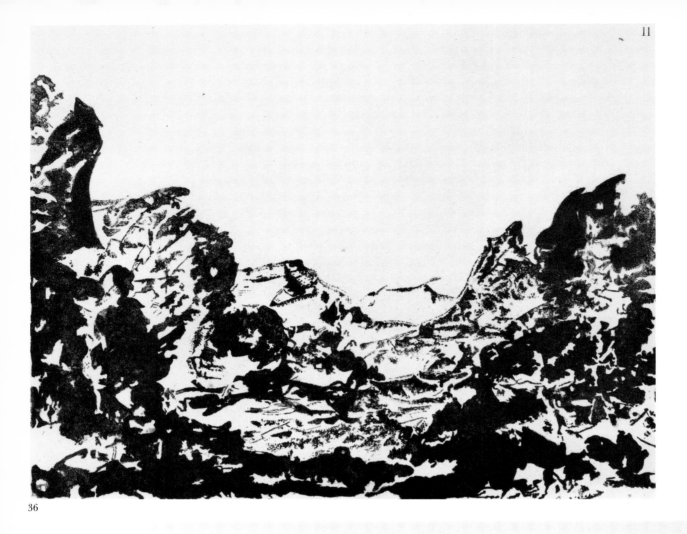

36

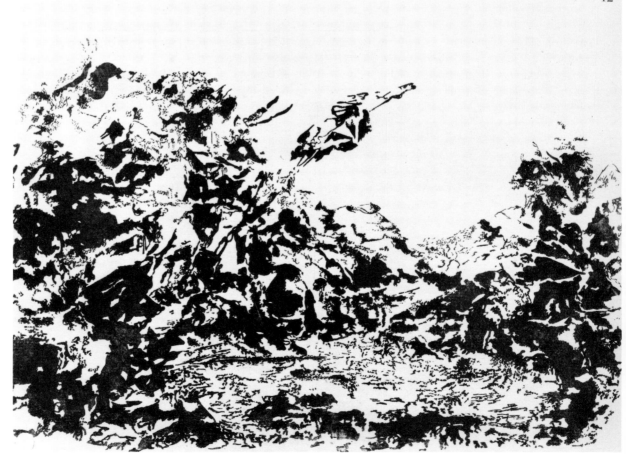

37

Plate 18

13

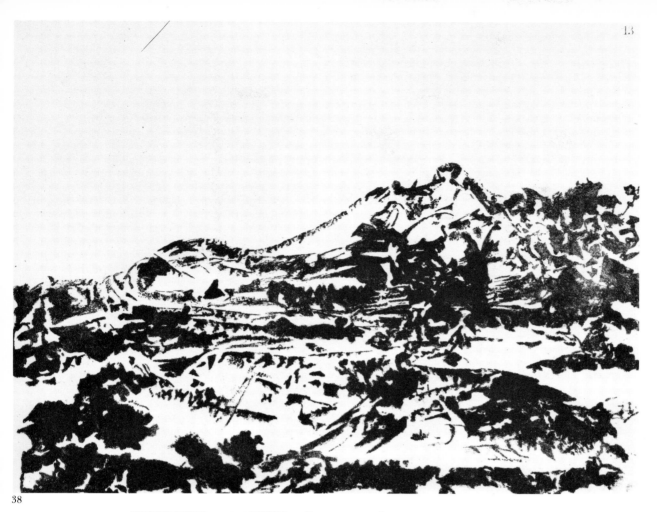

38

14

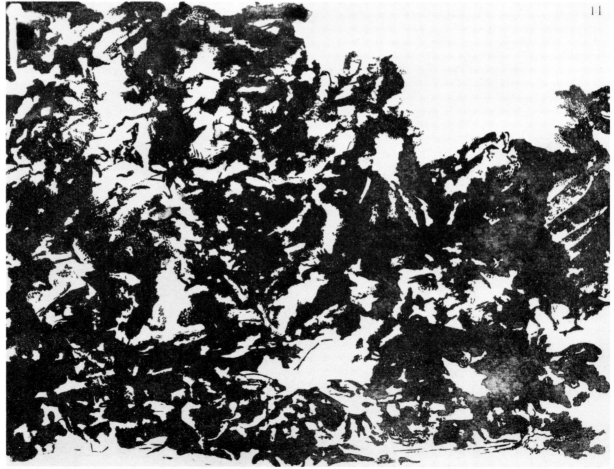

39

Plate 19

40

41

Plate 20

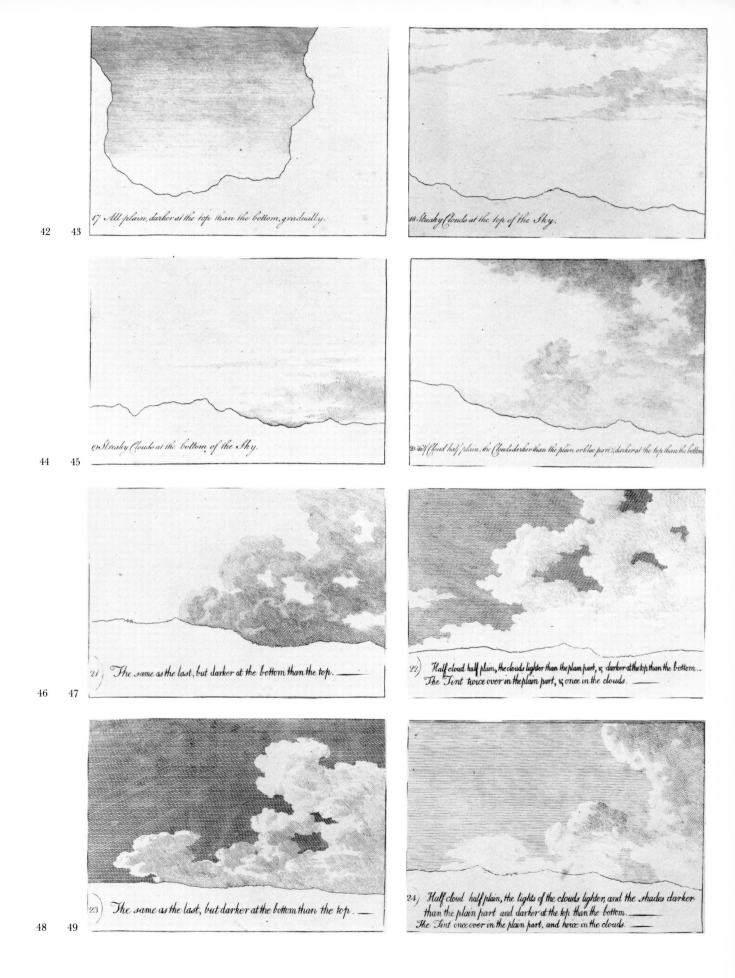

17 All plain, darker at the top than the bottom, gradually.

18 Streaky Clouds at the top of the Sky.

42 43

19 Streaky Clouds at the bottom of the Sky.

20 Half Cloud half plain, the Clouds darker than the plain or blue part; darker at the top than the bottom.

44 45

21) The same as the last, but darker at the bottom than the top. ———

22) Half cloud half plain, the clouds lighter than the plain part, & darker at the top than the bottom. The Tint twice over in the plain part, & once in the clouds. ———

46 47

23) The same as the last, but darker at the bottom than the top. ———

24) Half cloud half plain, the lights of the clouds lighter, and the shades darker than the plain part and darker at the top than the bottom. The Tint once over in the plain part, and twice in the clouds. ———

48 49

Plate 21

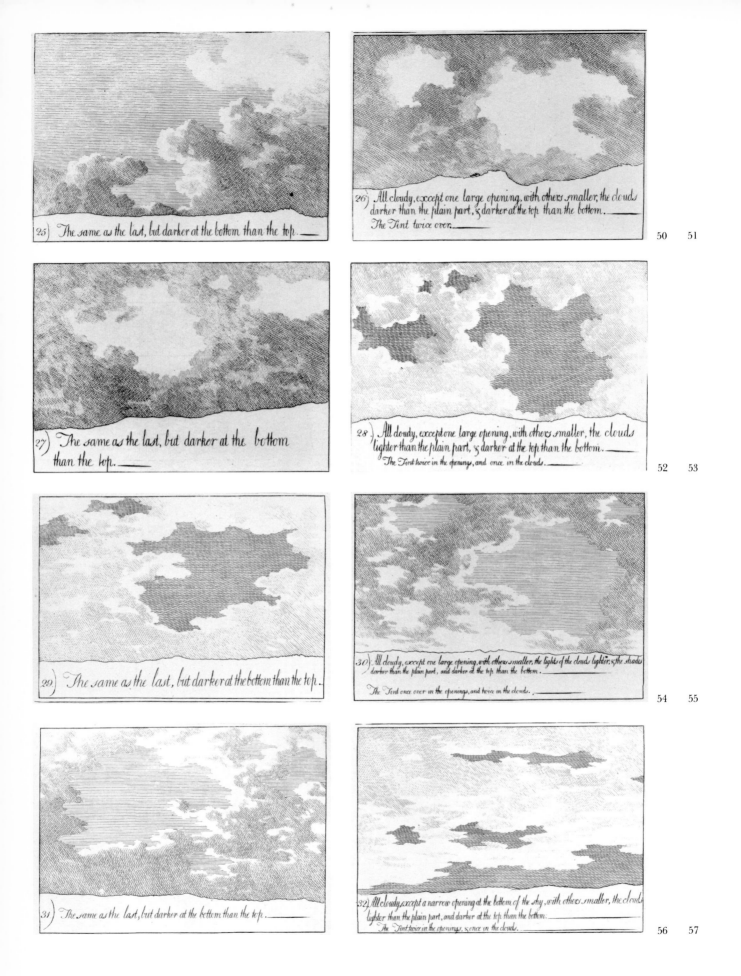

25) The same as the last, but darker at the bottom than the top. ——

26) All cloudy, except one large opening, with others smaller, the clouds darker than the plain part, & darker at the top than the bottom. —— The Tint twice over. ——

27) The same as the last, but darker at the bottom than the top. ——

28.) All cloudy, except one large opening, with others smaller, the clouds lighter than the plain part, & darker at the top than the bottom. —— The Tint twice in the openings, and once in the clouds. ——

29) The same as the last, but darker at the bottom than the top. ——

30) All cloudy, except one large opening, with others smaller, the lights of the clouds lighter, & the shades darker than the plain part, and darker at the top than the bottom. —— The Tint once over in the openings, and twice in the clouds. ——

31) The same as the last, but darker at the bottom than the top. ——

32) All cloudy, except a narrow opening at the bottom of the sky, with others smaller, the clouds lighter than the plain part, and darker at the top than the bottom. —— The Tint twice in the openings, & once in the clouds. ——

50 51

52 53

54 55

56 57

Plate 22

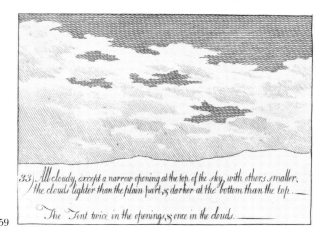

33) All cloudy, except a narrow opening at the top of the sky, with others smaller, the clouds lighter than the plain part, & darker at the bottom than the top. —

The Tint twice in the openings, & once in the clouds. —

58 59

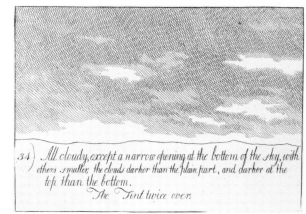

34) All cloudy, except a narrow opening at the bottom of the sky, with others smaller; the clouds darker than the plain part, and darker at the top than the bottom.

The Tint twice over.

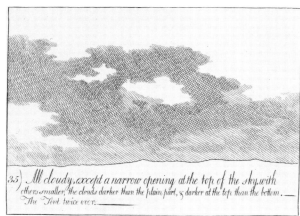

35) All cloudy, except a narrow opening at the top of the sky, with others smaller, the clouds darker than the plain part, & darker at the top than the bottom. —

The Tint twice over. —

60 61

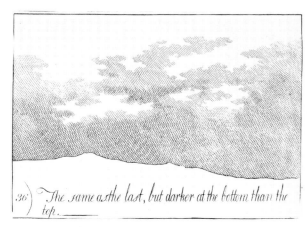

36) The same as the last, but darker at the bottom than the top. —

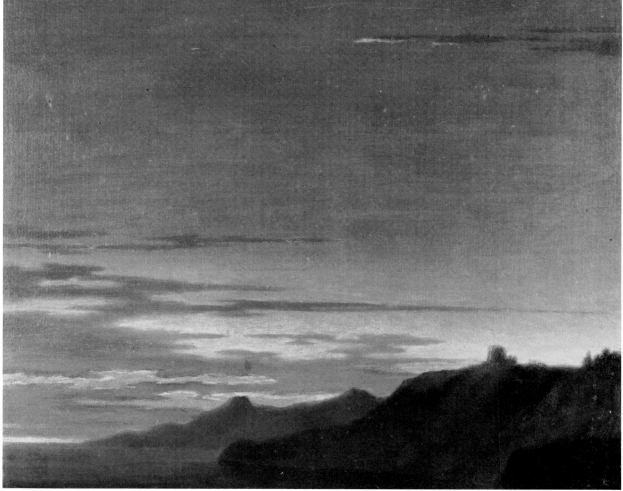

19

Plate 23

62

63

64

Plate 24

40

65

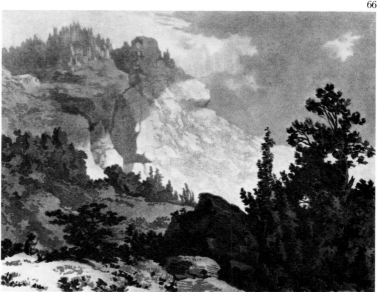

66

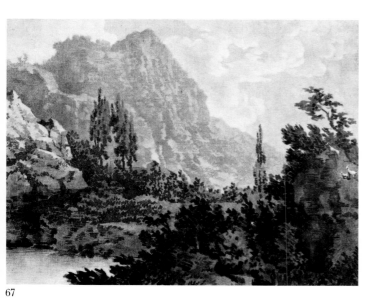

67

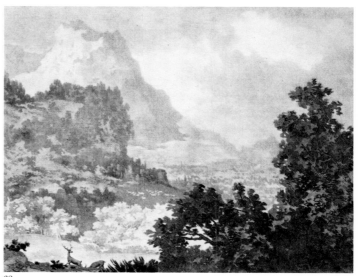

68

Plate 25

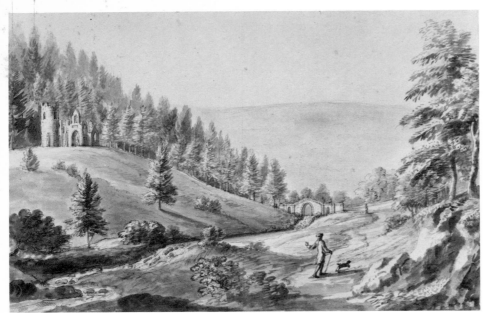

145

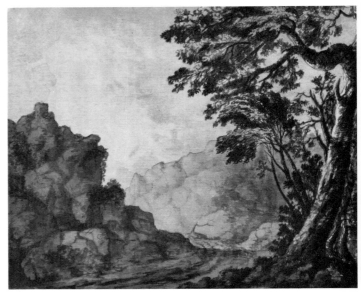

155

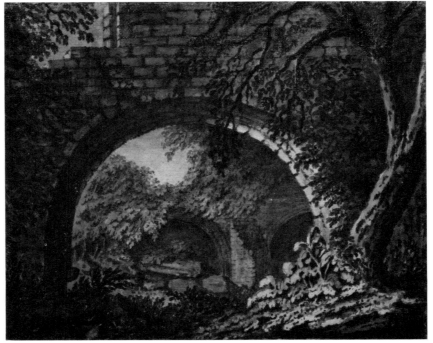

156

Plate 26

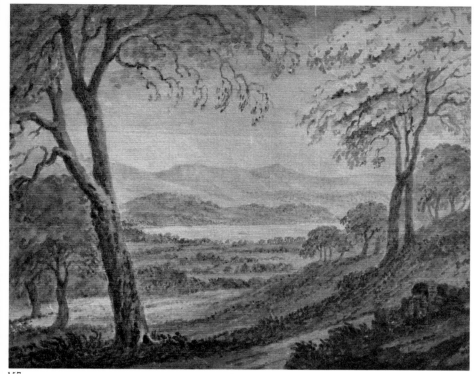

157

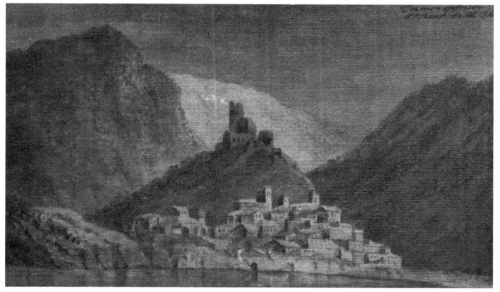

158

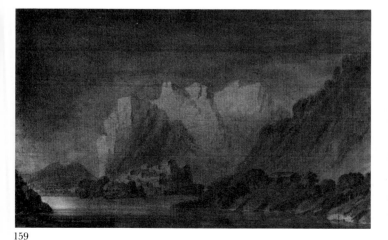

159

167

Plate 27

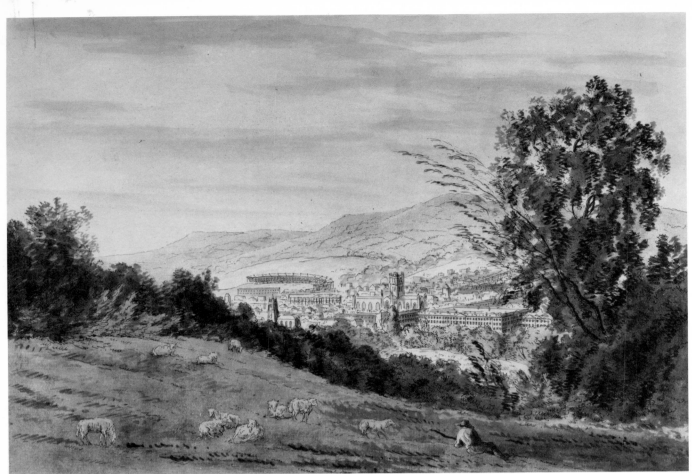

75

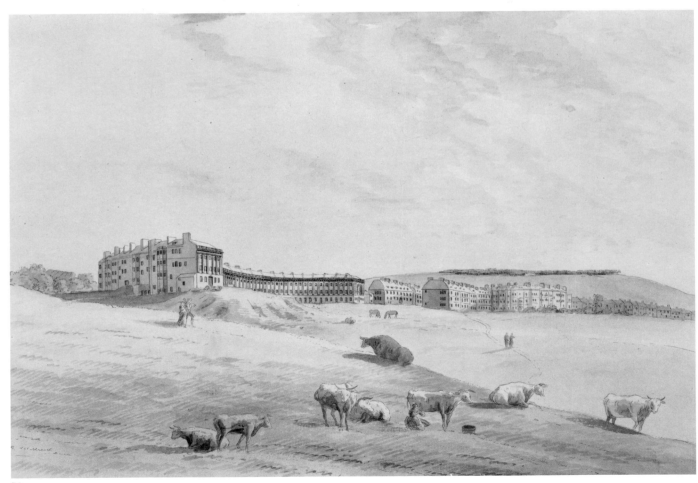

76

Plate 28

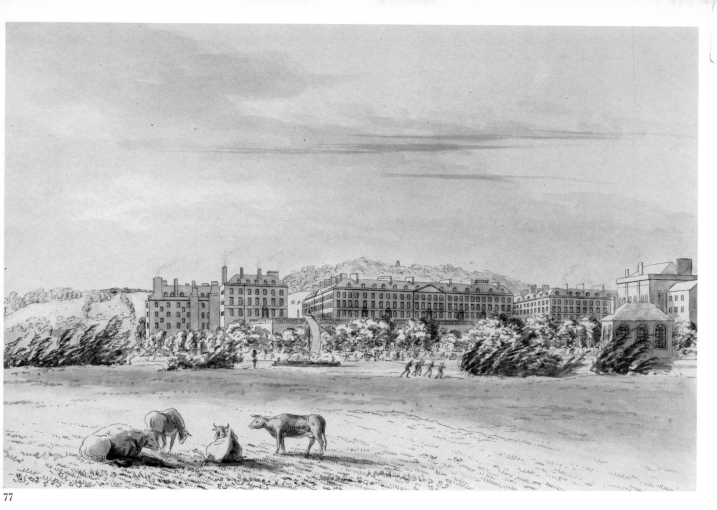

77

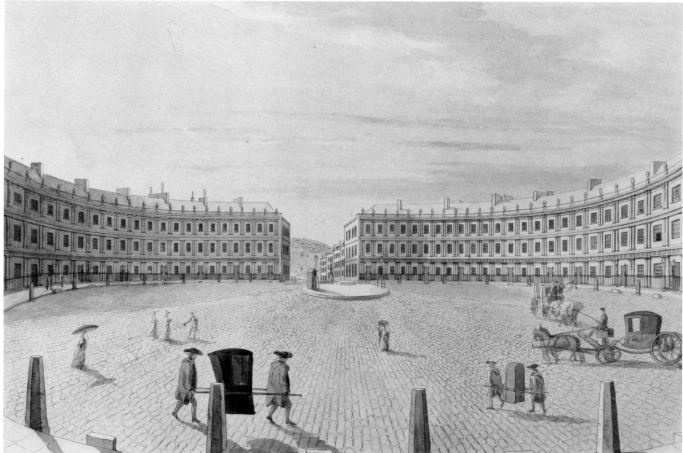

78

Plate 29

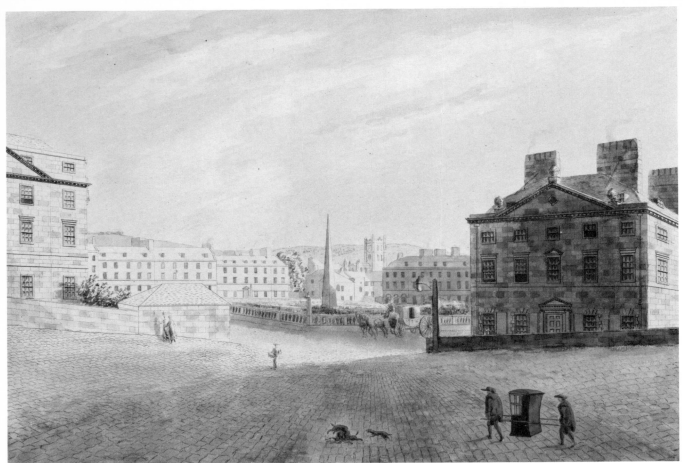

79

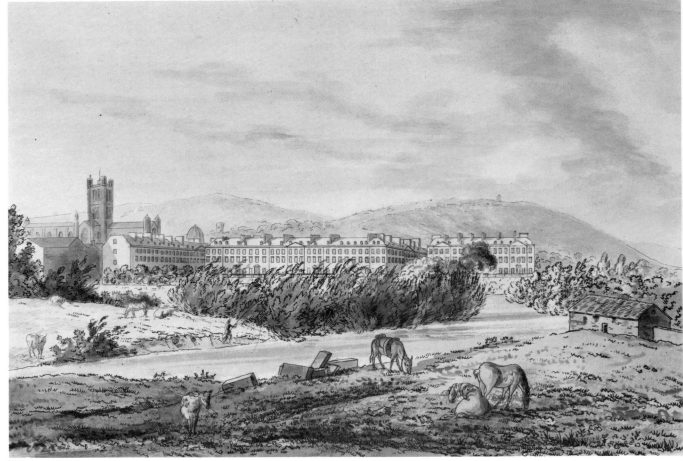

80

Plate 30

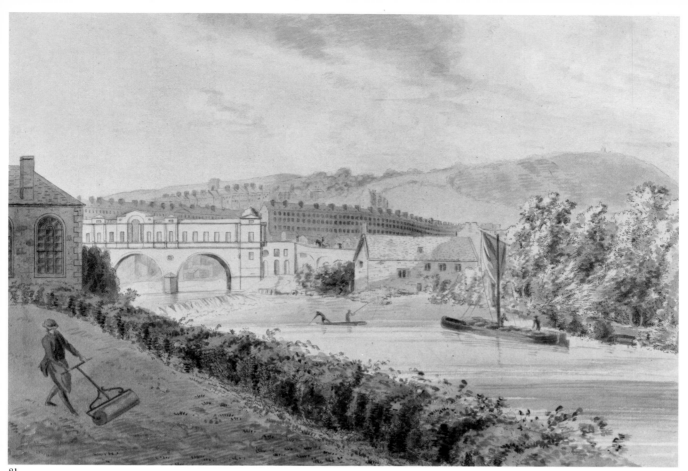

81

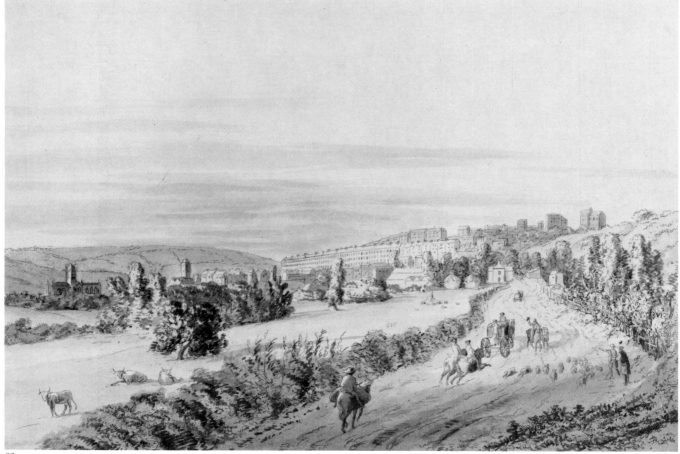

82

Plate 31

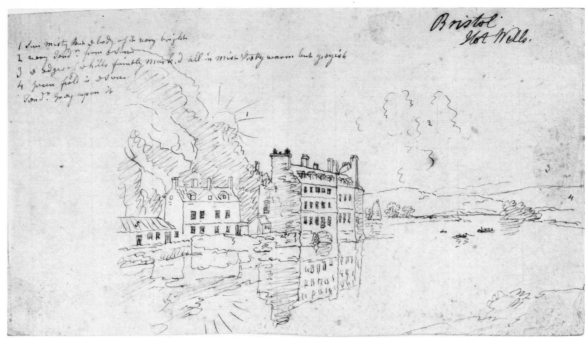

83

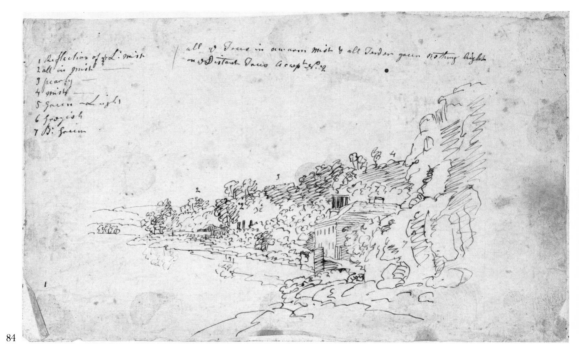

84

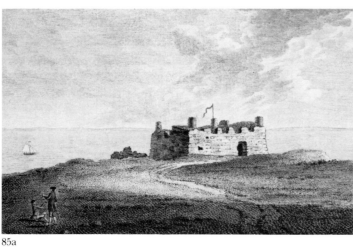

85a

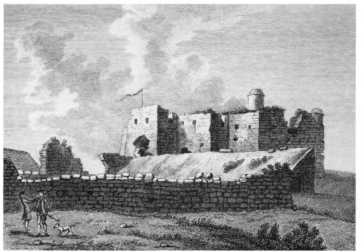

85b

Plate 32

86

87

Plate 33

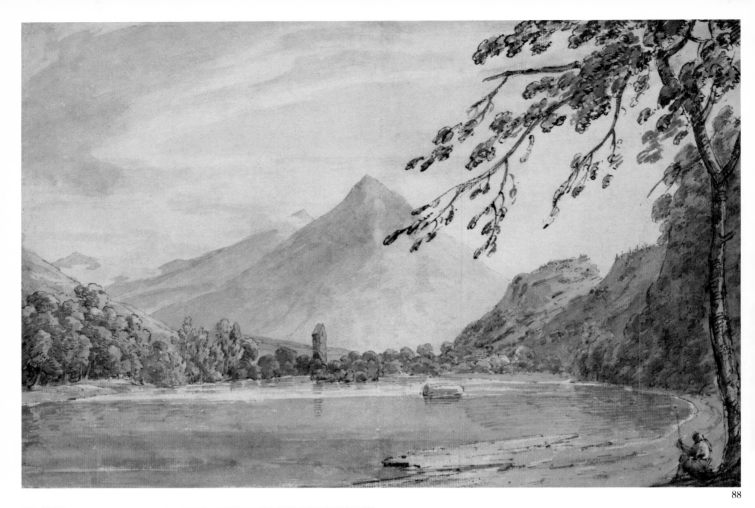

88

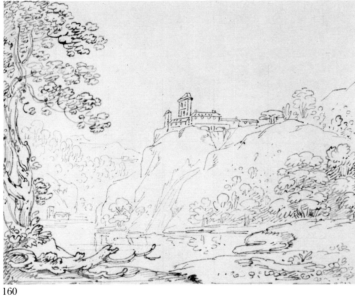

160

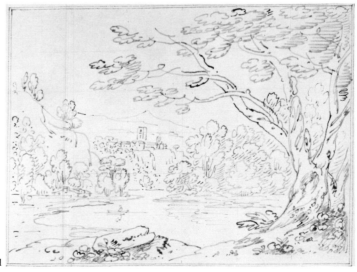

161

Plate 34

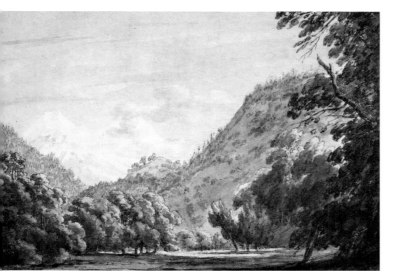

90

135

Plate 35

91

92

Plate 36

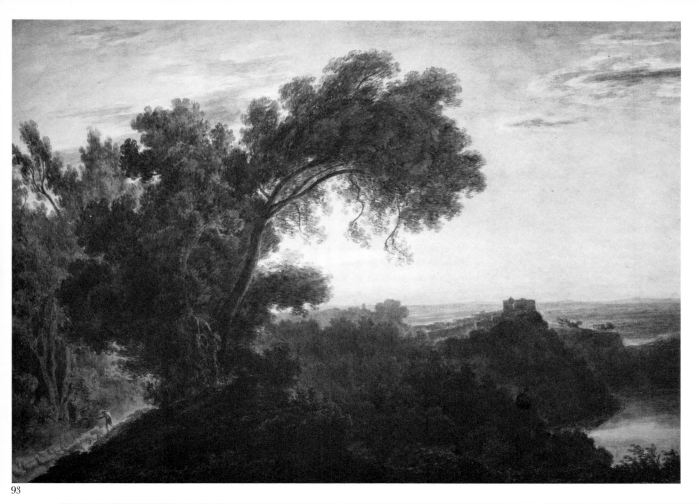

93

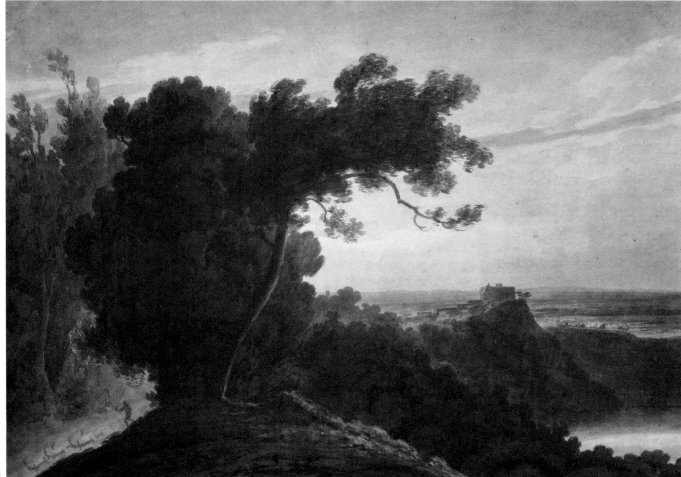

134

Plate 37

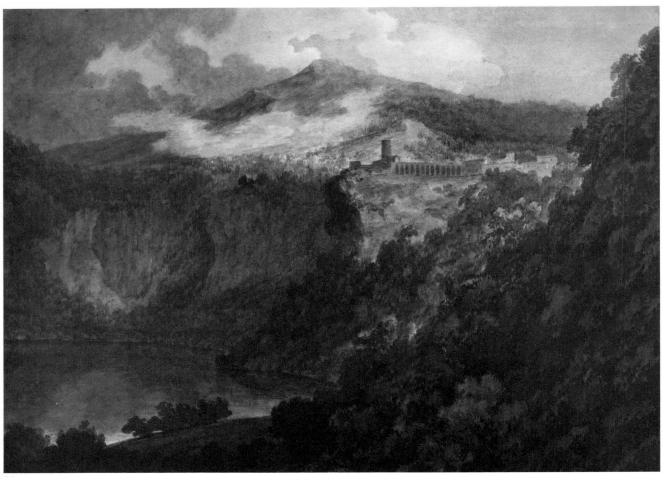

94

95

Plate 38

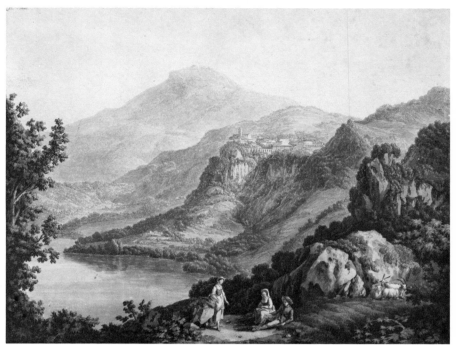

147

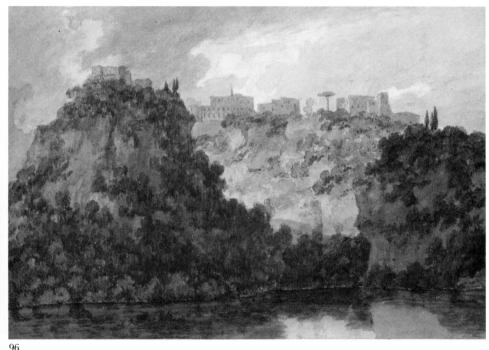

96

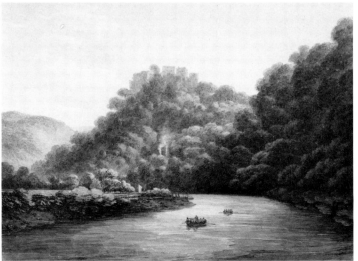

163

Plate 39

97

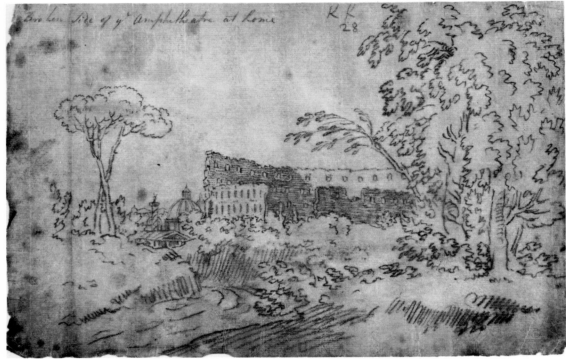

98

99

Plate 40

101

The Roman arch at Canterbury

102

Plate 41

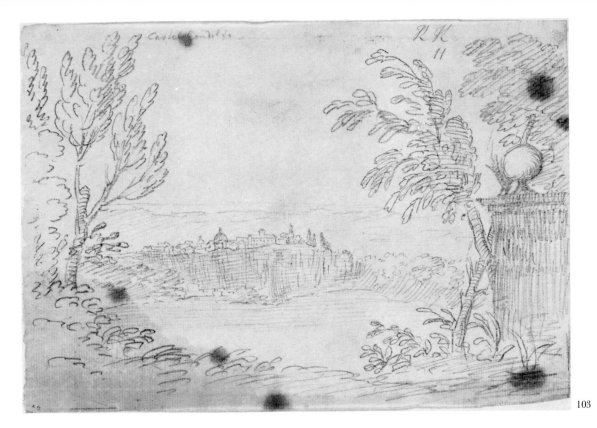

103

104

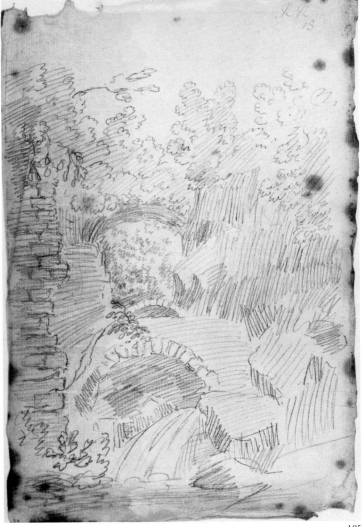

105

Plate 42

Waterfall at Terni.

106

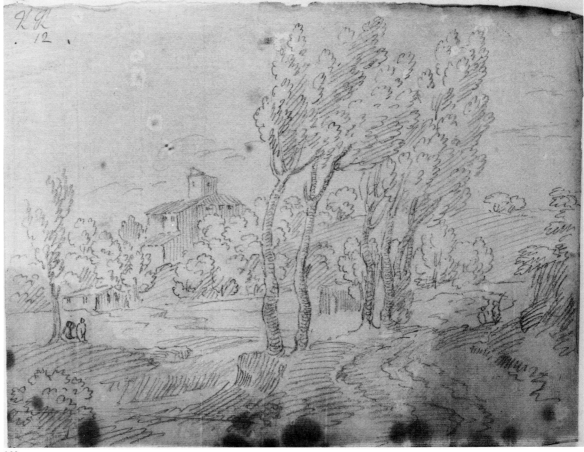

109

Plate 43

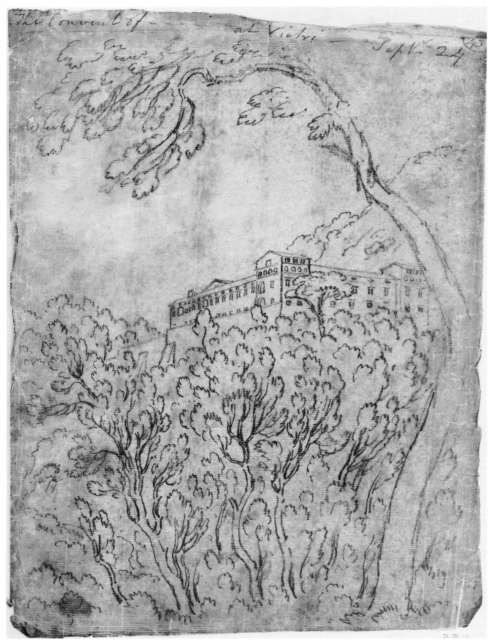

The Convent of _____ at Vietri _____ Sept. 24

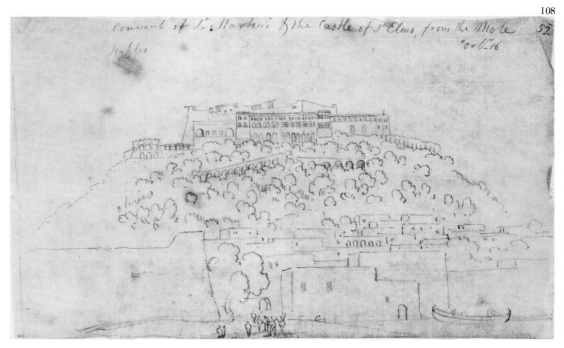

Convent of S.t Martini & the Castle of S.t Elmo, from the Mole
Naples
Octr. 16
52

Plate 44

110

At Portici — august 9 — evening —

111

Monte Circello, from the road between Terracina & Veletri — Dec. 9

112

Plate 45

The Pagliaro in the myrtle plantation at S.r W. Hamilton's Villa Portici
august 30

113

Part of Padua from the walls — The mountains of the Tirol —
June 18.

18

114

From Mira-bella — the Villa of Count Algarotti —
on the Euganian Hills — 10 miles from Padua
June 19 -

20

116

Plate 46

groft in the Garden of San Francescani ...Salest...
...22. near 1800 gdearth...
... 39

115

near aquebelle — oct. 22. 9

117

From the top of the Arena — Verona — June 10. 15

118

Plate 47

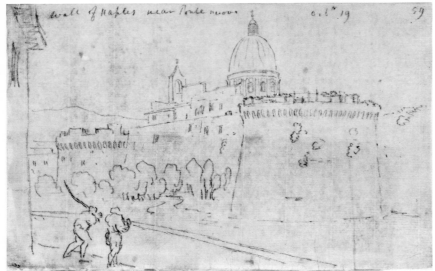

119

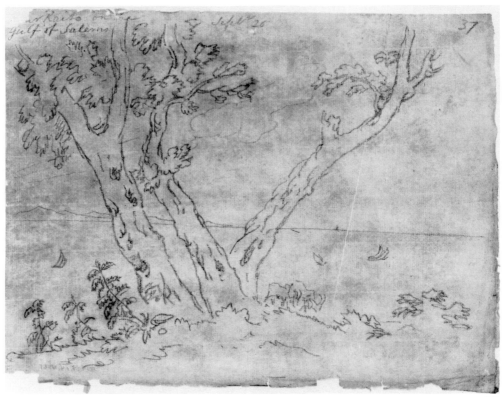

120

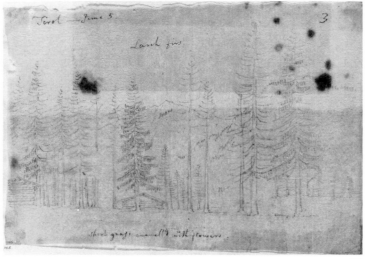

121

Plate 48

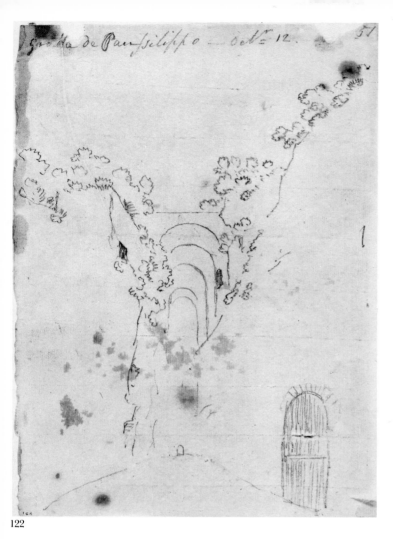

122

123

124

Plate 49

126

127

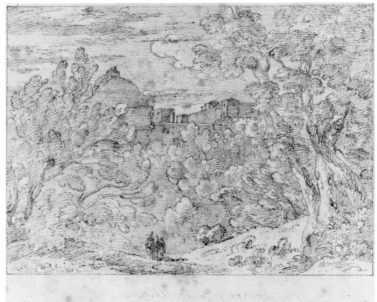

128

Plate 50

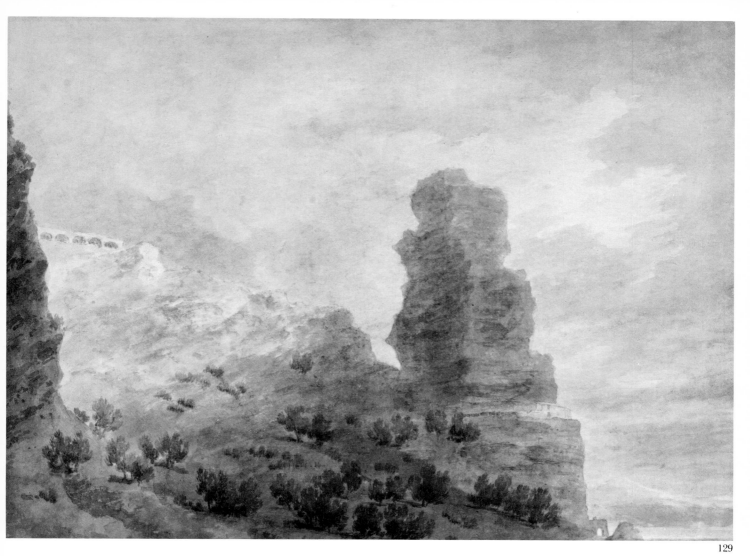

129

125

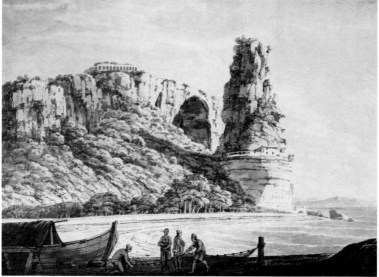

148

Plate 51

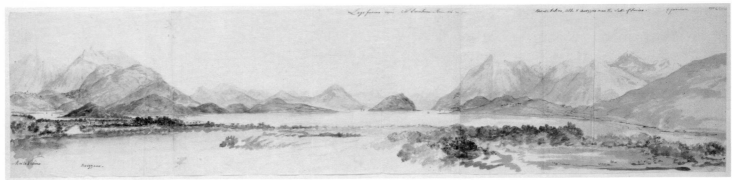

146

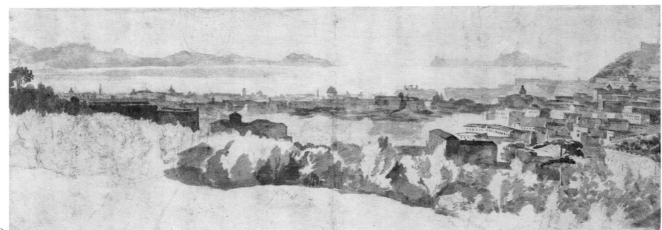

149

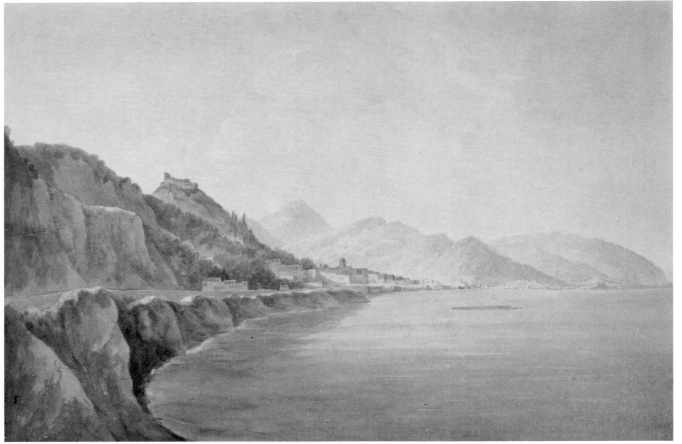

162

Plate 52

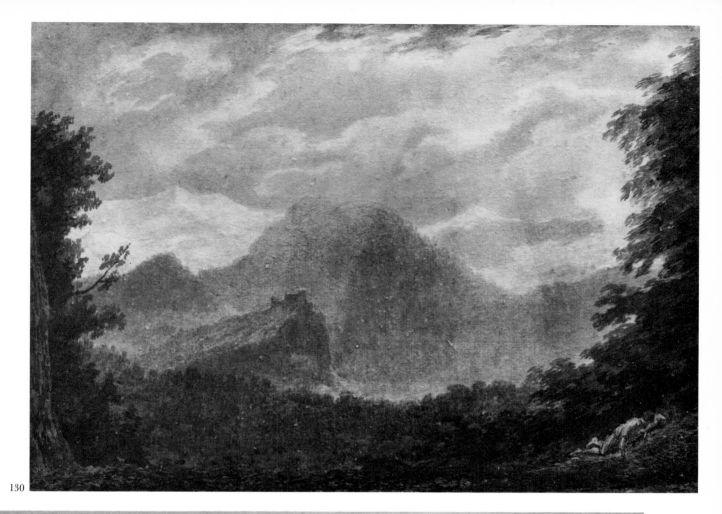

130

131

Plate 53

132

133

Plate 54

136

Plate 55

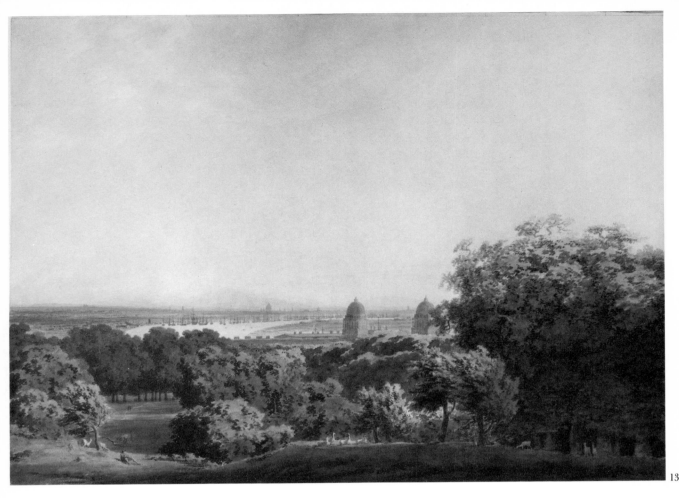

137

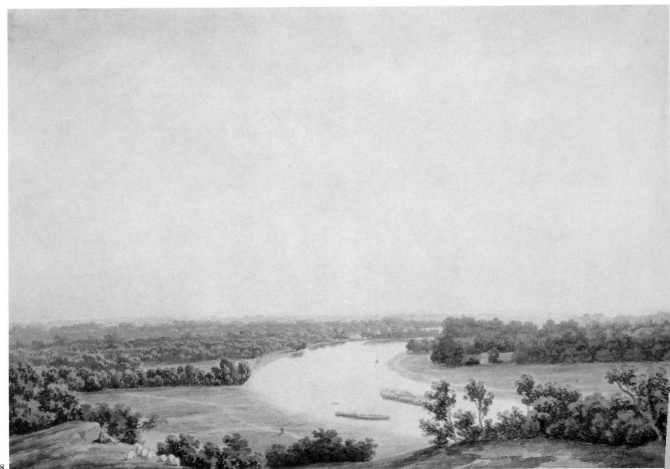

138

Plate 56

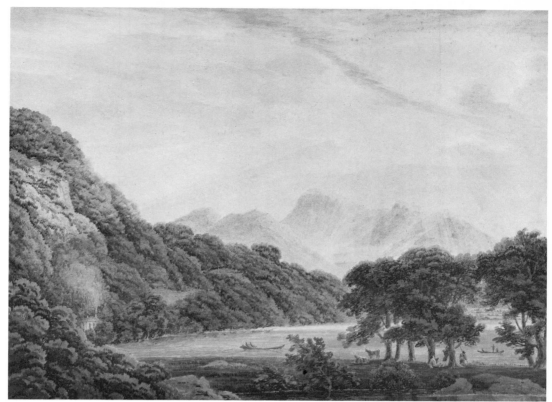

164

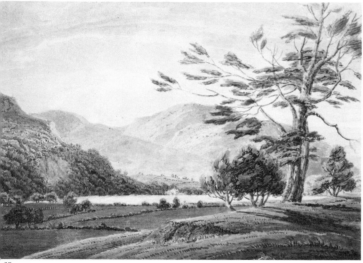

65

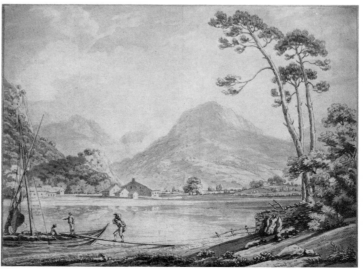

166

Plate 57

100

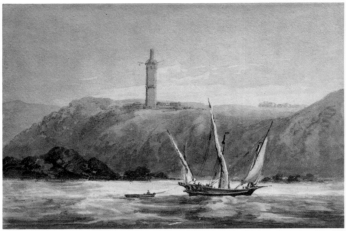

168

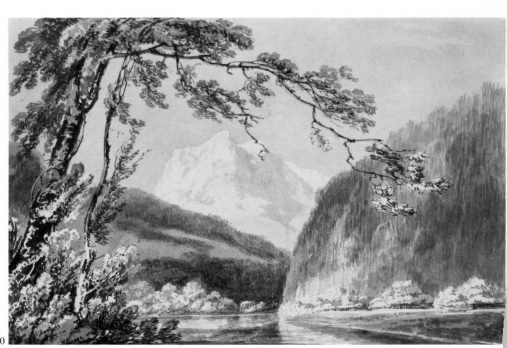

169

170

Plate 58

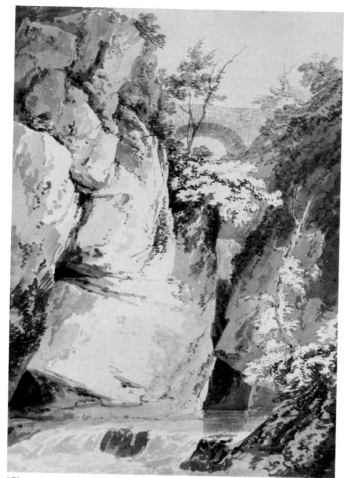

171

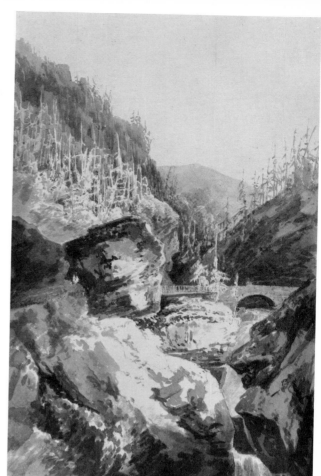

172

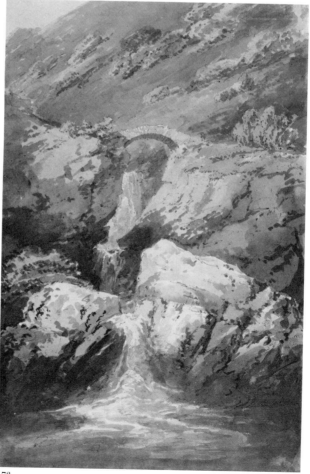

173

Plate 59

174

175

176

Plate 60

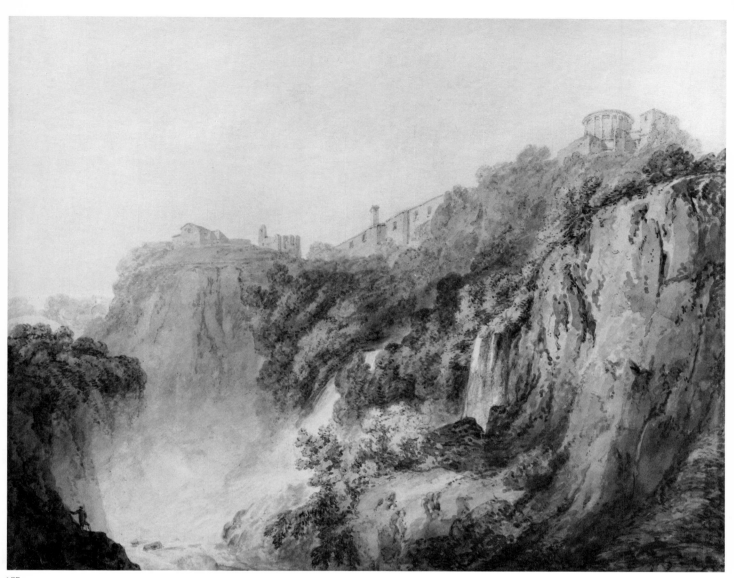

177

Plate 61